Hogarth's Literary Relationships

Hogarth's
Literary Relationships

by

ROBERT ETHERIDGE MOORE

But when t'examine every part he came,
Nature and Hogarth were, he found, the same.

1969

OCTAGON BOOKS
New York

Reprinted 1969
by special arrangement with the University of Minnesota Press

OCTAGON BOOKS
A DIVISION OF FARRAR, STRAUS & GIROUX, INC.
19 Union Square West
New York, N. Y. 10003

LIBRARY OF CONGRESS CATALOG CARD NUMBER: 70-76001

Printed in U.S.A. by
NOBLE OFFSET PRINTERS, INC.
NEW YORK 3, N. Y.

To
CHAUNCEY BREWSTER TINKER

Preface

A STUDY of a great painter which ignores such pure-
ly plastic sides of his art as form, color, design, and tex-
ture, and emphasizes instead his literary importance, will meet
with a certain amount of disapproval from critics of painting.
They will surely regard the literary merits of a pictorial artist
as irrelevant. Such criticism would in many instances be jus-
tified, for, although a study of the painting of any age will
increase our understanding and appreciation of that age's
literature, few painters have exerted any notable formative
influence upon writers. That Hogarth is an outstanding and
complete exception even a cursory examination of this volume
will show. He insisted that he was a "dramatic writer," and in
the advertisements of *A Harlot's Progress* called himself "the
Author" of the series. More than that of any other painter,
his relationship with the writers of his time goes far beyond
a mere reflection of common themes; he was instead a foun-
tainhead of inspiration, an artist whose works played a major
part in shaping the tradition of realistic satire in English fic-
tion. His influence upon the greatest novelist of the age is an
obvious proof of his singular literary importance. Remarkably
enough, no study of the subject has ever been attempted
before.

Some readers may feel that an undue proportion of the pres-
ent book is devoted to a description and analysis of the pictures
themselves. Yet several urgent considerations have persuaded
me to this course: since we are concerned with Hogarth's
literary influence, the stories and actions of the pictures are of
the first importance; since often it is the details of the pictures

which most interest a writer, unless we have these details be-
fore us we cannot understand the subject nor can we see into
Hogarth's comic method; since his great subtlety, which has
been shamefully ignored, depends upon details, they must be
clearly visualized; and, finally, since no collection of Hogarth's
works has been available for roughly a hundred years, many
readers will be unfamiliar with the pictures.

It is a pleasure to express thanks to the friends who have
helped me in the course of this work. In particular I am in-
debted to Professor Chauncey B. Tinker, who first introduced
me to the subject and whose advice and kind encouragement
have been constant; to Professor Gertrude Ingalls, for whose
criticisms and suggestions I have a very high regard; and to
Professor Samuel H. Monk, who has given me invaluable help
in revising the manuscript for the press. For reading parts of
the manuscript in the course of its composition, I wish to
thank Professors R. D. French, R. J. Menner, F. A. Pottle,
and L. L. Martz, all of Yale University. For other generous
and helpful suggestions I am grateful to Professors J. W.
Beach and C. A. Moore of the University of Minnesota, Pro-
fessor B. H. Bronson of the University of California, Dr. C.
H. Collins Baker of the Huntington Library, and Professor
R. M. Myers of Tulane University. In securing the illustra-
tions I have had the kind assistance of Dr. A. F. Blunt of the
Courtauld Institute, Mr. Karl Freund of New York City, and
the staffs of the Frick Art Reference Library and the print
room of the Metropolitan Museum of Art. Finally, I am
grateful to the University of Minnesota for a fellowship grant
which enabled me to complete my research.

R. E. M.

NOTE. After the page proofs were returned to the printer, my
article on another phase of Hogarth's literary relationships,
"Hogarth as Illustrator," appeared in *Art in America* for Oc-
tober 1948 (Vol. XXXVI, no. 4).

Table of Contents

List of Illustrations

Hogarth's Literary Relationships

Hogarth Invades the Augustan Age

To SPEAK of Hogarth's appearance upon the Augustan scene as an invasion may seem strong and even flamboyant, but in truth no more accurate term can be employed. He was an invader from the beginning of his career to its end. The truth of the epithet is in no way lessened by recognizing that Hogarth, like all great artists, was as much molded by his age as the age in turn was molded by him. Indeed, in a study of this kind it is of the very first importance to make clear at once that Hogarth is not being considered as the signal phenomenon of the century, from which all things sprang. Certainly the principal purpose of the book is to reveal the influence he exerted upon the literature of his age — he exerted little on the painting — yet there is no one more thoroughly a product of that age than he.

Historians rely heavily upon his work as the most faithful pictorial transcription of the period. Fifty years one way or the other would have made a vast difference in his work, for though his satire is timeless, its accoutrements are altogether mid-eighteenth century. Yet few figures of the age overturned more barriers, or more clearly influenced others by revealing a new path. To understand this we must first understand something of the scene upon which he suddenly appeared, after which we may discern changes that Hogarth popularized, and eventually how these changes affected the literature of the middle of the century.

Until the appearance of his first great success, the six prints of *A Harlot's Progress*, in April 1732, William Hogarth was a comparatively obscure artist. There is certainly no reason

why he should have been known, for it was the heyday of a group of writers and painters whose principles were utterly foreign to Hogarth's genius. Around him he saw an inclination toward moderation and conservatism, while he, like Swift, was disposed toward energy and violence. Sir Godfrey Kneller and Sir Peter Lely, the two most talented and fashionable London painters of the preceding fifty years, had found their ideal in court beauties with large blue eyes and bee-stung lips; he found his in a radiant street wench with a basket of shrimps on her head. Sir Godfrey and his large tribe of drapery painters imitated an infinitely greater painter, Van Dyck; Hogarth did not pattern his work after any other painters, and except for purposes of ridicule infrequently imitated them. Augustan painters and poets attempted to look alike and act alike, to paint alike and write alike. Though their souls may have been sincere, their bounty was usually not large.

In contrast, Hogarth seldom tried to be like anybody but himself, and his bounty was enormous. Writers both in poetry and prose accepted certain rules and principles in accordance with which they wrote. Hogarth attempted to lay down rules only once, when he produced the *Analysis of Beauty*. In its day it was unanimously condemned as a heavy, elaborate failure, and though today aestheticians take a kindlier view of the book, it is by no means an exposition of Hogarth's usual practice in painting.

A perfect expression of this gilded and beautiful age comes from its most brilliant product, Alexander Pope, an expression which may be quoted to remind us of the world Hogarth was to encounter and in large part reject, and to suggest why *invader* is his proper epithet.

> Close by those meads, for ever crown'd with flow'rs,
> Where Thames with pride surveys his rising tow'rs,
> There stands a structure of majestic frame,
> Which from the neighb'ring Hampton takes its name.
> Here Britain's statesmen oft the fall foredoom
> Of foreign Tyrants, and of Nymphs at home;

Here thou, great Anna! whom three realms obey,
Dost sometimes counsel take — and sometimes Tea.
Hither the Heroes and the nymphs resort,
To taste a while the pleasures of a Court;
In various talk th'instructive hours they past,
Who gave the ball, or paid the visit last;
One speaks the glory of the British Queen,
And one describes a charming Indian screen;
A third interprets motions, looks, and eyes;
At ev'ry word a reputation dies.
Snuff, or the fan, supply each pause of chat,
With singing, laughing, ogling, *and all that.*

The delicate charm of Pope's descriptions, the elegant ur-
banity of his satire, are obviously almost entirely alien to the
world of Hogarth. Instead of meads crowned with flowers, he
shows the Tyburn gallows surrounded by seething chaotic
throngs. The London of Pope — the pleasures of a court, in-
structive hours of gossip, charming Indian screens — gives way
in Hogarth to another London of unashamed harlots on mid-
night streets, of depraved wretches in the black cells of Bed-
lam and the Fleet. Pope's unique refinement may be seen in
the lines on Queen Anne: he can lend a very special and
subtle charm to his compliment to her by adding the joke
about tea; Hogarth seldom compliments anybody, and what
little charm he has is of an order not very refined. Pope's satire
at its best consists of delicate anticlimax, witty paradox, a
nicety of balance within the couplet; Hogarth's is more often
turbulent, coarse, exciting in its brutality. Even on the rare
occasions when Pope forsakes his ordered avenue for the riot-
ous Hogarth street, as in the second book of *The Dunciad,*
the effect is decidedly more Popean than Hogarthian, for we
are more impressed by the brilliance of the author than the
impact of his subject matter. Pope himself, in a facetious note
on the race between Lintot and Curll, says truly that "our
author . . . tosses about his dung with an air of majesty. . . .
The politest men are sometimes obliged to swear, when they
happen to have to do with porters and oyster-wenches." Pope

impresses with his wit, while Hogarth illustrates the broader vein which is humor.

Pope actually lived his poetry in his elegant estate at Twickenham, where Nature was without any doubt dressed to advantage. Landscape gardening subdued all rusticity, and a grotto ornamented with mirrors turned a stream into a masterwork of artifice. His poem, "On his Grotto at Twickenham composed of Marbles, Spars, Gems, Ores, and Minerals," begins:

> Thou who shalt stop where Thames' translucent wave
> Shines a broad mirror through the shadowy cave;
> Where lingering drops from mineral roofs distil,
> And pointed crystals break the sparkling rill,
> Unpolish'd gems no ray on pride bestow,
> And latent metals innocently glow;
> Approach. Great Nature studiously behold!

Hogarth divided his life between a simple house in a moderately respectable part of London and an even simpler retreat in Chiswick. In neither place might Great Nature be studiously beheld.

Although Pope remained the most popular poet of the age for years after his death in 1744, it is obvious that both his art and that of his far less gifted contemporaries in painting appealed to a comparatively limited circle. England's greatest verse satirist is possessed of both high ideals and a realistic eye; but he satirized only a small segment of eighteenth-century life. No great artist existed for the common man except perhaps Defoe, and he was really a journalist. Swift, although as violent and hard as Hogarth, can certainly not be called a bourgeois writer, since, for one thing, he is usually beyond the level of bourgeois comprehension. This is not to imply that the public were breathlessly waiting and thirsting for art, but the fact that they had not had much of it before helps to explain Hogarth's singular success. For *A Harlot's Progress* was a success unparalleled and brought art to the man who was, literally, in the street.

Up to that time Hogarth was not widely known. Although today his portraits are judged the best in English painting between Van Dyck and Reynolds, in his own age he was not sought after as a portrait painter because he would not flatter his subjects. The novelty of the small "conversation pieces," playful portraiture in natural and intimate surroundings, to which he next turned, and which he first popularized in English painting,[1] wore off in a few years. In his memoirs, printed by John Ireland toward the end of the century in the book entitled *Hogarth Illustrated*, the artist himself relates that his profession was not sufficiently profitable to pay the expenses his family required. He goes on to give his solution: "I therefore turned my thoughts to a still more novel mode, viz., painting and engraving modern moral subjects, a field not broken up in any country or any age."[2]

To hear Hogarth speak of modern moral subjects as a "novel mode" is surprising, for his work in part had been long anticipated. Narrative pictures were familiar from the saints' legends painted by artists as early as Giotto. The increasing book illustrations all through the seventeenth century would suggest to Hogarth the possibility of engraving a narrative series; in his own *Don Quixote* illustrations he made use of Coypel's engravings for an early French edition. Furthermore, pictorial comedy in engravings was known in Europe during the Renaissance, and in the seventeenth century the Dutch had painted genre chronicles with caricature comment.[3] Even earlier, Jerome Bosch's goblin pictures and grotesqueries, though presenting no connected story in a series of paintings, illustrate on a single canvas several stages of a Biblical event. In the elder Brueghel, Hogarth would seem to have found a tradition for treating the familiar and the realistic in painting, and for the highly symbolic or allegorical nature of these familiar scenes; yet Brueghel, like Bosch, never paints a continu-

[1] Sacheverell Sitwell, *Conversation Pieces* (London, 1936), p. 9.
[2] *Hogarth Illustrated* (2d ed., London, 1804), III, 24–25.
[3] See R. H. Wilenski, *English Painting* (London, 1933), p. 77.

ous narrative with a plot involving the same characters in different circumstances. The genre painting of Jan Steen is the nearest ancestor to Hogarth. With his interest in satire and facial expression, Steen is the only Dutch painter from whom Hogarth actually borrowed definite motifs, particularly of drinking scenes. But Steen never takes a story beyond one scene, which often illustrates a proverb, nor is there in his work the thorough differentiation among characters that we find in Hogarth. Actually Steen is undramatic; despite his geniality and liveliness, the hand of the Dutch still life is upon him. Thus in a learned article on Hogarth's borrowings, Dr. Antal can place primary emphasis on his originality:

Since in the cycles he expressed didactic, critical, combative, humanitarian middleclass ideas through themes of his own choosing, covering every aspect of life, in all its ups and downs, he did not specialize in any one particular field of human activity or any particular strata [sic] of society as did the Dutch genre painters in their much more "pleasant" subject matter.[4]

Hogarth surpasses them by a great leap both thematically and in individual motifs. Although it is not remarkable, in the light of his predecessors, that he should have had the idea of painting and engraving narrative cycles, Hogarth plainly is justified in speaking of his own particular accomplishment as a "novel mode."

The first work of this new mode was the series of six oil paintings of *A Harlot's Progress*, probably begun soon after his marriage to Jane Thornhill in 1729 and completed two years later. The date on the harlot's coffin in the final picture, *2d Sep 1731*, has been generally accepted as the day on which the set was completed.[5] The following January Hogarth announced in the newspapers that prints of the paintings were forthcoming, and after several delays they appeared in April.

[4] F. Antal, "Hogarth and his Borrowings," *The Art Bulletin*, XXIX (March 1947), 40.
[5] Austin Dobson, *William Hogarth* (London, 1898), p. 35.

From that day forward he was a famous man. These six prints had the effect of a meteor in a dark sky. John Nichols, compiler of the *Biographical Anecdotes* of Hogarth, the first biography, asserts that they were "tasted by all ranks of people," and over twelve hundred names were entered in Hogarth's subscription book.[6] The prints were pirated in almost every conceivable size; Nichols alone saw eight such sets, and there were probably others. All six plates were copied in miniature on fan mounts, three compartments on one side and three on the other. Nichols relates that Hogarth presented a fan thus adorned to every maidservant who entered his employ, though probably more as a graceful gift than as a solemn warning. The pictures also appeared on sets of chinaware, as did many of Hogarth's works,[7] for the harlot series is but a harbinger of his subsequent popularity. The next year the satire on drunken revelry, *A Midnight Modern Conversation*, found great favor in France and Germany, and was transferred to fans, pottery, and snuffboxes.[8] The prints were pirated throughout his life, despite a bill passed by Parliament in 1735 at Hogarth's own instigation to prevent piracy. An interesting example is the picture *Taste in High Life*, painted for a certain rich and cantankerous Miss Edwards, who wanted it as a satire on her modish friends. Since it was a private commission Hogarth refused to have it engraved, but through the connivance of the lady's servants a copy was made and enjoyed great popularity.[9]

One naturally asks why the prints of an obscure artist should suddenly become the most sought-after articles in town. He does not at first seem entirely original, for just as certain anticipations of his art may be seen in the Dutch paint-

[6] *Biographical Anecdotes* (London, 1782), p. 249.

[7] H. J. L. J. Masse, "Some Notes on the Pewter in the Victoria and Albert Museum at South Kensington," *Burlington Magazine*, III (September 1903), 76.

[8] Dobson, p. 50 n.

[9] *Catalogue of Satirical Prints in the British Museum* (London, 1870-1938), III, Part One, 449. This work is hereafter referred to as *B.M.*

ers, so his milieu had been treated by certain Augustan writers who immediately preceded him. He was of course not the first man of his age to turn for his subject matter to the lower classes. The frightful conditions in which the poor lived could not be ignored by artists as serious as Defoe, Swift, and Steele. Swift had written for the *Tatler* a set of verses called "A Description of the Morning," every couplet of which may find an illustration in Hogarth:

> Now hardly here and there an hackney-coach
> Appearing, show'd the ruddy morn's approach,
> Now Betty from her master's bed had flown,
> And softly stole to discompose her own;
> The slip-shod 'prentice from his master's door
> Had par'd the dirt, and sprinkled round the floor.
> Now Moll had whirl'd her mop with dextrous airs,
> Prepar'd to scrub the entry and the stairs.
> The youth with broomy stumps began to trace
> The kennel's edge, where wheels had worn the place.
> The small-coal man was heard with cadence deep,
> Till drown'd in shriller notes of chimney-sweep:
> Duns at his lordship's gate began to meet;
> And brickdust Moll had scream'd through half the street.
> The turnkey now his flock returning sees,
> Duly let out a-nights to steal for fees:
> The watchful bailiffs take their silent stands,
> And schoolboys lag with satchels in their hands.

One of Swift's sermons, called "On Sleeping in Church," recalls Hogarth's *Sleeping Congregation*, but they are alike only in subject, not in detail. Gay's *Trivia* is a humorous poem on the art of walking the streets in eighteenth-century London, but is not without serious overtones. *The Beggar's Opera* is laid in Newgate prison and in unsavory taverns nearby. Ned Ward's *London Spy* had glanced at nearly as many of the less respectable aspects of city life as Hogarth, in a much more forceful manner, was to record later. Defoe's Moll Flanders appeared ten years before Hogarth's Moll Hackabout.

Obviously the painter's subject matter was not entirely new.[10] Addison and more especially Steele in the *Spectator* did not shrink from chastising some of the more sordid aspects of a London existence. Steele, in number 266, has even been thought to have supplied Hogarth with the inspiration for *A Harlot's Progress*. In the essay, "A Consideration of poor and publick Whores," he mentions seeing "the most artful Procuress in the Town, examining a most beautiful Country-Girl, who had come up in the same Waggon with my Things." Even if this gave Hogarth some of the material for the first picture — and it is doubtful — he went on to do five others on his own. At least it is clear that Hogarth drew material from all around him and that he was not the first to do so, though perhaps no one before him had concentrated to such an extent upon the gutter.

It was not his subject that was original, but his manner of translating that subject into pictorial art. This was new in itself, but he was also the first painter in England to get a new and huge public, the middle classes, by large-scale production — engraving his own paintings and selling them at reasonable prices. The six prints of *A Harlot's Progress*, for example, sold at only a guinea. Nor was he above a practice that would have horrified the court painters — advertising his works in the newspapers. The result, at its best, was like that of the famous print of John Wilkes as the Champion of Liberty; four thousand prints were worked off on the first publication, and the sale was so rapid that the printer had to keep the press going day and night.[11] Thus Hogarth was the first great English artist after Pope to become wholly independent of wealthy patrons by means of his own earnings.

Yet it is not enough to say that it was the novelty of the commonalty's being able for the first time to buy pictures cheaply which accounts for Hogarth's success, because his

[10] Hogarth's advance over Defoe in narrative technique is discussed in Chapter IV.

[11] Samuel Ireland, *Graphic Illustrations of Hogarth* (London, 1794), I, 177.

public extended to other classes (connoisseurs bought some of the paintings); and while novelty would soon have worn off, the prints sold well all through his long life. It is rather his fresh and individual treatment of his subject that made his contemporary reputation and has given him immortality. Strictly speaking, an artist's treatment of the subject makes up the actual content of the subject; but in an examination of the content of Hogarth's art, we may simplify the problem by calling it an examination of how he lent new values to his subject matter.

Some of the factors are obvious. For example, the first and simplest element of Hogarth's appeal is his titles. Many of them alone are still a strong magnet to the curious, and in 1730 they were doubtless even stronger. Who remains indifferent to such titles as *A Harlot's Progress, A Rake's Progress, Strolling Actresses Dressing in a Barn, A Lady's Last Stake*? The relation of sex to comedy is no less obvious than its relation to popular appeal. In these Hogarthian titles we see its relation to both. Place them beside the most famous titles of the age — *An Essay on Man, The Spectator, Robinson Crusoe, Gulliver's Travels, An Epistle to Dr. Arbuthnot, Pamela.* It is easy to see whose bait is more enticing.

For another reason for his popularity, and for a firsthand account of the way the prints were vended and received by the public, we may turn to a pamphlet published in 1748, soon after the appearance of Hogarth's longest series, *Industry and Idleness*.[12] The title page is itself revealing:

The Effects of Industry and Idleness Illustrated; In the Life, Adventures, and Various Fortunes of Two Fellow-'Prentices of the City of London. Being an Explanation of the Moral of Twelve Celebrated Prints, lately Published, and Designed by the Ingenious Mr. Hogarth.

We are led to expect a moral discourse in the familiar eighteenth-century manner, and that expectation is unhappily

[12] This pamphlet was advertised in the *Gentleman's Magazine*, XVIII (1748), 144.

fulfilled, but not until the anonymous author has taken us on an intimate excursion through the London streets on the very morning that Hogarth's prints appeared in the print shops all over the city. It is a unique document, and very important for reasons that become apparent as we read.

Walking some Weeks ago from Temple-Bar to 'Change in a pensive Humour, I found myself interrupted at every Print-Shop by a Croud of People of all Ranks gazing at Mr. Hogarth's Prints of Industry and Idleness. Being thus disturbed in my then Train of Thoughts, my Curiosity was awakened to mingle with the Croud, to take a View of what they seemed so much to admire. Mr. Hogarth's Name at bottom was sufficient to fix my Attention on these celebrated Pieces, where I found an excellent and useful Moral discovered by the nicest strokes of Art to the meanest Understanding. After I had step'd into the Shop to look at such as were not stuck up in the Window, and viewed the whole more calmly, I purchased a Set, and was proceeding on my Way to 'Change, when a Thought struck me in the Head, I apprehended might divert me more than the Business I had there, which was to take a Tour around all the Print-Shops, and listen to the Opinion of the several Spectators concerning this new Performance of the ingenious Mr. Hogarth. By this means I expected to find out the Influence which a Representation of this kind might have upon the Manners of the Youth of this great Metropolis, for whose Use they seem chiefly calculated; and at the same time I promised myself an agreeable Amusement from the diversity of Notions and Reflections the Vulgar are apt to make about Things the least removed from their Sphere of Knowledge.

He stops at a number of shops, each of which displays in the window several of the twelve prints as a means of luring the purchasers inside. Although he had ingenuously expected to hear the crowd talking of the moral of the story and of the different stages of misfortune attendant upon vicious Idleness, he instead comes upon a beadle gazing at Plate III and loudly exclaiming:

G – d S – ds, Dick, I'll be d – n'd if that is not Bob ——, Beadle of St. —— Parish; it's as like him as one Herring is like another; see

his Nose, his Chin, and the damn'd sour Look so natural to poor Bob. G – d Suckers, who could have thought Hogarth could have hit him off so exactly. It's very merry; we shall have pure Fun tonight with Ned; I expect to see him at our Club; I'll roast him. I'll buy this Print, if it was only to plague him.

Throughout the entire day the story is the same. He goes to other print shops and recounts the remarks of the spectators outside. Nearly all discover in one or another of the prints persons of their acquaintance, and go away much pleased with the artist, not for his general design or fable but for hitting off some lucky strokes that correspond with notions of the spectators' own. After this the author proceeds to relate, in the leaden part of the pamphlet, a narrative and a moral explanation of the prints designed to be sold to the ignorant spectators.

The pamphlet underscores the immediacy of Hogarth's pictures to his public. He made many of his prints as topical as a page from the morning newspaper. Even before he had formulated the idea of narrative pictures, he had incorporated into his drawings those things that were at the moment most in the news. As early as 1724 he had satirized the widespread rage for pantomimes (helping to pave the way, as we shall see, for Fielding's burlesques of several years later), not only because he was disgusted at their remarkable vogue, but also because anything touching so closely the passion of the crowd would be likely to sell. *A Harlot's Progress* had something far more sensational to offer. The very first plate illustrated two widely known scandals of the day. The procuress befriending the innocent Moll Hackabout, who has just arrived from the country, is the infamous Mother Needham, described by Pope in a note to *The Dunciad* as

a matron of great fame, and very religious in her way; whose constant prayer it was, that she might "get enough by her profession to leave it off in time, and make her peace with God." But her fate was not so happy; for being convicted, and set in the

pillory, she was . . . so ill used by the populace, that it put an end to her days.[13]

This flamboyant fate overtook her in 1731, just when Hogarth was painting his pictures. The old roué in the background watching with a lecherous eye Mother Needham's transaction is an even more notorious personage, Colonel Francis Charteris, a libertine of so vile a character that when he died in 1732 the people of the neighborhood raised a great riot, tried to tear the body from the coffin, and threw dead dogs and cats and garbage into the tomb.[14] A scurrilous epitaph, written by Arbuthnot and calling Charteris "the most unworthy of all the descendants of Adam," appeared in the *Gentleman's Magazine* for April. Although no names were engraved under the pictures of these people, the likenesses were too close to escape recognition. Thus Hogarth in the same picture achieves satire on two disreputable characters as well as a sure recipe for popular success. Nichols tells us that soon after the pictures appeared the Lords of the Treasury hastened to the print shop for the "striking likeness" of Sir John Gonson, the harlot-hunting justice who appears in Plate III.[15] The series had the appearance of actual biography.

This sort of thing was of course common to journalism and to satire, but Hogarth makes it popular in pictorial art and suggests it to prose fiction. His prints are obviously satirical. The difference from conventional literary satire like that of Dryden and Pope and Swift is that here the real personages incorporated into the story, and thus satirized, are merely minor figures in a work where the chief interest is in the story itself. *A Harlot's Progress* was not created to satirize Mother Needham or Colonel Charteris any more than were

[13] Warburton's edition of *The Dunciad* (London, 1749), I. 52n.

[14] See E. B. Chancellor, *The Lives of the Rakes* (London, 1925), III, 153. Soon after Charteris' death appeared a poem entitled "Don Francisco's Descent to the Infernal Regions, an Interlude," in which he meets and converses with Mother Needham in hell. (*Ibid.*, 158.)

[15] Nichols, pp. 25–28.

Smollett's novels created to satirize the many actual people who appear in them. In both cases the main purpose was to tell a thrilling and often horrifying tale, and, in Hogarth's case at least, to expose an entire way of life. The work that nearest approaches this before Hogarth is *Gulliver's Travels,* a tale of fiction with actual contemporary references sometimes incorporated; but when Swift's satire becomes specific it is aimed at political parties rather than at individuals, and even then the contempt is for parties in general rather than for Whigs and Tories. In the last two books he largely abandons the pretense that he is telling a story, and devotes himself to the very blackest satire. Hogarth allows nothing to get in the way of his story.

An even clearer example than *A Harlot's Progress* of Hogarth's ability to feel the pulse of the town, for turning a nine days' wonder to his own advantage, is afforded by the Sarah Malcolm print. It is probably the first example of the sensational pictorial journalism which supports so many of our contemporary monosyllabic publications. Malcolm, as the newspapers of the day call her, was a young laundress who was hanged on 7 March 1733 for robbing and murdering two elderly women and their maid. She had accused three other persons of the deed, saying that she only stood on the stairs as a watch, but her guilt was established. Her trial and execution attracted huge crowds.[16] On the very day of her hanging the *Daily Advertiser* announced: "On Monday last the ingenious Mr. Hogarth made her a Visit, and took down with his Pencil, a very exact likeness of her, that the Features of so remarkable a Woman may not be unknown to those who could not see her while alive." On the next day, a Thursday, the same paper announced that Hogarth's print would be on sale by Saturday. Two days after this, on Monday, 12 March, appeared a pamphlet to add more excitement to the case, "A True Copy of the Paper deliver'd by Sarah Malcolm, the Night before her

[16] A full account of the case may be read in the *Gentleman's Magazine,* III (1733), 97, 137, 153.

Execution, to the Rev. Mr. Piddington." So eager were the public to possess her picture that three copies were engraved, besides one in wood which was made for the *Gentleman's Magazine*.[17] A slightly different copy was pirated from Hogarth's plate to be used as the frontispiece to a pamphlet entitled "The Friendly Apparition: Being an account of a most surprising appearance of Sarah Malcolm's Ghost to a great assembly of her acquaintance at a noted Gin-shop; together with the remarkable speech she then made to the whole company."[18] Could there be clearer evidence of the sureness of Hogarth's hold on the pulse of the London populace?

This story could be repeated again and again. It is sufficient to mention only two more examples: *The March to Finchley*, the scene picturing the disorders of a military dislodgment; and the splendid picture of Lord Lovat counting the highland clans on his fingers, painted a few days before his execution for high treason. In the former print the bawd at one of the windows of the King's Head brothel, piously joining her hands in a prayer for the speedy return of the soldiers, is the enormously fat Mother Douglas, a notorious madam of the Covent Garden Piazza. Hogarth pictured her in a similar action in *Industry and Idleness* (Plate XI), and in *Enthusiasm Delineated*. In 1760 Samuel Foote made her the central character in his burlesque of Methodism, *The Minor*.

Simon Fraser, Lord Lovat, was one of the principal instigators and leaders of the rebellion of 1745, the abortive attempt to put Bonny Prince Charlie on the English throne. It is the same rebellion that the guards are marching to Finchley to stifle. When Lovat was captured in 1746, Hogarth traveled to an inn at St. Albans in order to take the likeness of the prisoner, who was stopping there because of alleged sickness en route to London.[19] The story of his career and of his capture was being told and retold on every hand with countless em-

[17] *B.M.*, II, 775–76.
[18] Nichols, p. 153. This pamphlet is advertised, with a slight variation in the title, in the *Gentleman's Magazine*, III (1733), 388.
[19] Dobson, p. 100; *B.M.*, III, Part One, 608.

bellishments when Hogarth published his print. Consequently the rolling press could not supply impressions as fast as they were wanted; and though the prints sold cheaply, Hogarth received payment for several weeks at the then unusual rate of twelve pounds a day.[20] While it is not certain that he is the author of *Lovat's Ghost on Pilgrimage* (to Scotland), a mezzotint which appeared nearly ten months later, it is at least significant that the subject of one of Hogarth's finest portraits and prints was still in the news. He seldom chose wrong.

Closely akin to the representation of actual persons is the introduction of actual places, a third reason for the immediate success of Hogarth's prints. Hazlitt, in a notable essay on the painter, has remarked, "I know no one who had a less pastoral imagination than Hogarth. . . . His pictures breathe a certain close, greasy, tavern air."[21] Hogarth is a painter of the indoors. Even his many street scenes are so compressed that, conveying no feeling of space, they assume an indoor quality. His scenes are nearly all played against the background of a city, and the city is always London. Henry B. Wheatley has even published a volume of some 450 pages entitled simply *Hogarth's London*. There is little that goes to the making of the Greater London of the mid-eighteenth century that Hogarth does not represent. From the premier thoroughfare, St. James's Street, to the Triple Tree at Tyburn, nearly all the notable places are there. The effect on his public is obvious. Actual places were mentioned in the *Spectator*, but that was a newspaper, and in *Trivia*, but that was a guidebook in verse. A picture is different. Browning has remarked the attractiveness of seeing familiar places transferred to canvas or prints:

> For, don't you mark? we're made so that we love
> First when we see them painted, things we have passed
> Perhaps a hundred times nor cared to see;
> And so they are better, painted — better to us,
> Which is the same thing.

[20] Nichols, p. 229.
[21] *Lectures on the English Comic Writers* (London, 1819), p. 282.

Hogarth's careful delineation of his London has made him one of the historian's most accurate sources of the eighteenth-century scene. Furthermore, he accomplished the brilliant feat of turning the ordinary familiar world into the extraordinary and unusual.

Not only does he give us the actual mise-en-scène of the London in which he lived, but, as its natural accompaniment, all the various facets of London life — the habits, the customs, and the amusements of the whole people and all the classes into which it may be divided. This goes far toward explaining not only his remarkable contemporary popularity, but his eclipse in the last half of the century when a more romantic age admired only Gainsborough, Reynolds, and other highly elegant masters, and when the frank mirror of satire was being laid aside almost altogether. The earlier part of the century was more interested in the development of society and institutions than in the assertion of the individual, and in this Hogarth was at one with his contemporaries; but his directness, his realism, and his range go so far beyond theirs — Swift excepted — that it seems different in kind. Charles Lamb, whose understanding essay written for Leigh Hunt's journal, the *Reflector*, probably did more to revive critical interest in Hogarth in the next century than any other single stimulus, remarks on this side of his genius. Lamb compares *Gin Lane* with Poussin's *Plague at Athens*, and says:

Disease and Death, and bewildering Terror, in Athenian garments, are endurable, and come, as the delicate critics express it, "within the limits of pleasurable sensation." But the scenes of their own St. Giles's delineated by their own countryman, are too shocking to think of.[22]

Hogarth made his appearance in an age when all painters were either literally or figuratively clothing everything in Athenian garments, and poets cluttered their works with turgid addresses to the muses.

His rebellion against this tradition, which asserted itself in

[22] *Reflector*, II (1811), 64.

a vigorous exposé of life as he saw it around him, even in its most sordid aspects, could not but be stimulating to the whole populace. His point of view was absorbed by Fielding and Smollett,[23] and together they brought strength and solidity back to art, until works of such tender sensibility as the Ossian poems, *The Man of Feeling*, and the idealized romantic portraits of Reynolds's school generated the temporary damp of which Lamb speaks. Hogarth is not milk for babes but strong meat for men, says Lamb;[24] and it is eventually men and strong meat that have come into their rightful inheritance. Naturally a certain class of people could see nothing beyond sensationalism in the prints, and, seizing upon those things which were suited to their own tastes, reflected their own vulgarity back upon the artist. But Hogarth's pictures have transcended the particular moment, so that they are as powerful and meaningful today as they ever were. He has projected the immediate into the sphere of the universal, the object of all great art.

Thus far it has been suggested that after Hogarth found his forte with *A Harlot's Progress*, his prints succeeded remarkably because of their titles, their dramatis personae, their familiar locale, and their wide range of vigorous contemporary subject matter. Yet it has been apparent that other works earlier than Hogarth, particularly the *Spectator*, had dealt with this same all-inclusive subject matter, and that Hogarth's originality must lie in his unique treatment of these familiar themes. Aside from the excitement of having such themes transferred to pictures, there remains, then, the one most important aspect of Hogarth's originality and the most far-reaching of his contributions. It is simply that he accentuated story — a story with a plot. In the *Spectator* paper referred to earlier, Steele contributed a dramatis personae, a setting, and a theme — but he left it at that. Over and over again he and Addison will set a scene, will describe an incident, will

[23] See Chapters III, IV, and V.
[24] *Reflector*, II (1811), 72.

lay a groundwork, and will then show no interest in going on. When they do tell a story, as the tale of Inkle and Yarico in the eleventh issue of the *Spectator*, it is to inculcate a lesson. The story does not grow naturally out of the immediate surroundings. Defoe could relate an incident superbly, but he lacked a plot; his stories are aimless narratives held together only because the events deal with a single character. *The Dunciad* enjoyed all the excitement incident to scandal involving well-known men whose names were but thinly disguised. Yet the poem told no story and, in one respect at least, must have been less exciting than *A Harlot's Progress*, which combined both scandal and plot. Hogarth's work has, to my mind, the added distinction of being a superior satire, for Johnson's judgment upon *The Dunciad* is sound: "That the design was moral, whatever the author might tell either his readers or himself, I am not convinced."

Perhaps the best manner of underlining the concentration and originality of Hogarth's contribution is to compare him briefly with a writer whose name is frequently linked with his because of their common locales, the author of *The London Spy*, Ned Ward. Ward's was a struggling independent talent with an acute sensitivity to the picturesque hurly-burly of contemporary London. He loitered about the city's streets and taverns writing down what he observed, and earning for himself the epithet "jovial, brutal, vulgar, graphic Ned Ward." [25] Hogarth could merit the same epithet, though it would not tell the whole of the story as it does with Ward. For *The London Spy*, despite all its entertainment, is wholly lacking in purpose and direction. Claiming to be satirical, it takes more delight in the picturesque and in the salacious, and it never does more than merely amble. The age needed a genius who, animated with a great purpose, could seize upon all this vibrant material and ram it into a tight, exciting form which would translate it into enduring art.

Suddenly Hogarth appeared and, using the same sort of

[25] See H. W. Troyer, *Ned Ward of Grubstreet* (Cambridge, 1946), p. 8.

incidents his predecessors had used, not only wove them into a plot with a satirical purpose, but did so in the manner of the experienced dramatist. He himself realized his accomplishment and explained it in his memoirs:

> I . . . wished to compose pictures on canvas similar to representations on the stage, and further hope that they will be tried by the same test, and criticized by the same criterion. . . . Let the figures in either pictures or prints be considered as players dressed either for the sublime, for genteel comedy, or farce, — for high or low life. I have endeavoured to treat my subjects as a dramatic writer: my picture is my stage, and men and women my players, who by means of certain actions and gestures are to exhibit a dumb show.[26]

When an artist tells us about his own work we may do well to listen to him. This statement of purpose from Hogarth's own pen has the utmost significance for the present study. He considered himself a "dramatic writer" and admits here that he has given us all the essentials for drama except the words; versifiers and playwrights will not be able to keep away from the pictures, will not resist supplying the finishing touch. As Gautier once said, Hogarth is the Aristophanes of the pencil, an author who paints instead of writes his comedies.[27] In all the prints the expression is caught at the salient point in a state of progress or change, and it is this that gives them such animation. The deep serenity and peace of the great Italian masters and of Rembrandt are not to be found in Hogarth. Instead each of his pictures teems with life and motion; the scenes never stand still. His singular ability to give the impression of actual speech is illustrated brilliantly in the levee scene from *Marriage à la Mode*, but it is also immediately apparent in every picture of *A Harlot's Progress*, which we are

[26] John Ireland, III, 25-26. The French academicians had attempted dramatic narrative in their historical paintings, but what they could accomplish by their formal manner on a single canvas — not in a series — is obviously a far cry from Hogarth.

[27] From notes in the *Moniteur*, translated by G. A. Sala, *Temple Bar*, V (1862), 323.

now to examine. From here it is but a short step to the literary performances inspired by these and other of the prints; the strange history of these performances is revealed in the next chapter. After that we shall see how Hogarth's literary connections extended to two of the greatest writers in the language, Fielding and Smollett, and finally how a study of his work may immensely illuminate our understanding of theirs.

Grub Street Invades Hogarth

A Harlot's Progress

THAT Hogarth was easily the most eminently and immediately vendible of all English pictorial artists is shown by the tribe of authors who at once embraced *A Harlot's Progress* as a great fountainhead of literary inspiration, and by the enormous public who bought their feeble works. The series was so popular that on 24 April 1732, about two weeks after the publication of the prints, there appeared a pamphlet setting forth the story in verse, which in its turn was so popular that it actually went through four editions in seventeen days.[1] Even more surprising is another pamphlet professing to tell the harlot's story, this time in prose, written before the prints had even appeared. Both pamphlets, whose stories will be unfolded presently, lent excitement to the sale of the prints. We are told that distinction ebbs before a herd of vulgar plebs, but for Hogarth at least the opposite was true.

For a man of Hogarth's artistic craftsmanship the experiment begun with *A Harlot's Progress* could not conceivably fail. From the first it was a sure thing. I have already spoken of the title, the dramatis personae, the familiar locale, the topical references, and the dramatic story, all of which insured a popularity immense and instantaneous. Popularity is no inconsiderable achievement in itself, but Hogarth was shrewd enough to see that if he could add edification to mere popular excitement he might assume gigantic stature, for to

NOTE. A portion of this chapter is a summary of a portion of the author's doctoral dissertation, written at Yale University in 1943.
[1] See below, p. 32.

combine entertainment with instruction has nearly always been the straightest way to prosperity. The first half of the eighteenth century, combining a lustful curiosity with an instinct for satire, was especially delighted with anything that canted "moral," and even more especially when the moral was arrived at by lurid and breathless paths. One remembers the success of Defoe's *Moll Flanders*, published but ten years before Hogarth's series. The eighteenth-century sinner, as the Methodist Whitefield learned, enjoyed being exposed to what they called a "lesson"; it was the attraction of opposites.

All this may make Hogarth appear to be a cynical hypocrite who was sufficiently cunning to supply his public with whatever they wanted, whether good or bad. The error of such a judgment is at once apparent when we examine the six pictures of *A Harlot's Progress*. Hogarth was certainly a keen businessman, but the pictures are a serious work of art and a great one. An object of the present chapter is to show how the best in Hogarth was often deliberately ignored by the pamphleteers, or else misinterpreted, in order to throw a more salacious light on the pictures. But Hogarth was able to weave a certain amount of sensationalism into a unified texture, thus transforming it into a work of art.

The pattern of *A Harlot's Progress* is simple. It begins as a rather special kind of success story and then it backfires. It shows six episodes in the career of Mary Hackabout, whose name we learn from a note in the third picture and from the coffin plate in the last. Probably Hogarth, always eager for topical allusions, was referring to an actual woman who appears in the following extract, recounting an arrest, from the *Grub Street Journal* of 6 August 1730:

The 4th was the famous Kate Hackabout (whose brother was lately hang'd at Tyburn), a woman noted in and about the Hundreds of Drury for being a very termagant and a terror, not only to the civil part of the neighborhood by her frequent fighting, noise, and swearing in the streets in the night-time, but also to other women of her own profession.

Such an explanation is of course unnecessary, for *hack* is a carriage for hire, *about* implies the variety necessary to the real mistress of her trade, and the combination might be translated *Madame à tout le monde.*

In the tragedy's first scene, which Hogarth carefully lays in front of the Bell Inn in Wood Street, Cheapside, the simple country girl, just alighted from the York Wagon, is listening to the blandishments of a beflounced bawd (Mother Needham), while a prospective customer (Colonel Charteris) lecherously ogles her youthful beauty. The picture, like the others in the series, is replete with comical and satirical detail. For example, she has brought a basket containing a dead goose labelled "To my loved cousin in Tems Street, London"; the goose is a fine emblem of Mary's own gullibility.

Her immediate future, so clearly indicated in the first scene, is confirmed in the second where we see her as the pampered mistress of a rich Jew (probably a real person). Hogarth here suggests her eventual ruin, for she is already being false to her keeper; by her stupidity and dishonesty she will lose all that she has acquired. She is shown in this spirited scene engaging him in a quarrel at the tea table in order that a young spark with whom she has spent the night may escape unobserved from the room. In her affected tantrum she kicks over the table, astonishing both her keeper and her little blackamoor attending with the teakettle, and scalding her pet monkey, who scampers yelping across the room. Thus the attention of the Jew, who frantically grasps at the falling table, is successfully diverted from the escaping lover.

In the third scene she has been turned out of keeping, and, with a noseless companion, is sharing an impromptu breakfast in a dreary Drury Lane lodging, littered with objects of poverty-stricken disorder. That she is consorting with criminals is indicated by the wig box of an infamous highwayman, James Dalton, lying on top of her bed. At the back of the room a magistrate (the famous "harlot-hunting justice," Sir John Gonson) enters cautiously with his constables to arrest

her for thievery. She is dangling a watch stolen from her para-
mour of the previous night.

The harlot now goes from very bad to considerably worse,
for in the fourth picture she is decked out in perhaps the last
of her finery as she beats hemp at Bridewell. Hogarth, with an
eye always attentive to news, probably got the idea for his
central figure from a passage in the *Grub Street Journal* of
14 September 1730, at which time he was almost certainly
engaged upon the paintings:

One Mary Moffat, a woman of great note in the hundreds of
Drury, who about a fortnight ago was committed to hard labour
in Tothill-fields, Bridewell, by nine justices . . . is now beating
hemp in a gown very richly laced with silver.

It is possible that Mary Moffat and Kate Hackabout gave Ho-
garth the name of his heroine. While a one-eyed harridan picks
her pocket, the savage keeper commands her to make haste
with her work.

The fifth scene, occurring several years later, discloses the
harlot's miserable death; the last scene, her funeral. The for-
mer takes us to an appalling room of dirt and chaos where on
one side the harlot falls back in her chair in the final death
agony, while on the other two doctors, completely oblivious
of their patient, wrangle over the efficacy of their separate
nostrums. They are satirical portraits of two scandalous
quacks of the time, Dr. John Misaubin and Dr. Joshua "Spot"
Ward. A final note of tragedy is struck by Mary's little son,
who turns a scrap of meat hung to roast by a string suspended
over the fire.

The harlot's funeral is a scene of utter depravity in which
all the mourners are fast on the way to complete drunkenness.
The small son, ignorant of the cause of the celebration, sits in
the center in his mourning clothes and amuses himself by
spinning a top. Beyond the heartlessness of the entire assembly,
Hogarth is ridiculing the absurdly expensive funerals in which
even the poor indulged. The series of pictures, while enforc-
ing the simple moral lesson that a deviation from virtue is a

departure from happiness, is infinitely more powerful as a satire on many of the shocking and terrible conditions that were a part of eighteenth-century life.

II

The six prints of *A Harlot's Progress* were presumably published on 10 April 1732. On 29 March the *Daily Advertiser* announced:

The six Prints from Copper-Plates, representing a Harlot's Progress, are now Printing off and will be ready to be delivered to the subscribers on Monday the 10th Day of April next. N.B. Particular Care will be taken that the Impressions shall be good. Subscriptions will be taken in till the 3rd Day of April next, and not afterwards; and the Publick may be assur'd, that no more will be printed off than shall be subscribed for within that time.

The prints enjoyed instantaneous success and, Hogarth himself tells us, were pirated on all sides.[2] Besides the eight sets of piracies that Nichols saw, other evidences of the unparalleled popularity of the prints are the various pamphlets that immediately sprang up based on Hogarth's pictures. A brief study of some of them offers as revealing an insight into Grub Street huggermugger as may be found anywhere.

The Grub Street tribe, as is well known, were an unofficial and unorganized group of garret poets who undertook to supply a small group of booksellers known as "the trade" with anything under the changing moon that might enjoy even a moment's popularity.[3] They were a literary Sears and Roebuck who only a day or two after the order would deliver the goods, which usually were of no merit. Yet to view some of Grub Street's hack work not only is one of the soundest methods of discovering the tastes and trends of the time, but also throws new light upon much of the material found in the work of genuine artists such as Fielding. Indeed Fielding and Dr. Johnson both served a Grub Street apprenticeship.

[2] John Ireland, *Hogarth Illustrated* (2d ed., London, 1804), III, 32.
[3] For a good book on the subject consult A. S. Collins' *Authorship in the Days of Johnson* (London, 1927).

The exploitation of *A Harlot's Progress* in Grub Street will serve to illustrate nearly all the ways of making a given material take with the town. The first of the pamphlets to appear is the clearest possible case of a favorite Grub Street subterfuge, writing before the event. Although it was given to the public on 21 April, eleven days after Hogarth had delivered the pictures to the subscribers, the numerous pirated copies were only just beginning to make their appearance. One G. King, who brought out copies of the prints with Hogarth's permission, the first three on 21 April, the others on 28 April, warned the public that if any other copies were published "or offered by the Hawkers or their Accomplices before the Publication of These, they will be Impositions and bad Copies, there not having been Time enough to finish them neatly." [4] This obviously indicates that King either suspected piracies momentarily or had already seen some. The prints were only just beginning to have a wide circulation, then, when this pamphlet appeared, and its author was sure to be in the vanguard of the excitement and profit. How he managed to get there so quickly becomes apparent as we examine the pamphlet. [5]

The title page, a very ingenious creation in itself, reads as follows:

The Progress of a Harlot. As she is described in Six Prints, by the Ingenious Mr. Hogarth. Containing,
 I. Her coming to Town. Being met by a Bawd who took her home, and arrested her.
 II. Her being released by a Jew, who took her into Keeping.
 III. Her being turned out of Keeping. Her taking Lodgings in Drury-Lane. A description of the Life led by her, and the rest of the Whores there.
 IV. Her being sent to Bridewell, the Trick she put on those who

[4] *Daily Journal*, 19 April 1732.
[5] This prose pamphlet was advertised in the *Daily Journal* of 21 April (Dobson, *William Hogarth* [London, 1898], p. 167). The *Grub Street Journal* of 27 April announces "The Progress of an Harlot" as published on 25 April. This may indicate a second printing or may refer to another pamphlet altogether, the "Six Hudibrastick Cantos." (See below, p. 32.)

committed her. Her being released. Her Adventure with a Parson whom she pawns for the Reckoning. Her Adventure with a Turkey Merchant. The Trick she play'd two French Refugees and their Wives. Her setting up a Punch-House. The Trick she put on a Widow.

v. Her contracting the foul Disease. Her being laid in a Salavation and carried to the famous Lock. The Dispute of the Doctors. Her Death.

vi. Her Funeral, with the comical Trick that was play'd the Parson and Undertaker.

With several other entertaining Particulars to[o] tedious to be inserted here.

Printed for E. Rayner, at the Pamphlet-Shop next the George Tavern, Charing Cross . . . Price One Shilling.

A comparison with Hogarth shows that except for Part iv, which is unbridled invention on the part of the author, this table of contents follows with fair accuracy the narrative of the pictures. Obviously this summary could not have been composed before the writer had either seen the pictures himself or been given a clear account of them. Having formed this impression, the reader of the pamphlet is amazed to discover that he is following a tale quite different from what the table of contents promised. He is inclined to believe that the title page, with its preview of the contents, was written for another book altogether and by mistake was bound with this one. In other words, the author of this minor horror has meant to pass off his work as something predominantly Hogarthian, which it certainly is not.

The trashy story, though not without a salacious interest, is not worth being related here. Told in the first person, it takes the heroine from her childhood, when she is sent to school dressed as a boy (one can immediately sense the drift of the situations), through a long, bawdy, and thoroughly happy career which has nothing at all to do with Hogarth's prints. On page 47 the narrative in the first person abruptly breaks off, and, in a little more than a page, there follows the brief account of her disease, death, and funeral. Here, on the next

to last page, we have the first concession to the Hogarth prints which the entire forty-eight pages profess to elucidate. As in the pictures, the doctors wrangle while the harlot dies, and both minister and undertaker are debauched at her funeral. Obviously the advertisement on the title page was a mere bait to lure the public; the whole enterprise is a thorough hoax.

To guess the desperate and by no means unique history of the pamphlet's composition is easy enough. Hogarth had announced publicly as early as 29 January that he was undertaking to engrave six pictures of *A Harlot's Progress*.[6] Exactly two months later he announced, again in the newspapers, that the prints would be ready for the subscribers on 10 April. A Grub Street hack got wind of it and conceived the scheme of having Mr. Hogarth help him sell a story that he would at once dash off about a harlot. The wretched author not only had never seen the pictures but did not even know what story they told; nor did he take any pains to find out, as he might easily have done. When the prints appeared he hastily tacked on the ending, composed the title page, and had the book at the printers all within a day or two. The pamphlet was on the bookseller's stand just eleven days after the prints were issued. This sort of rapid undercover work could come off simply because of the comparative smallness of London in 1732, and because of the peculiar intimacy of the entire Grub Street trade — writer, printer, and bookseller alike. They were all desperate men out to entrap the gullible public, and they had discovered that their only chance of survival was to be in league one with another. The history of this worthless pamphlet allows us a glimpse into a union that, unless civilization becomes far more simplified, is unlikely ever to rise again.

III

The next pamphlet of which we have any record appeared three days later, on 24 April. Its title page reads:

[6] Dobson (p. 40) quotes the advertisement in the *Country Journal: or, the Craftsman*.

The Harlot's Progress: or, the Humours of Drury Lane. In Six Cantos, Being the tale of the noted Moll Hackabout, in Hudibrastick Verse, containing her whole Life; which is a key to the Six Prints lately publish'd by Mr. Hogarth . . . London: Printed for S. Dickinson and others, 1732. Price One Shilling.

This is the poem which, incredible as it may seem, went through four editions in slightly more than two weeks. Dobson says that the poem, with a frontispiece of a group of three figures from Plate 1, first appeared on 24 April; the fourth edition with the price raised to two shillings was announced on 11 May.[7] I have used the second edition, enlarged with an epistle "To the Ingenious Mr. Hogarth," which the *Daily Post* records was published on 4 May.

Unlike the former work, the story of the poem follows closely the elaborate digest printed on the title page. It was actually written from Hogarth's pictures as the verse epistle states:

> Henceforth I'll not invoke or choose
> Th'Assistance of an airy Muse;
> Let but my Eye your Pictures see,
> My Thoughts must flow in Poetry.

Could the airy muse have made these verses any better one regrets she was not found, for no one could call what follows poetry. Yet the passage is important as indicative of the ease with which these literary performances arose out of the pictures. The rhymester, besides inventing a good deal on his own account, overlooks some of Hogarth's most amusing and most telling strokes, enough in itself to render him an inadequate interpreter of the painter's art. Such omissions, a characteristic of all these pamphlets, are in general due to one of two faults: either to pirated prints, of which many were so hastily and badly executed that they lack much of the Hogarthian detail, or to the author's lack of interest in or lack of perception of the significance of these details in the pictures. A striking omission in the present poem, hardly a detail, is

[7] Dobson, p. 168.

Mary's little son, who is roasting a piece of meat in the grim death scene. In Hogarth the child is a dramatic and pathetic addition; his omission from the poem shows how little the versifier cared about the real power of the pictures.

What he did care about is easily discovered. We have seen how the first Grub Street hack made capital of Hogarth's pictures by writing before the event, thus putting all his eggs in a basket which did not yet exist; the second makes his capital on a much surer market, lewdness. The mild indecencies of the earlier pamphlet pale beside the avidity with which the rhymester seizes upon the coarse details in Hogarth and exploits them to shocking lengths. For example, the harlot's maid in the second canto, a lass of unlimited amorous experience, speaks a long, coarse, and exceedingly graphic tirade against men and their desires. In the third canto (based on Hogarth's third picture) occurs a phallic description of the candle and its bottle holder which would bring a blush to even the most worldly cheek. The last canto is less shocking, yet it describes all the lusty mourners at the funeral, the following passage telling of the priest sitting beside a buxom Venus. In reproducing it here I am allowing truth to triumph over taste, for it must be seen to be believed.

> For he had got the prettiest Doxy,
> And made his F——r do by Proxy,
> What would become a nobler Part,
> To do with Pleasure, and with Art . . .
> He felt, she grin'd and leer'd, and he
> Star'd, and he grin'd as well as she;
> And lest the rest see this and that,
> He laid a Cover on't — his Hat;
> Oh Hat sublime! thy Brims have cover'd
> The deepest Thing Man has discover'd;
> A Myst'ry deep, unfathomable,
> As Bay of Biscay with a Cable;
> And tho' the Pr—sts have hidden Springs,
> They can't discover hidden things,
> Without the Help of Revelation,
> For Reason's Rules are now D——on.

And so on. Few clearer examples can be found of one of Grub Street's most dependable tools — smut. Other examples need not be given, nor any remarks on why the pamphlet went through four editions in eighteen days.

IV

The next two pamphlets are of more interest than the others for several reasons. First, they represent a peculiarly eighteenth-century method of exploitation; second, they bear an intimate relation to the work of both Fielding and Hogarth discussed in the next chapter; and finally, the second of the pamphlets is by a well-known contemporary writer and actor, Theophilus Cibber, son of the poet laureate. These pamphlets illustrate how Hogarth's pictures were turned into theatrical fare, an inevitable fate for subjects so popular, and help to explain the disgust that Hogarth and Fielding felt for such entertainments. The first is a ballad opera, the second a pantomime.

The ballad opera had long been one of the eighteenth century's principal forms of amusement, especially since *The Beggar's Opera* had established it as a vehicle for ridicule in 1728. From that date ballad opera all but ousted regular comedy and tragedy from the stage. In 1733, when the pamphlet in question appeared, it offered one of the surest stairways to financial success. The title page of this piece, published on 14 February 1733, reads:[8]

The Jew Decoy'd; or the Progress of a Harlot. A New Ballad Opera of Three Acts; The Airs set to old Ballad Tunes. London: Printed for E. Rayner . . . 1733. (Price One Shilling).

The frontispiece, a crude copy of Hogarth's second plate, carries a jumbled explanation: "She is suppos'd Cashier'd her service is then seen in grand keeping with a Jew and soon after turned upon the Common for misbehaviour." In spite of

[8] See the *Daily Advertiser* of 14 February. It is also advertised in the *Gentleman's Magazine*, III (1733), 106.

all its promising omens, however, *The Jew Decoyed* was never performed.[9]

To examine the action of the piece is to see an interesting example of the eighteenth century's method of taking a simple tale and blowing it up into a ballad opera. The author in the first scene shows his method of carrying on the story by introducing "The Time-teller," a sort of master of ceremonies, who announces that he will supply the continuity between each scene. Though it is obviously a weak device, the author is thus able to present a smoothly running story without much effort. The actual scenes of the opera are largely built around Hogarth's pictures, the various situations there being given extended action. A fair illustration of how this forgotten yet not untypical hack managed to work up his opera may be seen in the episode of the Jew's bedroom. First the time-teller announces that Moll Hackabout soon learned every vice and went into the keeping of a rich Jew. The scene then opens upon her bedroom in Ben Israel's home. She is sitting on the bed talking and singing with Spruce, her young gallant, when the maid rushes in to announce the Jew. Spruce hastens out, shoes in hand. Moll pretends anger and upsets the tea table, but eventually her keeper persuades first her and then Julio, the blackamoor, to sing. Many songs, though totally irrelevant to the story, fill every scene and may well have been very pleasant to hear.

An example of the author's exuberant additions to his source is illustrated by the remainder of the scene. As the Jew leaves the apartment he spies Spruce's snuffbox and, in a towering rage, prepares to run Moll through with a stiletto. She knocks him over and precipitates a lusty battle, which, had the play reached the stage, could have been carried to slapstick lengths. Then she and her maid Alice run out, lock the door, and leave the Jew shrieking "Murder, Thieves, Whores, Devils." What all this has to do with Hogarth is beyond conjecture.

[9] D. E. Baker, *Biographia Dramatica* (London, 1812), II, 344.

The last half of *The Jew Decoyed* becomes a great deal
more somber and actually makes something of Hogarth's
satire on the foul contemporary social conditions. There oc-
cur a rather terrifying conversation between the jailers and a
painful scene as Moll is ridiculed by the Bridewell women.
The author, like Fielding in *Jonathan Wild*, presents the
scenes almost gaily but clearly conveys the utter wretchedness
of the situation. Nevertheless the frivolous songs continue,
creating two differing spirits which he cannot blend. The note
of cynicism and revulsion, so faithful to the Hogarth pictures,
in all likelihood kept this opera from ever being performed.
One can enjoy the comedy and vulgarity of certain features
in *A Harlot's Progress*, yet at the same time be aware of its
power as a relentless satire. Hogarth could accomplish the
miracle of union, and so could Gay in *The Beggar's Opera*,
but the forgotten hack of *The Jew Decoyed* could not.

<div align="center">V</div>

A full year after *A Harlot's Progress* was published it was
still sufficiently popular to be made the basis of the most
ephemeral of all entertainments, a pantomime. The author was
Theophilus Cibber, celebrated in the eighteenth century as an
actor, as the son of the famous Colley, and as the husband of
the actress and singer for whom Handel wrote some of his
most celebrated airs. But today even Colley is remembered
only as being the hero of *The Dunciad* and as having added
two immortal lines to Shakespeare; Theophilus rests in peace-
ful oblivion. The exact date on which this rare pamphlet was
published has eluded discovery, but on 14 April 1733 the *Daily
Advertiser* ran the following announcement:

At the Theatre Royal in Drury-Lane, on Tuesday next, being the
17th of April will be presented a Comedy call'd *The Careless
Husband*, To which will be added a Grotesque Pantomime, call'd
The Harlot's Progress, or, The Ridotto Al'Fresco.[10]

[10] The title page of this pamphlet announces that it was to be had at the
theater, so it must already have been published at the time of the first per-
formance. John Genest, *Some Account of the English Stage* (Bath, 1832), III,

In contrast to the opera of the unknown Grub Street hack, this piece met with considerable success, running through the season as an afterpiece to various plays.[11] Theophilus Cibber was not by fortune or residence of the Grub Street tribe, but since his literary abilities and methods were of a piece with theirs, he may certainly be considered with them. Cibber dedicated his work to "the Ingenious Mr. Hogarth" undoubtedly before he had seen the unflattering reference to himself in *Southwark Fair*, painted the same year.

Because in 1733 pantomime was the most enormously and most undeservedly popular of all theatrical entertainments, an examination of a portion of Cibber's work will show a number of interesting things. For example, since we know its source, a study of Cibber's work will reveal how easily a pantomime was clapped together, what the taste of a mid-eighteenth century audience was like, and the basis of Hogarth and Fielding's war on these entertainments, a phenomenon investigated in the next chapter. In order to illustrate a few of the really astonishing embellishments, I reproduce a portion of the pamphlet, which consists entirely of stage directions and songs. It is not a pure pantomime, for even though the action is conveyed in dumb show all the characters except Harlequin sing. But this was true of virtually all pantomimes in the 1730's. The reader will be surprised, as he reads the following extract, if he recalls what Hogarth emphasized in his six pictures.

After the Overture, the Curtain rises; – the Scene represents an Inn; the Bawd, the Country Girl, the Debauchee and the Pimp all rang'd as they are in the first Print. – The Parson on the Right Hand, reading the Letter, soon goes off – while the Bawd is persuading the Girl to go along with her, Harlequin appears at the Window, and seeing the Country Girl, jumps down, and gets into a Trunk which belongs to her, while the Bawd sings.

371, records a performance of "Harlot's Progress" on 7 April which may be a mistake for 17 April. The heroine was Miss Raftor, afterwards famous as Mrs. Clive, who played the ingénue in nearly all of Fielding's plays.

[11] See W. L. Cross, *The History of Henry Fielding* (New Haven, 1918), I, 143.

Air i. (What tho' I am a Country Lass)
Let Country Damsels plainly nice,
In Home-spun Russet go, Sir;
While, Frolick we, chearful as wise,
More pleasing Transports know, Sir. . . .

After the Song, the Bawd beckons a Porter, orders him to take
up the Trunk and follow her and the Girl, which he does, with
Harlequin in it. — Then the Debauchee comes forward, who seems
to be enamour'd with the Girl; the Pimp assures him he can pro-
cure her for him, upon which the Debauchee seems rejoic'd and
sings in Praise of Women and Wine.

Air ii. (Brisk Tom and Jolly Kate)
Brisk Wine and Women are,
The sum of all our Joy . . .

After the Song he follows her — the Pimp struts about and
sings

Air iii. (Maggy Lawther)
Pimping is a Science, Sir,
The only Mode and Fashion,
To Virtue bids Defiance, Sir,
'Tis the Glory of the Nation . . .

After the Song he follows the Debauchee. — The Scene changes
to the Street; the Debauchee having found Harlequin in company
with Miss Kitty, turns her out of Doors, and the Pimp kicks out
Harlequin; Kitty goes out in the greatest Distress —. Harlequin
by his Action signifies he's in Love, and is in doubt whether to
hang or drown himself, or cut his Throat, etc. At length he re-
solves to follow her, and determines to dress himself like a smart
Cadet, in order to address her: To accomplish which he strikes
the Ground, and there rises a Dressing Table fix'd in a Cloud,
furnish'd with all necessary Appurtenances. — After he is drest,
the Table vanishes and he goes out. The Scene changes to the
Lodging that Beau Mordecai has provided for Kitty, whom he has
just taken into high Keeping. (This Scene is taken from the Sec-
ond Print) She is discovered lolling upon a Settee, attended by her
Maid and Black-Boy.

Except for a number of songs and an amorous encounter be-

tween the harlot and Harlequin, this scene follows Hogarth's story fairly closely. The Jew discovers Harlequin, who is trying to slip out the door in back as in the print. He sings a vociferous duet with Kitty.

After the Song he turns her and her Maid out of Doors, then pursues Harlequin. — A Picture falls down, Harlequin jumps thro' the Hangings, and the Picture returns to its place and conceals him. The Subject of the Picture, which was before an Historical Story, is now chang'd to a Representation of the Jew with Horns upon his Head. — While he stands in astonishment the other Picture changes likewise, and represents Harlequin and Kitty embracing — upon which the Jew runs out in the greatest surprise. Scene changes to the Street. Harlequin meets the Jew, who immediately draws; Harlequin catches him by the Leg, and throws him down, jumps over him, and runs off.

Much more of the same sort of nonsense follows; but the most surprising transformation in the entire piece occurs in the Bridewell scene. The women are leaning idly upon the hemp blocks.

The Keeper enters, and seeing them so idle threatens to beat 'em — as they take up their Hammers and Beetles, and are going to beat, the Blocks all vanish, and in their stead appear Harlequin, Scaramouche, Pierrot, and Mezetin, each takes out his Lady to dance, and signify they'll go to the Ridotto al' Fresco; the Keeper runs away frighted, they all dance off.

At the end the scene changes to the Ridotto, a copy of Vauxhall, where a masque, *The Judgment of Paris*, is performed.

A more thorough and absurd transformation can scarcely be imagined. Hogarth's feelings upon seeing such a mockery of his art are easy to guess. Cibber's perversion of the great pictorial series is as typical of the nature of the pantomime entertainment as John Thurmond's treatment ten years earlier of the Faustus story, the most popular of all pantomimes.[12] The expense of the elaborate stage trickery was alone enough to wreck the theater. Add to this the banality of the action,

[12] See below, p. 81.

and Fielding's determination to batter it to a pulp becomes understandable. But for years pantomime remained one of the safest means for Grub Street to keep itself going.

VI

In one way the final pamphlet which we are to examine resorts to the most scandalous subterfuge of all, for it amounts, in effect if not in fact, to forgery. The story of its origin is fairly complicated, but reveals more graphically than any other example I know the desperate subterfuge resorted to by the downtrodden tribe of hacks and booksellers in the first half of the eighteenth century. The manner in which Hogarth was exploited to feed these hungry mouths even involves the most eminent literary figure of the age, Alexander Pope.

Perhaps it is best to begin by looking at the cover of the pamphlet, which appeared at the end of April 1733. It reads simply, "Mr. Gay's Harlot's Progress. Price One Shilling Six-pence." But the title page inside bears a different title:

Morality in Vice: an Heroi-Comical Poem. In Six Cantos. By Mr. Joseph Gay. Founded Upon Mr. Hogarth's Six Prints of A Harlot's Progress; and illustrated with Them. Necessary for all Families, wherein there are Females; especially, Boarding-Schools. . . . London: Printed in the Year MDCCXXXIII.

No record of the appearance of this pamphlet has been found; Austin Dobson, who went through nearly all the periodicals of the period, discovered no notice of it and apparently was unaware that the title *Morality in Vice* ever existed. But in the list of books published in May 1733 compiled by the *Gentleman's Magazine* occurs notice of "The Lure of Venus: or, A Harlot's Progress. An Heroi-Comical Poem in Six Canto's. By Mr. Joseph Gay." [18] Except for the title page, this poem is exactly the same in every way as *Morality in Vice*. The fact that the title page is obviously a cancel, that is, has been pasted in (and the pasting here is clearly visible), and that the title

[18] Dobson (p. 169) notes that it was advertised in the *Daily Journal* of 1 May 1733. It apparently went through another edition within the year, for on 6 December the *Grub Street Journal* advertises it as "Lately Publish'd."

itself has been made far more alluring, is sufficient proof that *The Lure of Venus* is the later of the two. The practice of changing titles was one of the most cunning and dishonest among the bookselling tribe. If a new book did not please the public, it was the habit of Edmund Curll, the notorious pub-lisher, instead of changing the book's contents, to make an entirely different and much more enticing title page.[14] An ex-ample of this sort of thing may be seen not only in replacing *Morality in Vice* with *The Lure of Venus*, but also in chang-ing the original motto,

> Read, but take Heed, that you such Actions shun;
> For Honesty is best, when all is done;

to a more suggestive one,

> Females! the wily Harlot's Net beware,
> Pleasing's the Lure, but fatal is the Snare.

The near-forgery, mentioned above, centers in the name "Mr. Gay." One of Hogarth's commentators, George Augus-tus Sala, calls Joseph Gay "the wretched pseudonym of some Grub Street, gutter-blood rag-galloper."[15] The name is one of the many scandalous impostures which Curll played upon his readers. The story begins in January 1716, when John Gay's *Trivia* was published and enjoyed a considerable vogue. On 28 June Curll published a poem, *The Petticoat*, "by Mr. Gay." Although the preface is signed "Joseph Gay," many copies were bought under the impression that it was by the author of *Trivia*; this of course was exactly what Curll had intended.[16] Pope, a friend of John Gay and an enemy of Curll, referred to the matter in *The Dunciad* (II, 127–30):

> Curll stretches after Gay, but Gay is gone;
> He grasps an empty Joseph for a John.
> So Proteus, hunted in a nobler shape,
> Became, when seized, a puppy, or an ape.

[14] See Ralph Straus, *The Unspeakable Curll* (London, 1927), p. 25.
[15] *William Hogarth* (London, 1866), p. 162.
[16] Halkett and Laing, *Dictionary of Anonymous and Pseudonymous in English Literature* (London and Edinburgh, 1926–32), VI, 418.

Curll himself tells us that the author of *The Petticoat* is Francis Chute, but that *The Confederates*, a farce published the next year and attributed also to Joseph Gay, is by John Durant de Breval.[17] Chute apparently ceased to write, and Breval adopted the pseudonym which he still employed in the poem founded on *A Harlot's Progress*.[18]

Opposite the title pages of *Morality in Vice* and *The Lure of Venus* is printed a letter to Mr. Joseph Gay praising these "admirable Cantos" as "A true Key and lively Explanation of the Painter's Hieroglyphicks," and signed "A. Philips." This has been taken as Ambrose Philips, the poet and playwright, and though it may be another imposture, I suspect that it is not. Philips had every reason to encourage Breval because of their common grudge against the powerful Pope, of whom they were both afraid. Breval had offended Pope in *The Confederates* in 1717, but Pope took a scathing revenge in *The Dunciad* (II, 126, 238). As for Philips, Pope had given him a wound which could never heal in the well-known fortieth essay from Steele's paper, the *Guardian*, where he pretended to praise Philip's pastorals by quoting some of the most absurd passages imaginable and praising their elegance. The company that misery is said to like doubtless produced Philips's endorsement of Breval's poem.[19]

Thus a remarkable welter of circumstances involving the highest and the lowest eighteenth-century poets converges upon the simple cover, "Mr. Gay's Harlot's Progress." Obviously the publisher hoped to sell at least some copies on the reputation of the author of *The Beggar's Opera*, who had only recently died. Others who turned the cover to the title page he hoped to entrap with a suggestive title, *The Lure*

[17] *A Compleat Key to the Dunciad* (London, 1728), p. 11. This book was published by Curll, who is the attributed author.
[18] Baker, *Biographia Dramatica*, I, 65; and the *D.N.B.* article on Breval.
[19] It is likely that they were friends since they both received the M.A. degree at Cambridge at about the same time (Philips in 1699, Breval in 1700), and both remained there as fellows until 1708. (*Biographia Dramatica*, I, 64–65; and *The Poems of Ambrose Philips*, edited by M. G. Segar [Oxford, 1937], pp. xvii–xviii.)

of Venus. In either case Hogarth, unhappily, was the victim.

The poem itself requires little comment. Written in mock-heroic style clearly patterned after *The Rape of the Lock*, it is sad stuff. It does, however, contain a very accurate description of each of the prints except the Bridewell scene, which was apparently too strong for Breval's pen. The level of the poetry may be inferred from one unintentionally amusing couplet which occurs in the third canto, the dreary scene in the Drury Lane lodging:

> Muse, cease a while thy Progress to pursue,
> And deign her Chamber Furniture to view.

The poem is full of cant moralizing for the edification of those readers, especially feminine, referred to on the title page; but that the author's chief interest is not his moralizing is easily proved by examining in the last canto the space he devotes to a description of the priest's amour with one of the mourners.

<div align="center">VII</div>

The Lure of Venus is the last pamphlet connected with *A Harlot's Progress* which I have been able to find. There were doubtless others, because Breval in his preface speaks of two "pitiful Performances" in verse that had "crept forth" before he directed his own limited powers to the task. Since these and any others that existed were all written by "gutter-blood rag-gallopers" there is no reason to expect them to have survived nor to lament their passing. Two sets of explanatory verses were engraved under two different sets of pirated prints, one printed for John Bowles, the other for Edward Kirkall.[20] The former set is merely descriptive, the latter ponderously moral. Their poetic merit, like that of the pamphlets, is nil. But regardless of their literary worth the foregoing examination, illustrating many of the ways in which material was

[20] The Bowles verses are reproduced by Nichols, *Biographical Anecdotes* (London, 1782), pp. 167–71; the Kirkall verses in *B.M.*, III, Part One, 29ff.

hacked to pieces and then renovated to cater to the public's taste, has revealed a number of things about the writing of the age. Each pamphlet has illustrated a different method, each inglorious, yet each not unusual with these debased hacks: writing before the event, making capital of lewdness, blowing a simple tale up into a ballad opera or a pantomime, and finally deceiving the public by passing upon them a deceptive pseudonym and substituting a more alluring title page without changing a syllable of the book. And finally they suggest the latent literary qualities in Hogarth, which must wait to be absorbed by an artist like Fielding before they can become an invigorating force in English literature.

A Rake's Progress

The engravings of the eight scenes comprising Hogarth's second great narrative series, *A Rake's Progress*, were not published until June 1735, though he had begun the paintings as early as 1732. *A Harlot's Progress* would naturally lead Hogarth to contemplate a series on her male counterpart, and the prodigious success of the earlier pictures would surely cause him to redouble his efforts. That the paintings were completed in the next year, 1733, we know from an advertisement in the *Country Journal; or, the Craftsman* of 29 December 1733 announcing that the artist was already occupied with the engravings and that subscriptions were being taken.

The series opens as young Tom Rakewell,[21] being measured for a mourning suit, takes possession of his miserly father's effects. He offers a handful of gold to the enraged mother of the young and obviously pregnant girl he has seduced by promises of marriage. His subsequent career of idleness, dissipation, and ruin is suggested by the vacant, stupid look on his face, by his attempting to free himself from his obligation to

[21] "My Son Tom" appears on a memorandum in Plate i, and "A Poem dedicated to T. Rakewell Esq." in Plate ii.

the girl by a bribe to the mother, and by his allowing the greedy lawyer to take charge of a bag of uncounted gold.

The second picture, his levee, shows Rakewell, the clumsy man of fashion, as he stands surrounded by masters in the various arts cultivated by all fine gentlemen: music, poetry, gardening, horse racing, dancing, fencing, and boxing. Characteristically, Hogarth has made some of them actual portraits: the prizefighter, Figg; Old Bridgeman, the eminent landscape gardener; and Dubois, the French fencing-master. The next picture, one of the most famous in all Hogarth, shows the deliriously drunk Rakewell reveling in Drury Lane's notorious Rose Tavern at three in the morning, the hour when the nocturnal amusements of the house are in full glory.

In the fourth picture disaster begins to loom upon the hero's horizon when, going in resplendent dress to court to celebrate the queen's birthday, he is hauled out of his sedan chair and arrested for debt. At this moment he is seen by the girl he had wronged in Plate 1, and is rescued by the savings she has painstakingly earned as a milliner. The near-arrest takes place in St. James's Street, and Hogarth gives in the background a clear view of St. James's Palace and White's Chocolate House, a gambling den which serves its inevitable place in the story a little later. The best feature of the print is a spirited group of urchins, all engaged in dice and cards, who do not appear in the painting or the first state of the print.

The fifth scene, occurring some years later, shows us Marylebone Church, where Rakewell, in a desperate attempt to recoup his fortune, marries an awesome one-eyed dowager. The evergreens decking the altar not only are a fine emblem of this evergreen of the sex, but also suggest a winter marriage in two senses. The rake's attention is diverted by the comely young servant girl, who is arranging her mistress' bridal gown. The cobweb over the poor box, the Creed covered with mildew, and a crack running through the tenth commandment are amusing examples of Hogarth's minute satiric detail.

The last three scenes, depicting the catastrophic ending of the rake's career, rise to great dramatic heights. The sixth plate shows the hero in White's crowded gambling house, where he has just lost all his newly acquired fortune. The seventh occurs in the Fleet, where he has been thrown for debt. He is harangued by his enraged wife and distracted by his former mistress, who has come with her child to soothe him but who falls fainting at the horrible scene. The last scene of all discloses Bedlam, where he is a raving maniac chained to the floor and oblivious to the tears of the same faithful girl who has come to comfort him.

Hogarth, feeling the closeness of his dramatic pictures to the written word, employed his friend Dr. John Hoadly, a son of Bishop Hoadly of Winchester, to write a description in verses to be engraved under each of the eight prints.[22] It has been often asserted that the popularity of the versified explanations of *A Harlot's Progress* suggested this plan to Hogarth, but such an explanation is unnecessary when one remembers that Hogarth had been allied with verse-makers from the beginning of his career, verses having appeared under other of his prints long before the *Harlot* was even begun.

Only one pamphlet based upon *A Rake's Progress* merits examination, and this one only because it presents a lurid and perhaps unique record — how the pirate of prints, a man who literally stole the artist's pictures, managed to supply his partner in crime, the Grub Street poet, with the materials to hoax the public. This may be the only traceable case of the chicanery that was daily practiced between these impoverished wretches. Yet the frequency of the practice is proved in a note written by John Bancks, one of the Grub Street tribe, to a versified description engraved under a piracy of *A Midnight Modern Conversation*:

Soon after its appearing, the Author was sollicited by a Print-seller, whom he knew, to write some Lines for a Copy of it that was then engraving. As Custom, at that Time, had given a Sanc-

[22] Reproduced by Nichols, pp. 182–92.

tion to such Kind of Piracies, among the Print-sellers of all De-
grees, he made no Scruple of complying with the Request.[23]

Nearly all the pamphlets based upon *A Harlot's Progress*
were illustrated with cheap and slovenly executed miniature
copies of pirated prints from Hogarth's own larger and dearer
plates. Nothing could have been more maddening to Hogarth
than seeing the fruits of his labors stolen from him and, after
being badly mauled, sold for the thief's profit. As far back as
1724 with his print of *Masquerades and Operas* he had en-
countered the pirates, about whom he wrote:

[It] had no sooner begun to take a run, than I found copies of it
in the printshops, vending at half price, while the original prints
were returned to me again; and I was thus obliged to sell the plate
for whatever these pirates pleased to give me, as there was no
place of sale but at their shops.[24]

Finally in 1735, with a few fellow artists, he petitioned Parlia-
ment for permission to bring in a bill to vest in designers and
engravers an exclusive right to their own works, and to pre-
vent the multiplying of copies without their consent.[25] By 3
June 1735 the plates of *A Rake's Progress*, together with the
excellent *Southwark Fair*, were printing off, but their delivery
to subscribers was delayed until the twenty-fifth in order to
give them the full protection of the new act, which became
known as Hogarth's Act. Yet in spite of this precautionary
measure, Hogarth was not able to escape the print pirates,
whom he struck at in the following advertisemnt in the *Lon-
don Daily Post Boy* of 14 June, revealing their manner of
stealing:

Several Printsellers, who have of late made their chief gain by
unjustly pirating the inventions and designs of ingenious Artists,
whereby they have robbed them of the benefit of their labours,
being now prohibited such scandalous practices from the 24th of

[23] *Miscellaneous Works, in Verse and Prose, of John Bancks* (London,
1738), p. 87 n.
[24] John Ireland, III, 14.
[25] *Ibid.*, 33; and Dobson, p. 42.

June next, by an Act of Parliament passed the last Session . . .
have resolved notwithstanding to continue their injurious pro-
ceedings, at least until that time; and have, in a clandestine man-
ner, procured persons to come to Mr. Hogarth's house, under
pretence of seeing his Rake's Progress, in order to pirate the same,
and publish base prints thereof before the Act commences, and
even before Mr. Hogarth himself can publish the true ones. This
behaviour, and men who are capable of a practice so repugnant
to honesty and destructive of property, are humbly submitted to
the judgment of the publick, on whose justice the person injured
relies. — N.B. The Prints of the Rake's Progress, designed and en-
graved by Mr. William Hogarth, will not be published until after
the 24th instant; and all Prints thereof published before, will be
an imposition on the publick.

Simultaneously with this complaint appeared a series of
copies pirated by Boitard, and a few days later another set
pirated by Overton, Bowles, and others.[26] To counteract as
far as possible the ill effects of these extremely poor pirated
reproductions, Hogarth allowed a print and map seller,
Thomas Bakewell, to copy closely the originals and sell them
at 2s. 6d. the set. They were not issued until 10 August.[27]

One set of these piracies was the source of the poem we are
to examine. Obviously the illustrated verse pamphlets could
never have appeared almost simultaneously with Hogarth's
genuine prints had not the pirates beforehand supplied the
versifiers with their plagiarized copies. It is exactly the situa-
tion that occurred with Verdi's operas. Because of the throng
at rehearsals, all the tunes were being played by hurdy-gurdies
even before the opening curtain; the story of Verdi's conse-
quent concealment of the *Rigoletto* air, "La Donna è Mobile,"
is well known. Because Hogarth allowed prospective sub-
scribers for the prints to come to his house to view the paint-
ings, he was faced with the same situation. The pirates, under
pretence of subscribing, could view the pictures, and, as soon

[26] Nichols and Steevens, *The Genuine Works of William Hogarth* (Lon-
don, 1808), I, 84–85.
[27] *Ibid.*

as they went away, draw them from memory. This dishonest practice is sufficient explanation of an announcement in the *Daily Advertiser* for 3 June, three weeks before the publication of Hogarth's prints:

Now Printing, and in a few Days will be publish'd, the Progress of a Rake, exemplified in the Adventures of Ramble Gripe, Esq.; Son and Heir of Sir Positive Gripe; curiously design'd and engrav'd by some of the best Artists. Printed for Henry Overton . . . and others.

It will soon be apparent that the first part of our poem was based upon this plagiarized set of prints, or else upon piracies of these plagiaries. For it is known that at least two complete sets of *piracies of the plagiaries* were published shortly after the plagiaries themselves.[28] This is pirating the pirates, or piracy once removed.

The complete title of the poem reads:

The Rake's Progress; or, the Humours of Drury Lane. A Poem. In Eight Cantos. In Hudibrastick Verse. Being the Ramble of a Modern Oxonian; which is a Compleat Key to the Eight Prints lately published by the celebrated Mr. Hogarth.

Owing principally to the wretched character of the piracies, it can be established that the poet began by modeling his verses upon the pirated prints before he had ever seen the Hogarth pictures of which his poem professed to be the explanation. As a result he not infrequently explained in his verses things that Hogarth had never drawn. Yet when one considers the wealth of detail in every Hogarth picture, it is surprising to discover how much the pirate did manage to remember.

One question naturally arises about the plagiaries which

[28] F. G. Stephens, "Hogarth and the Pirates," *Portfolio*, XV (1884), 9. Stephens, who compiled the Hogarth items in the *Catalogue of Satirical Prints in the British Museum*, believed that the poem was illustrated with piracies of the original pirated set cited above from the *Daily Advertiser*. Only the first print of the original pirated set exists (*B.M.*, no. 2171), while six out of eight of the piracies of the original piracies are there. (*B.M.*, nos. 2172, 2184, 2198, 2222, 2235, 2257.) The first and fifth of this series I have reproduced.

were pirated to illustrate the poem: why has the rake been named Ramble Gripe when Hogarth's hero is called Tom Rakewell? The answer is interesting, for at the extreme left of Hogarth's first print the initials on the chest are "P.G.," which probably indicates that his original intention was to call the miser Positive Gripe, the name adopted by the plagiary. When he decided to change the name to Rakewell, a name as suitable to the father as to the son, though in an entirely different way, he neglected to change the initials on the chest. The pirate obviously had already printed his copies when Hogarth changed the miser's name.[29]

The poem tells a tale moderately similar to Hogarth's. Up through the fifth canto it is a much closer description of the pirated prints than of Hogarth's own, but in the last three cantos the reverse is true. The pirate obviously had allowed the poet to see the plagiarized prints, and the poet began to write from them. By the time he got to the sixth canto Hogarth's prints were out, and the poet finished his work from the genuine prints. When the verses were ready to be published, miniature copies of the pirated prints were bound in the pamphlets as illustrations.[30]

To describe the poem would be tiresome and needless. A few details are sufficient to illustrate the method of composition. The poet wrote the first canto with the plagiary before him. He describes an incident not in Hogarth of a glove filled with gold falling from its place of concealment in the wall as the draper puts up the funeral hangings. A glance at the plagiary reproduced here will reveal the glove. Also the poet explains that the pregnant girl had become the rake's mistress upon a promise of marriage from him, but that he had expressly told her that the wedding would have to wait until after the death of his father. In the plagiary one of the rake's love letters held up by the irate mother reads, ". . . but after his

[29] The poet calls his hero Tom, but his last name is never mentioned.
[30] The illustrations are small and lacking in detail, yet clearly follow the descriptions in B.M. of the pirated prints. See above, p. 49 n.

Death may Heaven renounce me if I don't make you my Lawfull Wife my Dearest." The condition of the father's death is not in Hogarth. Among the chief omissions in the description of Hogarth's levee scene are the tailors, milliners, and others in the antechamber, and the fraudulent old masters hanging on the wall. These are also omitted in the pirate's drawing. Then, too, the pirate introduced into the levee an Italian singer, whom the poem particularly mentions before launching into a consideration of singing and castratos in general. The fifth picture of the plagiary, also reproduced here, was manifestly in front of the poet as he wrote. The decorations of one of the church pillars — an escutcheon, sword, glove, and so forth — peculiar to this design are particularly noted in the poem. The same is true of the maid, who "behind her Mistress simp'ring stood." In Hogarth she neither simpers nor stands.

Beginning with the sixth canto there is no other incident borrowed from the plagiarized plates. Hogarth's own prints, undoubtedly the models, are described in some detail in the verses.

The only confusing aspect of this poem is that although the first five cantos are based on the pirated set, there are several details in those cantos which come not from the piracies but from Hogarth. Examples are the thieving lawyer in the first print and the ragged boy who lays the hassock in the fifth. Since the pamphlet for some unknown reason was not published until 24 July,[31] the likely conclusion is that the poet began his work with the prints supplied him by the pirates, and finished with the genuine Hogarth plates. Of course he would have had ample time for the recomposition of the entire poem from the genuine prints, but such a procedure apparently did not seem worth adopting. After the poet procured Hogarth's prints he added touches to the first five cantos, which were written from the plagiaries, but did not feel called upon to rewrite the whole. The fact that the pamphlet was

[31] *Daily Advertiser*, 24 July 1735.

illustrated with small copies of the plagiaries doubtless influenced his decision.

Such is the history of a poem which cannot accurately be called "a Compleat Key to the Eight Prints lately published by the Celebrated Mr. Hogarth," but which uncovers to a later age a desperate practice now almost impossible to trace, yet then a frequent extremity resorted to by an appalling army of Grub Street poets and by their accomplices in the printing business.

II

Attempts to repeat a success with the same formula often end in failure, and though *A Rake's Progress* was very far from a failure, it was not awarded the acclaim of its predecessor.[32] Several reasons suggest themselves: the world is less interested in and more indulgent toward the vices of men than of women, the *Rake* series was less probable than the *Harlot*, and though it rises to great dramatic and artistic heights at the end, some of the earlier scenes, particularly the fourth, are weak for Hogarth. But doubtless the principal reason was that the *Rake* came second, and second attempts do not receive the attention of firsts.

It is not surprising to find that *A Rake's Progress* inspired fewer pamphlets than the earlier set. The only poem contemporaneous with the one already examined is *The Rake's Progress: or, the Humours of St. James's*, a moralizing botch in six Hudibrastic cantos. Descriptions of Hogarth's fourth and seventh prints, the arrest and the Fleet prison, are omitted. Three other productions bearing the rake's name were published in May 1732, over three years before Hogarth's engravings, to which they have no relation. The authors were obviously inspired by the great success of *A Harlot's Progress* and, in characteristic Grub Street fashion, thought to strike while the iron was hot. Perhaps also they had heard that Hogarth had begun a series about a rake. One of these pamphlets, entitled

[32] John Ireland, I, 67.

The Progress of a Rake: or, the Templar's Exit, written "By the Author of The Harlot's Progress," is a poem in Hudibrastics and from internal evidence is manifestly by the same anonymous bard who wrote "The Tale of the noted Moll Hackabout," the poem which went through four editions in less than three weeks.[33] In February 1738, three years after Hogarth's prints, appeared an amusing and quite bad poem called *Tom King's: or, the Paphian Grove,* whose inspiration is undoubtedly the tavern revels, Plate III, of *A Rake's Progress.*

Under the series of copies by Thomas Bakewell appeared a complete set of explanatory verses, apparently approved by Hogarth himself.[34] These verses explain much more of the story of the pictures than the heavily moral verses by Dr. Hoadly under Hogarth's original plates. Despite their poor quality, we really owe to these explanations much that is in the pictures, for Hogarth, knowing there would be explanations to his prints, was enabled to introduce into them details which might otherwise have been misleading or. ambiguous. Few artists have used the customs of their time to better advantage.

Marriage à la Mode

Hogarth's next narrative series, the six paintings of *Marriage à la Mode,* has been generally recognized as his crowning achievement. The paintings were completed in 1743, but the prints, which he employed other hands to engrave, were not published until May 1745.[35] The prints were popular not only for their superior merit (though the paintings are infinitely finer), but because, in spite of Hogarth's claim "that

[33] The other pamphlets, which I have not seen, are not known to exist in this country. One is in prose, *The Progress of a Rake* (Dobson, p. 168), and the other a poem called *The Rake's Night* (*British Museum Catalogue of Printed Books* under "Rake").
[34] See above, p. 48.
[35] *Daily Advertiser,* 4 May 1745.

none of the Characters represented shall be personal," a number of well-known faces were found among the dramatis personae. This series marked the artist's first sally into high life. "The plot," says Austin Dobson, "like that of most masterpieces, is extremely simple. An impoverished nobleman who marries his son to a rich citizen's daughter; a husband who, pursuing his own equivocal pleasures, resigns his wife to the temptations of opportunity; a foregone sequel and a tragic issue."

In the opening scene, which strikes at a heartless practice of the time, the marriage contract is drawn up by the pompous Viscount Squanderfield and the plebeian alderman, while the principals of the drama wait in the background. The young earl simpers at his own reflection in a mirror; the embarrassed girl dangles her wedding ring upon her handkerchief and listens to a smooth compliment from the handsome lawyer Silvertongue.

The next scene, occurring some months after the marriage, shows a wondrously gaudy apartment said to be copied from the drawing room of a mansion in Arlington Street.[36] It is well past noon, and the countess is refreshing herself with some tea after an all-night entertainment, while her husband has just come in from a long debauch exhausted and glutted with pleasure. For subtlety of expression, the two chief figures in this painting surpass any others in Hogarth.

The third picture, which takes place in the office of a quack to whom the young earl has brought a girl barely in her teens, has always remained obscure, no two commentators ever quite agreeing upon its meaning. It would appear that the earl is mockingly assuring the doctor that the pills he had prescribed for the girl and himself have by no means cured their disease. A formidable virago with the initials "E. C." on her bosom is apparently enraged over the earl's reproaches at the damaged condition of one of her young charges.[37]

[36] Dobson, p. 79 n.
[37] She is probably Betsy Careless, a famed procuress of the time. Others

The levee scene takes us back to the countess, who is entertaining informally in her boudoir with a morning musicale. On one side of the room a small group of people, subtle gradations of ridiculous affectation, sit around the glitteringly robed singing eunuch, Carestini, while on the other side Counsellor Silvertongue is urging the décolleté countess to meet him that evening at a masquerade.

The fifth scene, the least skillful of the lot, is laid in the Turk's Head Bagnio, where the earl has surprised his wife and her lover after they have quitted the masquerade for a bed. The lawyer has mortally wounded the nobleman and is leaping from the window in his shirt, while the countess, horrified and remorseful, falls upon her knees at her husband's feet and implores his forgiveness.

The countess has returned in the last picture to her miserly father's house near London Bridge. Silvertongue has been hanged for murder; his "Last Dying Speech" lies on the floor. The countess has poisoned herself with laudanum and lies dying, oblivious of the nurse who holds up her little child for a farewell kiss, and of her prudent father who draws a valuable ring from her finger before the body stiffens with rigor mortis. This picture, like the others, is crammed with fascinating and completely relevant detail, which a brief digest of the story cannot even suggest.

II

After noting the many pamphlets that sprang up like asparagus in May from the two *Progresses*, one is surprised to find only one verse treatment of the *Marriage*. An advertisement in the *Daily Advertiser* reveals that it did not appear until 10 February 1746, fully nine months after the prints were published. The reason is hard to discover. Perhaps the *Marriage* offered less fertile ground for sensational exploitation; certainly it did not create the excitement of the two earlier series. It is not unlikely, either, that there are other

have said the initials were "F. C.," meaning Fanny Cock, daughter of an auctioneer with whom Hogarth had quarrelled. (John Ireland, II, 34 n.)

pamphlets which have eluded my search. This particular poem, entitled simply *Marriage à la Mode*, is another of those execrable Hudibrastic creations which combine lewd suggestion and cant moralizing. While giving a faithful narration of Hogarth's story, the poet misses most of the pertinent satiric and often dramatic details that cram each picture. This is a very revealing comment on Hogarth's subsequent reputation as an artist. The self-styled connoisseurs who scorn him as a bourgeois painter are even today plentiful. They rank him as an artist of and for the lower middle classes, a painter whose appeal is obvious and low; yet the only thing that is obvious is that these people see no more than what our truly bourgeois Hudibrastic poet saw. The subtlety and intellectual genius of Hogarth, as well as the gorgeous color and skillful composition, they miss. Their opinion must therefore be set down as the judgment of ignorance.

Two other works found inspiration in *Marriage à la Mode*, but not until sometime later, one in 1754, the other in 1766. The first, Dr. John Shebbeare's novel, *The Marriage Act*, was a popular book in its day, running through three editions in as many years. It consists of a group of clumsily connected tales all illustrating the ill effects of the so-called Marriage Act, whereby the parents can arrange their children's marriages without their consent. The author, who appears in the third *Election* print, would be almost forgotten were not he and Dr. Johnson pensioned by George III at about the same time, prompting one of the newspapers of the day to say that the king had pensioned both a He-bear and a She-bear.[38] Shebbeare is heavily indebted to Hogarth's first picture. Not only is the principal arrangement – the union of an earl's son to a rich plebeian's daughter – the same as in Hogarth, but all the accessories are the same. The old earl has gout, he discourses at length to the merchant on his ancient and honorable lineage, and he attempts to put aside the fellow holding the

[38] Boswell, *Life of Johnson*, edited by Hill and Powell (Oxford, 1934), IV, 113.

mortgage. But Shebbeare did not stop with the *Marriage*. One of the tales incorporated in the book, the history of Miss Sally Standish, is clearly beholden to *A Harlot's Progress* for several of its incidents. The book is readable, but deserves the oblivion into which it has sunk. Shebbeare is a mere tractarian writing to right a wrong, while Hogarth has composed a serious tragedy and a great work of art.

The other work said to draw its idea from *Marriage à la Mode* is one of the most popular comedies of the entire century, *The Clandestine Marriage*, by David Garrick and George Colman. Hazlitt, somewhat too generously, has said that the play is an excellent example of the middle style of comedy and is "nearly without a fault." [39] It is at least a pleasant piece, and achieved success from the time it was first acted at Drury Lane in 1766. Garrick wrote the prologue, which announces the source of the play and pays tribute to the late Hogarth, one of his closest friends:

> Poets and Painters, who from Nature draw
> Their best and richest Stores, have made this Law:
> That each should neighbourly assist his Brother,
> And steal with Decency from one another.
> Tonight your matchless Hogarth gives the Thought,
> Which from his Canvas to the Stage is brought.
> And who so fit to warm the Poet's Mind,
> As he who pictur'd Morals and Mankind?
> But not the same their Characters and Scenes;
> Both Labour for one End, by different Means;
> Each, as it suits him, takes a separate Road,
> Their one great Object, Marriage-a-la-Mode . . .
> The Painter dead, yet still he charms the Eye;
> While England lives, his Fame can never die.

The play was printed and went through several editions that same year. Hogarth's pictures do not really have very much to do with the action of the play except that the situation revolves around a marriage of convenience. The contract scene,

[39] *Lectures on the English Comic Writers* (London, 1819), p. 331.

the first scene of the third act, has some Hogarthian hints, but naturally Hogarth's later tragic scenes can have not the slightest influence on this frivolous comedy. The plot is concerned chiefly with how the heroine Fanny, married secretly to young Lovewell though being pressed by her father to marry an elderly nobleman, can reveal her marriage to her father without being turned out of her fortune. By the end of the play we are pretty well convinced of the folly of marriage à la mode, and also convinced that the play owes less to "your matchless Hogarth" than Garrick would have us believe.

Industry and Idleness

Hogarth's longest series of narrative pictures, *Industry and Idleness*, was printed in 1747. Although not approaching the two *Progresses* or the *Marriage* in quality, it must be reckoned one of the artist's major productions, and is given a summary treatment here only because the chief pamphlet growing out of this series has been discussed fully in Chapter I. Hogarth engraved the prints from his own pen and India ink sketches; there were no paintings. He himself describes the design of the series thus:

Industry and Idleness exemplified, in the conduct of two fellow 'prentices: where the one by taking good courses, and pursuing points for which he was put apprentice, becomes a valuable man, and an ornament to his country: the other, by giving way to idleness, naturally falls into poverty, and ends fatally, as is expressed in the last print. As the prints were intended more for use than ornament, they were done in a way that might bring them within the purchase of those whom they might most concern; and lest any print should be mistaken, the description of each print is engraved at top.[40]

This statement makes it evident that *Industry and Idleness* is much nearer to being a morality than any of the three pre-

[40] John Ireland, I, 190.

vious series, and that to ignore the literary side of Hogarth's pictures is often to ignore the side he was most interested in. The idea for the pictures came from the popular Jacobean comedy, *Eastward Ho*, by Chapman, Marston, and Ben Jonson. In that play the honest old goldsmith, Touchstone, has two apprentices, Golding and Quicksilver. The former is the counterpart of Hogarth's Francis Goodchild, the latter of Thomas Idle. In the play, as in the prints, the industrious apprentice marries his master's daughter, becomes a magistrate, and eventually must pass judgment on his companion of old, who is brought before him as a criminal. In both comedy and prints one of the scenes takes place at Cuckold's Point.

Besides the description engraved at the top, each print had at the bottom a citation from Scripture applicable to the particular scene. These were selected for Hogarth by his friend, Dr. Arnold King. The pictures were composed quickly and roughly, yet vigorously, and the last two crowded scenes, the Tyburn execution and the lord mayor's procession, must be admitted among Hogarth's best work. All the pictures are full of splendid comic and satiric detail, but no description need be given of the story beyond that engraved as titles above the prints:

i. The Fellow 'Prentices at their Looms.
ii. The Industrious 'Prentice performing the Duty of a Christian.
iii. The Idle 'Prentice at Play in the Church Yard during Divine Service.
iv. The Industrious 'Prentice a Favourite, is entrusted by his Master.
v. The Idle 'Prentice turn'd away and sent to Sea.
vi. The Industrious 'Prentice out of his Time and Married to his Master's Daughter.
vii. The Idle 'Prentice return'd from Sea, and in a Garret with a common Prostitute.
viii. The Industrious 'Prentice grown rich, and Sheriff of London.

IX. The Idle 'Prentice betray'd by his Whore, and taken in a Night Cellar with his Accomplice.

X. The Industrious 'Prentice Alderman of London, the Idle one brought before him and Impeach'd.

XI. The Idle 'Prentice Executed at Tyburn.

XII. The Industrious 'Prentice Lord-Mayor of London.

The portrayal of virtue was particularly unsuited to Hogarth's genius. He once intended to do a series entitled *The Happy Marriage* as a companion piece to *Marriage à la Mode* but gave up the project as too dull for his talents.[41] Three of the scenes devoted to Goodchild's triumphs turn into satires on various aspects of city life — the discordant hymeneals, the civic banquet, and the lord mayor's parade. In the main the more dramatic Tom Idle scenes are far more effective.

The only contemporary pamphlet, *The Effects of Industry and Idleness Illustrated,* is shown in the first chapter to be of great importance for the unique information it hands down to us about the contemporary reception of Hogarth's prints. Later, when the anonymous author gets round to explaining the story of the pictures, the pamphlet becomes the commonest commonplace. Its thumpingly moral air, which does scant justice to Hogarth's prints however moral, may be illustrated by quoting the concluding sentence:

I have said enough to caution Parents to beware of indulging idle Habits in their Children; and Youth to shun Vice and idle Company, since these are the sure and never-failing Paths to Misery, and an untimely End.

Sometime later James Love dramatized Hogarth's story, Thomas King performing the good apprentice.[42] Verses were written for a set of woodcuts of *Industry and Idleness* issued by Thomas Richardson in 1834; and in 1846 T. B. Murray based his *Two City Apprentices* upon the series. J. M. Morton produced a pantomime in 1851 called *Harlequin Hogarth: or,*

[41] Dobson, p. 94.
[42] John Ireland, I, 225. I can find no other record of the play; it would have appeared before 1774, when Love died.

the Two London 'Prentices. None of these has any merit beyond serving to keep alive some interest in the Hogarth prints.[43]

Hogarth's "Moral"

Now that we have examined a large portion of the Grub Street pamphlets which sprang up with Hogarth's prints, it is fitting to attempt some conclusion about them, and to see what they may reveal about Hogarth's position as a force in literature. As usual, Charles Lamb's essay is suggestive:

I was pleased with the reply of a gentleman, who, being asked which book he esteemed most in his library, answered, "Shakespeare": being asked which he esteemed next best, replied, "Ho-

[43] In addition to Hogarth's four major productions, the narrative cycles, certain of the lesser prints have minor literary connections which, for the sake of completeness, may be summarized in a note. Three prints, *A Midnight Modern Conversation, Southwark Fair,* and *Woman Swearing her Child to a Grave Citizen,* are subjects of verses by a minor poet of the 1730's, John Bancks. The first of these prints also inspired an afterpiece, never published, for the actor Hippisley at Covent Garden Theater on 23 March 1742. *The Roast Beef of Old England* (also known as *Calais Gate*) is the inspiration of a cantata by Theodosius Forrest (probably 1749); the source of Hogarth's title, which strangely has never been noted before, is a song that appears in two of Fielding's plays, *The Grub Street Opera* and *Don Quixote in England.* *Beer Street, Gin Lane,* and the *Four Stages of Cruelty* are celebrated in a moralizing prose "Dissertation" published in 1751. The *Election* prints, described in a set of Hudibrastic verses of 1759, are also the source of John Trusler's farce, *The Country Election* (1768). The plates of *The Times, Wilkes as Champion of Liberty,* and *The Bruiser* were inspired by Wilkes's celebrated war with Lord Bute's ministry, and Charles Churchill's *Epistle to William Hogarth.* A detailed history of this last bitter episode in Hogarth's career is given in an unpublished doctoral dissertation by Mabel Seymour entitled *A Group of Hogarth's Later Prints* (Yale, 1930).

The first commentary on a collection of Hogarth's prints, and one written with suggestions from the painter himself, is Jean Rouquet's *Lettres de Monsieur à un de ses Amis à Paris, Pour lui expliquer les Estampes de Monsieur Hogarth,* printed in London in 1746. They are important for one reason: a set of descriptions of the *Marriage à la Mode* always thought to have been written by Hogarth himself are, I discover, merely a translation of Rouquet. Thus, for an understanding of the obscure third picture of the *Marriage,* we can no longer rely on what have been thought Hogarth's own words; he may have given Rouquet certain suggestions, but he did not write the explanations.

garth." His graphic representations are indeed books; they have the teeming, fruitful, suggestive meaning of *words*. Other pictures we look at — his prints we read.[44]

And it is so. More than any other artist, even more than Jan Steen, Hogarth enriches his work with detail, and not the static detail of the old Dutch masters, but detail of vigorous movement, seething with action and life. In a typical Hogarth canvas nothing ever stands still. Obviously this is not what makes him a great artist, but it is what made for the many "Complete Keys" to the prints. Because of the action and the detail a need was at once felt for some sort of explanation of the crowded prints — not an attempt to bring order out of chaos, for in a sense chaos is the very essence of the pictures, but an attempt to make the chaos understood by the vast London populace which was his public.

But movement and detail alone did not inspire writers to take up their pens; Hogarth the dramatist had even more to do with it. He himself said that he composed his canvas like a play; and now that we have become familiar with his plots and dramatis personae, it is revealing to see how he went to work. Such a revelation is possible because of the lucky survival of three little-known sketches in oil, early stages in the development of *A Rake's Progress* and *Marriage à la Mode*.[45] They are painted hastily in what appears to be his early manner; certainly they are less graceful and less carefully finished than the later pictures. They were done possibly in 1732 just after Hogarth had completed *A Harlot's Progress* and was setting out upon the *Rake*, and experimenting with it.

The first sketch is a combination of the contract scene (i) of the *Marriage* and the levee and wedding scenes (ii and v) of the *Rake*. From this design it would appear that Hogarth's first plan was to marry the rake soon after his accession to his fortune. The scheming father, later to appear in the *Marriage*,

[44] *Reflector*, II, 61.
[45] They were reproduced by C. F. Bell, "Three Sketches by Hogarth," in *Burlington Magazine*, XLI (1922), 11–17.

is joining the hand of the rake and the hand of his daughter, a lady fast descending into middle age, though not nearly so repulsive as the harpy Tom Rakewell marries later. Aside from this central situation, many subsidiary figures in the picture are recognizable. In the foreground holding the silver bowl kneels the jockey, one of the prominent characters in the levee scene of the *Rake*. The antechamber on the left and most of its occupants have been transferred also to the rake's levee. The little blackamoor standing by the table, as well as some of the decorations of the room — a picture of the rape of Ganymede and several Roman busts — have been introduced into the second and fourth scenes of the *Marriage*. The faults of the composition are numerous, especially when compared with the final productions. First, there are far too many unrelated figures and details in all but the central group. The rape of Ganymede may symbolize the young Rakewell's being sacrificed to a rapidly withering woman, but the rest lack dramatic cogency. Secondly, there is no apparent reason why, still in the flush of fortune, he should resort to such an extremity. As *A Rake's Progress* now stands, the marriage occurs very naturally in the fifth picture, when the hero's fortune has been exhausted through dissipation and extravagance. The levee is displayed in the second scene, while he is still rich. The early painting indicates that the series as originally conceived was much more condensed and less dramatic than the finished set.

The second sketch, in which a dandy is robbed of his watch by several women of pleasure, is painted in Hogarth's earliest, somewhat awkward style; yet it embodies what may be the first idea of the theft of the watch, an incident in the splendid tavern scene of *A Rake's Progress*. This is almost the sole incident of the earlier work, while the later painting is a miracle of movement.

The third sketch, only partly finished, is in some ways the most interesting of all, for it makes us aware of the affinity between the prison scene of the *Rake* and the countess's death

in the *Marriage.* On the left reclining in a chair is a young woman, stripped to the waist, bleeding from a wound in her breast. A physician is attending her. The group on the right is similar, though more indistinct; here again is a fainting or dying woman surrounded by agitated spectators. The picture's unfinished state indicates that Hogarth was feeling his way and was not yet satisfied.

These sketches reveal the painstaking care of Hogarth's dramatic structure. In the finished paintings he has heightened the drama seen only in embryo in the three sketches. He is a playwright constantly probing his imagination for a more telling presentation of his story. His pictured chronicles are to be read as clearly as if they were explained by the speech and gesture of living actors. His drastic reworking of the incidents in his tales may be compared with the famous and happy revision Jane Austen made in the ending of *Persuasion*, the work of a dramatic, not a pictorial, artist: the first treatment would perhaps seem adequate were it not for the second. The early date at which these sketches were made indicates that the idea for *Marriage à la Mode* was being turned over in Hogarth's mind for years, for the paintings were not finished until 1743. This long period of meditation bore fruit in the most concentrated and dramatic of all his works.

Upon considering his carefully constructed drama, we are not surprised that Hogarth should have inspired so many literary performances, but surprised by what those performances are. Few of them make any capital of the rich dramatic possibilities; instead, despite the trash they chiefly emphasize, nearly all these pamphlets make at least some pretense that they are expounding a moral. To most of the pamphleteers, in other words, Hogarth's greatest significance was as a stern moralist. Under the guise of interpreting his moral, they could indulge their fill in the obscene and salacious. Thus they, in company with other and stronger forces, have helped to accentuate a judgment which has damaged Hogarth's reputation for two hundred years, and has prevented his being recog-

nized as a great literary force and a great pictorial artist. The pamphlets and even Fielding's remarks [46] show that Hogarth was revered most as a moralist even before 1768, when the Reverend John Trusler, with the help of Mrs. Hogarth, effectively put everyone's mind to sleep with his massive volume entitled *Hogarth Moralized*.[47] Trusler set the tone for the popular conception of Hogarth which exists to this day. Especially to the eighteenth and nineteenth centuries was *A Harlot's Progress* a spirited lesson on the wages of sin; *A Rake's Progress* revealed the consequences of intemperance and debauchery; and *Marriage à la Mode* was twice as good as either since it combined the lessons of both. Serious critics must of course realize that propaganda is not art, and when drawing is used obviously as a means to an end it is no longer art.[48] Nor can the picture be the mere illustration of a story or a lesson and be a great picture; it must be a part of the artist's imagination, a record of his mind.

To some it may seem superfluous to explain what Hogarth's contemporaries and commentators mean by the word *moral*, but since it is that very definition which has caused the heaviest misconception of his genius, the explanation must be given. The task is not a hard one, for they regarded *moral* in the strict sense in which it is commonly regarded today: dealing or concerned with establishing and disseminating principles of right and wrong in conduct, conforming to a standard of what is good and right. Johnson's Dictionary defines the word similarly as "reasoning or instructing with regard to vice and virtue." This certainly is Richardson's understanding of the word,

[46] See below, Chapter IV.
[47] The title page reads: "Hogarth Moralized. Being a complete Edition of Hogarth's Works. Containing near Fourscore Copper-Plates, most elegantly engraved. With an Explanation, pointing out the many beauties that may have hitherto escaped Notice; and a Comment on their Moral Tendency. Calculated to improve the Minds of Youth, and, convey Instruction, under the Mask of Entertainment. Now first Published, with the Approbation of Jane Hogarth, Widow of the late Mr. Hogarth."
[48] Many of Hogarth's minor works, especially original engravings never painted, fall into this class. Examples are *Masquerades and Operas, Enthusiasm Delineated*, and the two plates of *The Times*.

though there is a taint of slyness in Pamela that is not com-
patible with the highest morality. And Hogarth, too, was not
unaware of this kind of moral quality in his stories, else he
would not have chosen such plots as he did. But no view of
his art could be more mistaken than to imagine that he focused
his attention primarily upon this sort of moral, quite differ-
ent from the morally motivated laughter attendant upon satire.

To turn momentarily to Trusler is to perceive at its clearest
this limited and widespread "moral" conception of Hogarth's
art. It is significant that Trusler begins his explanations with
the most obvious and heavy-handed of the narrative cycles,
Industry and Idleness. There is something at once wonderful
and frightening about his manner. He utilizes the rather dull
second plate, where Francis Goodchild attends church with his
employer's daughter, for a sermon in full-blown Truslerian
vein:

As the very best of our services are ineffectual, with respect to
the end proposed, unless attended with the blessing of heaven, this
plate represents to us, the industrious young man performing the
duty of a Christian, in the service of his God; by which we are
taught, that an attention to our *eternal* welfare, should be a great
part of our concern, and go hand in hand with our *temporal;* in
opposition to the general practice of mankind, who vainly think,
that to eat, drink, dress and live, is the *summum bonum,* or chief
good on which our thoughts should be constantly employed.

The humor of Hogarth's delightful satirical pictures of sev-
eral wastrels snoring through the service Trusler misses en-
tirely, merely remarking that they introduce a contrast which
should make us the more diligent in pursuing proper deport-
ment. In the dramatic seventh scene, where Tom Idle is dis-
covered in a filthy garret with a prostitute, Trusler's really
impassioned remarks are restricted to the text, "The horrors
of a guilty conscience." The superb composition of the Ty-
burn scene, constructed on a half circle by which the eye,
despite the crowded foreground, is guided toward the back of
the scene with its appearance of recession, goes unnoticed by

Trusler. The merit of the series as a whole, however, is clear to him:

Thus have we seen, by a series of events, the prosperity of the one, and the downfall of the other; the riches and honour that crown the head of industry, and the ignominy and destruction that await the slothful. After this it would be unnecessary to say, which is the most eligible path to tread. Lay the roads but open to the view, and the traveller will take the right course; give but the boy this history to peruse, and his future welfare is almost certain.

He expresses the common notion of the sterling worth of *A Rake's Progress* in his opening line on the series: "Of all the follies in human life, there is none greater, than that of extravagance or profuseness; it being constant labour, without the least ease or relaxation." Throughout his descriptions he is ecstatic over the loyalty and self-sacrifice of the maudlin Sarah Young, Rakewell's long-suffering mistress. His closing sentence is a warning to us all: "Reflect well on this and shudder." Even so spirited and lighthearted a comedy as *Southwark Fair* is to Trusler an essay on the degeneracy of the times. And the good-humored satire of the election entertainment becomes severe indeed:

Where bribery, hypocrisy and venality are in view, there must we observe the tottering Christian, and the falling man; and thence we may draw this judicious conclusion, that when designing hypocrisy unbars the gates of bribery, then will the dirty sons of shameless venality rush like a torrent through the golden portals, beating down all that is just and honest in their way.

In Trusler's favor, one may at least observe that the artist's works were never a matter of indifference to him, but appeared to have been drawn with a pencil of flame. Doubtless his very energy and sincerity swept generations of readers into his fold, and assured him of his position as the most influential force on Hogarthian criticism all through the nineteenth century. In the preface to an edition of Hogarth's works in 1821 Thomas Clerk, himself a pious exponent of the preaching

school, testifies that all "successive commentators, illustrators, and elucidators, have been more amply indebted to him [Trusler] than they have cared to acknowledge." And as late as 1860 a discriminating critic and scholar like James Hannay can speak thus of the moral influence of Hogarth's works:

What student of the past, or what thinker has not learned something from them? Their familiar figures, reproduced in many shapes, have fallen broadcast over the land; and while educating thousands by their thoughtfulness, charming them with their humour, and touching them with their pathos, have helped to prepare the mind and heart of England for a milder and purer social life.[49]

It is clear that Hogarth was praised, not only in his own time but for generations thereafter, for merits which he certainly possessed, yet which were not his only merits, or even his greatest. A grateful age found its voice in the much-admired epitaph David Garrick wrote for his friend's tombstone:

Farewel, great Painter of Mankind!
Who reach'd the noblest point of Art,
Whose *pictur'd Morals* charm the Mind,
And through the Eye correct the Heart.
If *Genius* fire thee, Reader, stay:
If *Nature* touch thee, drop a Tear;
If neither move thee, turn away,
For Hogarth's honour'd dust lies here.

The epitaph is as revealing of the limitations of the age as it is of Hogarth's superiority to his contemporaries. Garrick is only a modified Trusler who does far less justice to his friend than does the wiser Johnson in the quatrain he suggested to Garrick as a possible emendation of the epitaph:

The Hand of Art here torpid lies
That traced the essential form of Grace:
Here Death has closed the curious eyes
That saw the manners in the face.

[49] P. xiv of Hannay's introductory essay to the Griffin edition of Hogarth's works (London, 1860).

But neither Garrick nor Johnson is very fully aware of the side of Hogarth's genius celebrated by Swift in a passage from the *Legion Club*, a passage which anticipates at least a part of the greatness of Hogarth we are only just beginning to understand today:

> How I want thee, humorous Hogarth!
> Thou, I hear, a pleasant rogue art.
> Were but you and I acquainted,
> Every monster should be painted:
> You should try your graving tools
> On this odious group of fools;
> Draw the beasts as I describe them;
> Form their features, while I gibe them;
> Draw them like, for I assure ye,
> You will need no *car'catura*;
> Draw them so that we may trace
> All the soul in every face.

The essays of Lamb and Hazlitt, emphasizing the intellectual genius of Hogarth, go much farther than Swift, and remain among the best appreciations of his art, but though they excited critical interest in the painter, they never remotely approached the popular acclaim enjoyed by the Truslerians.

The utter failure of Trusler's "moral" yardstick as a measure for the content of Hogarth's art may be quickly shown by merely glancing at several famous scenes. Our attention is almost entirely diverted from the "moral," for over and over again we find comedy and satire introduced into the most solemn scenes of the story. At the Fleet prison the rake is certainly a pitiable object, and some rare persons may pause to reflect morally on the results of a misspent life; but in this very scene there is irony and comedy in the person of the penniless T. L., who has formed a plan for paying the whole debt of the British Empire, and who, like Daedalus, has invented two monstrous wings, which of course cannot get him out of his cell. At Bedlam Hogarth evidently means us to laugh at many of the inmates, while at the same time he protests against the

odious custom of allowing casual observers, like the two ladies of fashion, to come into the asylum merely for diversion. As the harlot beats hemp we are amused at her low companion who is killing lice; and as she dies there are two physicians wrangling ludicrously underneath a loaf of Jew's bread hung up for a flytrap. Her funeral is shameful enough, but it is also very funny.

An execution at Tyburn, fitting end for Thomas Idle's wicked life, becomes a grand meeting place for some of the most riotous characters in Hogarth, each engaged in some absurd action revealing the artist's irrepressible satirical imagination. As Idle is carted to the gallows he is exhorted by a ranting Methodist screaming Wesley at him; a mischievous tramp is preparing to throw a dog at the two of them; a pious lady raises one hand in benediction over the victim while with the other she conveys a glass of gin to her lips; a female ballad-monger bawls out the "Last Dying Speech and Confession of Tom Idle" while her baby tries to leap over her shoulder with excitement at a fist fight directly behind; a sly urchin is picking the pocket of the pieman while his companion waits to receive the spoils; the executioner is sitting astride the gallows tree calmly smoking his pipe. It is obvious that the artist's interest goes far beyond merely illustrating a story or inculcating a lesson. The lord mayor's procession, the triumphant climax of Goodchild's virtuous career, turns into an indescribable array of comic confusion at which one must gaze long before finding the hero of the story. Certainly Hogarth's invention has strayed far away from the "moral" theme.

Lillo's play *The London Merchant* may serve as a striking commentary upon the genius of Hogarth, for it is a work inculcating the same lesson as *Industry and Idleness*. George Barnwell is ruined by temptation and becomes another Tom Idle, while his friend Trueman is the prototype of Goodchild. But there the similarity ends, for Lillo's talents are on the order of the worthy Dr. Trusler's. Indeed the last scene of the play, where Barnwell is hied to the gallows, reads remark-

ably like Trusler's account of the execution at Tyburn. Barn-
well ends his mortal career intoning: "From our example may
all be taught to fly the first approach of vice; but if o'ertaken

> By strong temptation, weakness, or surprize,
> Lament their guilt and by repentance rise.
> Th'impenitent alone die unforgiven!
> To sin's like man, and to forgive like heaven."

Had Hogarth not been a genius he might have produced *The
London Merchant* instead of *Industry and Idleness*.

Hogarth's lesser prints show the same tendency. *Southwark
Fair* and *The Enraged Musician* are pure comedy; they are
moral only in the sense that all great comedy is based on a moral
idea — the incongruity between what is and what ought to
be. *A Midnight Modern Conversation* is a most amusing
satire on drunkenness, but certainly does not emerge as a ser-
mon on temperance. *The Sleeping Congregation* is not an
acrimonious satire on the church (contrast it with the labor-
ious *Enthusiasm Delineated*); rather it is a comic scene, which,
allowing for some slight exaggeration, might occur almost any
Sunday.

It may be asked if there is not such a thing as morally mo-
tivated laughter. Of course there is, and it is in this much
broader interpretation of the word *moral*, a sense seldom
hinted at in most of Hogarth's commentators, that he must be
considered. In his old age the artist spoke of his narrative pic-
tures as "modern moral subjects"; but *moral* obviously has a
wide meaning, for he is primarily a satirist. And in this very
passage he goes on to say that his aim is drama, that his pic-
tures are to be read as if they were explained by living actors.
Furthermore, his intention is unimportant as compared with
the content of the works themselves. He does not tell a story
merely to inculcate a lesson, as Richardson was so successfully
doing, or at least appearing to do, in the same decade as *Mar-
riage à la Mode*. Instead he is holding up human folly or
abuses or vices to severe reprobation by ridicule, derision —

any means of intensifying incongruities. Satire is moral, cer-
tainly, but *moral* released from the limits of its usually re-
stricted meaning. The blue-law, prayer-meeting quality is
absent.

Others may still maintain that the most obvious feature of
the narrative pictures is the lesson. Hogarth's characters sin,
and then they meet with dire disaster. What plainer moral?
This, of course, is exactly what is wrong. The average rake
of the day did not end up a raving lunatic at Bedlam, nor was
the natural consequence of an idle disposition an execution at
Tyburn. The careers of Tom Rakewell and Tom Idle were
particularized and improbable. And what girl would be
"warned" by *A Harlot's Progress?* As a recent writer on Ho-
garth has remarked, "No doubt many of the servant girls for
whose edification the plates were published must have secretly
thought that given Miss Hackabout's chances they would
have contrived very differently." [50] In the first scene she is
the dupe of two experienced criminals; in the second she is
turned out not for sins but capriciousness; in the third she is
arrested not because she has lost her virtue (London's jails
could never have held all such) but because she has become a
petty thief. No moralist would have written the story this
way. The harlot is obviously the happiest person in the room
at her death, a scene well summed up by Miss Bowen:

No detail required to form a complete picture of human desola-
tion and misery is omitted here. The tremendous dramatic power
of the painter eclipses all moral intention; it is no longer a ques-
tion of punishment for a vicious, silly girl — the business is more
serious and more terrible. We see human nature degraded to the
lowest depths and completely unconscious of its degradation. The
only person that can escape from the horror of the scene is the
dying woman, who withdraws into the final silence amid a hide-
ous hurly-burly than which no Hell's Kitchen could be worse.[51]

 [50] Marjorie Bowen, *William Hogarth: The Cockney's Mirror* (London,
1936), p. 126.
 [51] *Ibid.*, p. 138.

It is surprising, after this, that Miss Bowen could think Hogarth published the prints merely for the edification of servant girls. In *Marriage à la Mode* the object of Hogarth's ridicule is the bargain marriage, the marriage for fortune on the one side and for title on the other. The real guilt lies upon the parents who forced the contract, not upon their weak victims. The series satirizes vice in high life; it is not a morality of the follies of inconstancy.

The sentimentality with which most moralities are at least flavored is, with only one notable exception, not to be detected in Hogarth. That exception is Tom Rakewell's faithful, deflowered seamstress, Sarah Young, who, by attaching herself to her seducer, proves that she is utterly lacking in wits and is perhaps an ideal heroine for sentimental romance. She is a maudlin addition to an otherwise relentless satire, and her presence has been deplored by many critics. One would like to believe that Hogarth introduced her as a satire upon the vacuity of the lovesick maiden, but I fear he did not. At any rate she was a mistake, and Hogarth never created her like again. The eighteenth-century ladies who loved to sit themselves down for an evening's revel in moral Mr. Richardson and tears, thus announcing already a coming romantic age, could not have well understood the works of the artist they called "our moral Hogarth."

As a summary of all I have been saying about Hogarth's comic satire versus his commentators' insistence upon morality, we may glance at a group of paintings by another artist, who was inspired by *Industry and Idleness*. This was only the beginning of his inspiration, unhappily, for the other obvious source is a combination of Richardson's *Pamela* and *Clarissa Harlowe*. This double allegiance to two different artists, each great in his own sphere but entirely different from each other, may account for the failure of the pictures. The modest genius of the painter, James Northcote, did not expand under this double influence, but merely became confused. The title of his series, *Diligence and Dissipation*, at once announces the

Hogarthian source. It is a story of two servant lasses, "The Modest Girl," whose adventures in rejecting her employer's illicit advances, until she finally brings him to terms at the altar, are practically the same as Pamela's; and "The Wanton," whose lurid career is a mixture of Mary Hackabout's and Clarissa Harlowe's. These ten pictures, which are very gracefully painted, offer, when compared with Hogarth, a brilliant illustration of the difference between satire and mere moral lesson. Aside from the central idea, Northcote has lifted so many incidents and details from the older artist that one is astonished at his presumption. Yet all that in Hogarth is hilarious or sly becomes in Northcote flat illustration to an obvious story. In the text I reproduce one of the pictures, which will help to clarify Hogarth's unique genius.

This canvas, "The Wanton Revelling with her Companions," shows the heroine at her zenith. Almost every detail in the picture was plainly suggested by the tavern revels in *A Rake's Progress*. In a scene of riotous drunkenness the Wanton appears to be floating in an arresting (though impossible) attitude, her waist encircled by the arms of a man on each side. Both her hands are raised above her head; the right is holding a glass of spirits, the left encircles the neck of one of the men. The gold watch, prominent in Hogarth, hangs from her waist and points to the late hour. Another woman rushes at her with threatening fists, but is being held back — an episode clearly indebted to the two enraged women in Hogarth. The broken staffs and lantern of the constable in Hogarth are here brought into action in the hands of a group of ruffians (or perhaps constables) invading the den. On the back of the canvas is an inscription from Proverbs 14:13, "Even in laughter the heart is sorrowful, and the end of that mirth is heaviness."

Another picture, the last in the series, is truly a masterpiece of derivation. It is entitled "The Modest Girl Married to her Master is Led to her Coach; the Wanton in Disease and Poverty is Laid in her Grave." The temptation is strong to say

that this picture includes a little of everything Hogarth ever painted. The heroine, beautifully gowned in satin and obviously very much pleased with herself, is being led to the coach by a graceful Mr. B. Behind them stands the clergyman, an exact copy of one of Hogarth's pictures of Orator Henley. In the left foreground stoops a little chimney sweep, who has stepped out of the fourth print of the *Rake*. At the back is the Wanton's funeral, a crowded Hogarthian melange. The planks and skulls lying around the open grave are copied from the third plate of *Industry and Idleness;* the group of mourning wretches are straight from Mary Hackabout's funeral, even to the horrible-looking female being revived with liquor from pretended prostration; the cracked tablet of commandments in the rake's wedding has here become the funeral tablet on the church wall: "Erected to the Eternal Memory of . . .," the rest crumbled away. In the left background are pretty trees and a sunset, showing that Northcote was painting in 1796 instead of 1736. The proverb on the back of the picture reads, "Behold the righteous shall be recompensed upon earth." (Proverbs, 11:31.)

Diligence and Dissipation fails for the same reason that all the "moral keys" to Hogarth fail; it is mere illustration of a story, not a part of the artist's imagination. In Hogarth we feel that the story is the pretext, not the content, of his work. Those pamphlets not emphasizing the "moral" exploited other equally subordinate features of his work — licentiousness and scandal, for example. They all were incapable of the perception which enabled Hazlitt to say, "Hogarth . . . is essentially a comic painter; his pictures are not indifferent, unimpassioned descriptions of human nature, but rich, exuberant satires upon it." [52]

As literature these hack performances are without exception contemptible. In emphasizing a number of things which doubtless contributed to increase their sale, they do small justice to the artist. Yet they are invaluable to a critic's study for

[52] *English Comic Writers*, p. 280.

their illustration of the taste of the age, of the methods of Grub Street poets and pirates of prints, of the immediate contemporary popularity of Hogarth, and of the mighty effect they must have had on his detailed method of work. In focusing attention on Hogarth, they did far more than he himself could ever have done not only toward spreading a knowledge of the prints but also toward promoting their sale. Finally, they suggest the huge variety and vigor in Hogarth that endeared him to greater writers, who often unconsciously absorbed him into their work.

Hogarth and Fielding Invade the Theater

THE writer most closely connected with Hogarth is the greatest novelist of the century, Henry Fielding. By the time he began writing novels in 1741, Hogarth was already a well-known literary figure. The artist was celebrated as the author of narrative pictures, and, whether he desired it or not, Grub Street had brazenly made those narratives its own property. During nearly all the decade of the 1730's the young Fielding, rapidly turning out potboilers for the theater, was a part of this same Grub Street world. He himself came to London as a man of good family and at least moderate means, but he soon fell in with James Ralph, one of the Grub Street crew, from whom he learned their way of life. All through his career of writing plays he made use of the ways of Grub Street to mock them, and in 1732 even became deeply embroiled in a hot battle with the enemy of the Grubeans, the *Grub Street Journal*.

Being in the thick of this world, Fielding could not possibly have avoided knowing the mass of Hogarthian pamphlet literature which was swarming about him. It is therefore not surprising to find him from time to time casually borrowing an incident, a character, or an idea from a Hogarth picture. He, like the pamphleteers, thought of the painter in a literary sense, or, as Hogarth himself described it, as a dramatic writer whose picture was his stage, whose men and women were his players. In addition, during this decade the two men became good friends and actually collaborated in several theatrical

77

ventures. The purpose of the present chapter is to study this early phase of their relationship.

Most of Fielding's plays are interesting not because they are masterworks, but because they are works of a master. What Hogarth actually contributed to them is not particularly important for the sake of the plays themselves, but is very important for a better understanding of the nature of Fielding's work as a whole. What he began as a playwright he continued as a novelist, and thus it is revealing to see the Hogarthian influence at its inception. Easily the most important aspect of the chapter is in showing how these two artists' minds and temperaments are alike, how their work complements each other, how Fielding's work cannot be completely understood without a knowledge of Hogarth. In other words, we are dealing not so much with source hunting as with a clarification of the work of the century's greatest prose artist by means of its greatest pictorial artist. The intimacy of the two men may be established at once by the story with which we shall begin.

I

Henry Fielding died in October 1754, ten years to the month before Hogarth. He had been famous during his lifetime, but when the publishers Arthur Murphy and Andrew Millar were drawing up the first collected edition of his works in 1762, they were dismayed to find that no picture of the great novelist existed to grace the first volume. For some likeness they turned instinctively to the only man who might be able to create one, the one artist Fielding had known intimately and had preferred to all others, Hogarth. But eight years had elapsed since Fielding's death, and after that long it is not easy to draw a picture from memory. Hogarth, who had never painted him in life, had difficulty in reproducing exactly the dimensions and outlines of the face. Notwithstanding, he accepted the task in order to honor the memory of his late friend. Murphy, in his life of Fielding prefixed to the first volume of

the works, tells a story of this posthumous picture that bears all
the marks of truth. It was published during Hogarth's lifetime
and not denied by him. According to this account, a lady had
at some time cut out a paper profile of the novelist which gave
the distances and proportions of his face sufficiently to restore
Hogarth's "lost ideas" to him. The lady has been positively
identified as Margaret Collier, who accompanied Fielding and
his wife to Lisbon in the year of his death.[1] One is inclined to
agree with H. B. Wheatley that a portrait drawn entirely from
memory is not likely to be a profile, and the accentuation of
the appearance of the nose in Hogarth's picture reminds one
of a silhouette.[2] It is improbable that Murphy would have in-
vented this story to account for the picture which he says
"recalls to all who have seen the original a corresponding image
of the man."

At the time, an absurd story became current that David
Garrick had made up his face to look like Fielding, dressed
himself in a suit of Fielding's clothes, and had sat to Hogarth
for the portrait. The story would be preposterous even if
Fielding had not been a much larger man than Garrick, who
could not possibly have worn his clothes. It is made the basis
of a one-act comedy, Le Portrait de Fielding, performed at
Paris in 1800. In its fanciful plot the heroine, Sophia Fielding,
daughter of the author by Amelia, marries Hogarth at the end.
This work is undoubtedly the ultimate reach of the arm of
Hogarth's literary relationships.[3]

Murphy tells us that Hogarth frequently urged Fielding
to sit for his portrait, but to no avail. Consequently the profile
is the only likeness of the writer that has come down to pos-
terity. This circumstance at once establishes and serves to in-
troduce the very close relationship that exists between Hogarth
and Fielding in many facets of their lives and art. These two

[1] Austin Dobson, William Hogarth (London, 1898), p. 255.
[2] Hogarth's London (London, 1909), p. 237.
[3] Recounted by W. L. Cross in The History of Henry Fielding (New
Haven, 1918), III, 184–85.

mighty forces stand at the opening of a huge world of humor and life that has immeasurably broadened and invigorated English art. Hogarth, the older of the two, was the pioneer and blazed a trail whose effect upon the brilliant young Fielding has never before been explored. It begins back in the decade of the 1720's when Hogarth was just setting himself up as an engraver. He had done a few thoroughly commonplace plates and satirical designs for booksellers, and discovered the occupation neither dignified nor lucrative. He therefore in 1724 struck out with his first print published on his own account, his first independent satire, which he directed against masquerades and operas. But before we can understand it we must glance briefly at the estate of the London theater of the 1720's.

II

Except for Gay's *Beggar's Opera*, which will enter this story later, the decade from 1720 to 1730 probably marks the lowest point in the entire history of London's theatrical fare. Indeed the arrival of *The Beggar's Opera* is largely accounted for by precisely that fact. It is the Nun's Priest's Tale of this irregular theatrical pilgrimage. The pantomime entertainments, or better the pantomime and other entertainments, had seized legitimate drama and were squeezing it to death. Singing, dancing, legerdemain, spectacle, and above all utter nonsense were mingled in an enormous sort of vaudeville which held supreme sway. The whole melee had been gradually accumulating ever since the reopening of the theaters in 1660. Serious plays were turned into "dramatick operas," as Shakespeare's *Tempest* became a Barnum and Bailey spectacle called *The Enchanted Island*. It had been "improved" as a play by Dryden and Davenant; Thomas Shadwell then converted it into an opera. Actors were held cheap; singers and dancers were better paid and costumed. In order to compete with these operas, as well as the new Italian operas which were beginning to flourish, theatrical producers felt themselves obliged to augment their regular drama with all manner of entertainments — dancing,

singing, ropewalking, tumbling — either between the acts or in the form of an afterpiece at the end of the play.[4]

As an illustration of this sort of performance, we note the *Daily Courant* of 1 January 1725 announcing that Drury Lane was to present *Don John* supplemented by the pantomime of *Harlequin Doctor Faustus*, while on the same evening Lincoln's Inn Fields would give *The Merry Wives of Windsor* plus a pantomime called *The Necromancer, or Harlequin Doctor Faustus*. Newspaper advertisements reveal that it was not uncommon for the theater to change the play nearly every night, but to keep the same pantomime for nights on end.

To make clear the passionate disgust that Hogarth and, of more consequence, Fielding felt for these pantomimes, it is instructive to examine at least one of them. *The Necromancer*, brought forth by John Rich at Lincoln's Inn Fields in December 1723 and continued through February of the next year, differed from the majority of pantomimes by employing both song and speech, though Harlequin, as Faustus, remained silent. Hogarth satirized the piece at the height of its popularity.

The pantomime opens with the Good and Bad Spirits each trying to sway Faustus. The Infernal Spirit arises and calls up the shade of Helen of Troy, which moves Faustus to sell his soul. In the next scene Faustus causes wheat sheaves to dance and binds up the amazed haymakers in a bundle. Next, when a heavily laden table appears out of the air, Faustus commands the wine to vanish in a flash of fire. It will be noticed already that this pantomime, like most others, has substantially the same degree of continuity as a more celebrated work of the century, Dr. Johnson's Dictionary. The fourth scene is the spectacular windmill scene where the

[4] The history of this whole movement is recorded in a highly interesting manner by Colley Cibber in *An Apology for the Life of Mr. Colley Cibber*, edited by R. W. Lowe (London, 1889), I, 87ff. Many of the entertainments are described by E. L. Avery in "Dancing and Pantomime on the English Stage, 1700–1737," *Studies in Philology*, XXXI (1934), 417ff.

miller is caught and carried around on one of the wings while Faustus dallies with his wife. Later a giant enters and beats the miller and his assistant, whereupon they cut off its head and arms. When it continues dancing they rip open its belly, out of which jumps Faustus. He beats them, runs off with the miller's wife, and causes the miller's sack to hop off after them. Hero, Leander, and Charon are introduced next in the doctor's school of magic; at the end, when a "monstrous Dragon" devours Faustus, the chorus of demons wildly rejoice, an action the audience might well have emulated.[5]

Such sorry stuff as this was by 1724 far more popular than legitimate plays, and was rapidly crowding them off the stage. True, dramatic inspiration was at ebb tide, as anyone who reads the plays of George Lillo and Sir Richard Steele will testify, but the tragedy was that should any real dramatic artist arrive he would likely fail for lack of an audience. The only other entertainments, besides opera, that would go down to any great extent were, first, mangled sentimental "improvements" of Shakespeare, and second, the inflated claptrap of heroic tragedy, which held its audiences by exotic costumes and scenery, and intimidated them with bludgeoning bombast.

It was at this point that Hogarth stepped in.

III

Hogarth always had a genuine feeling for the theater — in his memoirs, it will be remembered, he even calls himself a dramatic writer — and the tricks of pantomime were anathema to him. He saw that some sturdy fighter was needed to attack and indeed to change the entire nature of theatrical entertainment. Though he knew even in these unanchored years that his center of life was not the theater, from time to time he leaped into the fray for long enough to deliver a brisk thrust and to suggest vigorous changes.

The first effort, *Masquerades and Operas*, which Hogarth

[5] Another good example, described in Chapter II, is the *Ridotto al Fresco*, which took its idea from *A Harlot's Progress*.

himself sometimes called *The Taste of the Town,* reveals how definitely he had formed his point of view from the start. Dobson has noted that in a career devoted largely to excoriating charlatans, shams, and dubious exotics of all sorts, this little plate may be said to touch the keynote of nearly all Hogarth's future work.[6] Excited crowds are seen flocking on one side to the Italian opera, to Faux's "Dexterity of Hand," and to Heidegger's lewd masquerades. Above, on the showcloth advertising the opera, the Earl of Peterborough kneels and pours gold at the feet of the overstuffed Italian diva, Cuzzoni, who is greedily drawing the money towards her with a rake. On the other side of the print people throng the Lincoln's Inn Fields presentation of *Dr. Faustus.* Over the entry of the theater a Harlequin is perched pointing to a sign which reads "Dr. Faustus is Here" and pictures two whopping features of the piece, the monster and the windmill. In the foreground a vendor is peddling as "Waste paper for Shops" a wheelbarrow of neglected volumes by Shakespeare, Ben Jonson, Dryden, Congreve, Otway, Farquhar, and Addison. At the back looms the gate of Burlington House, labeled "Academy of Arts," and surmounted by a statue of the fashionable architect and decorator, William Kent, who has Raphael and Michael Angelo kowtowing to him on either side. Under the earliest impressions of 1724 appeared these summary verses:

> Could new dumb Faustus, to reform the Age,
> Conjure up Shakespeare's or Ben Johnson's Ghost,
> They'd blush for shame, to see the English Stage
> Debauched by fool'ries, at so great a cost.

> What would their Manes say? should they behold
> Monsters and Masquerades, where usefull Plays
> Adorn'd the fruitful Theatre of old,
> And rival Wits contended for the Bays.

Other verses of like tenor appeared under later impressions.[7]

[6] P. 19.
[7] Reprinted in John Nichols, *Biographical Anecdotes* (London, 1782), p. 122.

This early print, one we shall see that Fielding knew intimately, marks the beginning of the important relation in Hogarth's work between picture and verse and establishes his connection with the writers of his age.

The immediate popularity of this print is proved by the many pirated copies that sprang up on all sides. This was Hogarth's first encounter with the pirates, whom he denounces in his memoirs. The print had no sooner begun to sell than he found pirated copies at all the printshops.[8] This explains why he did so few theatrical prints subsequently. After 1726 he was obliged to turn most of his attention to oil painting, where there was no danger of pirates.

Although Hogarth's satire was sincere and obviously justified, it should be remembered that the print was designed to sell and that the effectiveness of this satire would depend mainly upon its vendibility. But the public enjoys seeing its faults laughed at good-naturedly, and Hogarth never let his hand slip from the public's pulse. He later satirized the evils of masquerades in a number of places, including a large *Masquerade Ticket* in 1727, the second plate of *A Harlot's Progress*, the fourth of *Marriage à la Mode*, and an unfinished painting sometimes called *The Ill Effects of Masquerades*.[9]

The next of the pantomime prints, *A Just View of the British Stage*, was designed in 1725.[10] It is very funny indeed, and since it is also very insulting to the three noted principals, it probably sold even better than the *Masquerades and Operas*. Horace Walpole calls this piece *Booth, Wilks and Cibber contriving a Pantomime, a satire on farces*.[11] Below the print is engraved the following explanation:

[8] See above, p. 47.

[9] This is the third of the early sketches discussed on p. 62.

[10] Dobson has questioned whether this and the print of *Rich's Entry* are authentic Hogarth works. Nichols, Ireland, and the *Catalogue of Satirical Prints* all accept them as genuine. And they appeared in the great 1822 folio of the works printed from Hogarth's original plates. They both are amusing and trenchant satires, completely in the vein of all Hogarth's earliest works. I see no reason to doubt their authenticity.

[11] *Anecdotes of Painting in England (with additions by Dallaway)* (London, 1828), IV, 166.

This Print Represents the Rehearsing a new Farce that will Include ye two famous Entertainments Dr. Faustus and Harlequin Shepherd to which will be added Scaramouch Jack Hall the Chimney-Sweeper's Escape from New gate through ye Privy, with ye comical Humours of Ben Johnsons Ghost, Concluding with the Hay-Dance Perform'd in ye Air by ye Figures A. B. C. Assisted by Ropes from ye Muses. Note, there are no Conjurors concern'd in it as ye ignorant imagine . . . The Bricks, Rubbish, etc. will be real, but the Excrements upon Jack Hall will be made of Chew'd Gingerbread to prevent Offence. Vivat Rex.

The ropes mentioned here are really halters suspended over the heads of the three theater managers, who are dangling puppets of Harlequin and Punch. On a table before these admiring gentlemen lies a pamphlet with an image of Jack Shepherd, the hero of the popular pantomime of *Harlequin Shepherd*, in confinement. Over the privy is suspended a parcel of wastepaper, consisting of pages torn from *Macbeth*, *Hamlet*, *Julius Caesar*, and *The Way of the World*. Ben Jonson's ghost rises through the stage and makes water on a fallen statue of a pantomime hero. A fiddler hangs by a cord in the air and plays from a scroll labeled "Musick for ye what Entertainment." This refers to the *What d'ye Call It*, an absurd yet very popular mélange by John Gay, combining tragedy, comedy, pastoral, and farce all in one piece. The faces of Tragedy and Comedy on each side of the stage are hidden by placards of *Harlequin Dr. Faustus* and *Harlequin Shepherd*. Also there is spectacle: a dragon ready to fly, a flask put in motion by machinery, and a trained dog sticking its head out of the kennel. Rich's trained dogs were attracting much notice in the plays at Lincoln's Inn Fields. Over the curtain appears the motto "Vivetur Ingenio." Much of the pantomime machinery that Hogarth satirizes here was introduced by John Rich and was lashed later by Pope in the third book of the *Dunciad*.

Hogarth was still contemptuous of Rich's tricks when, in 1732, he drew *Rich's Glory or his Triumphant Entry into Covent-Garden*. Rich, who is remembered today only for

The Beggar's Opera, which made Gay rich and Rich gay, was enormously popular in Hogarth's day because he pandered to the cheapest theatrical tastes. On 18 December 1732 he removed from the theater at Lincoln's Inn Fields to Covent Garden, the scene of the print. Hogarth has drawn on the right the Covent Garden Piazza leading to the theater, where a great crowd is flocking. Toward this colonnade streams a long procession headed by John Gay on a porter's back, and after them an open carriage drawn by six satyrs. Rich, as Harlequin, sits on the box, and in the carriage are Columbine and a dog, the latter an important figure in the Drury Lane pantomime of *Perseus and Andromeda,* a fact which pretty justly summarizes the worth of the whole piece. Following the carriage are crowds of variously costumed actors, many of whom are identified in the verses printed beneath the print. One of them cries, "Rich for ever." There is a cart loaded with theatrical properties including "A Box of Thunder and Lightning." The three columns of verse engraved below the design begin in this manner:

> Not with more glory through the streets of Rome,
> Return'd great conquerors in triumph home,
> Than, proudly drawn with Beauty by his side,
> We see gay R—— in gilded chariot ride.

The method of high burlesque has always been to exalt the inconsequential to the level of greatness. There could be no more withering satire than picturing the entry of this puny trickster with all the gilded fanfare of the hero in *Aïda.*[12]

The significance of these satires of Hogarth will be presently considered, but first we must note another group of prints closely related to them. It has been observed already that Ho-

[12] One episode in this print remains puzzling. In one corner Alexander Pope, identifiable by the letter "P" over his head and by the peculiarity of his figure, stands treating a copy of *The Beggar's Opera* in a vulgar and contemptuous manner. Pope had warmly supported the opera, and Gay was his good friend. Perhaps it was wanton satire, for Hogarth had the year before attacked Pope severely in a print called *The Man of Taste.*

garth's earliest attack on the pantomime, *Masquerades and Operas*, is just as much an attack on Italian opera. The fact and the date, 1724, are both important. The next example is *The Beggar's Opera Burlesqued*, drawn in 1728 while Gay's masterpiece was still the most exciting thing in town. Opera bears the full brunt of the satire here. Hogarth burlesques Gay only in order that he may ridicule the Italians. He naturally esteemed a satirist like Gay very highly; one of his most accomplished paintings is a scene from the third act of *The Beggar's Opera*.[18] In the burlesque, on the right of the design is a scene at the Italian opera, where a diva is surrounded by noblemen offering her homage and presents. This performance, by the motto at the top of the plate, *et cantare pares et respondere paratae*, seems to be judged equal in merit with the satirical representation of *The Beggar's Opera* on the left. A winged figure, "Harmony," is hastily flying away from both, and Apollo is asleep under the stage, his lyre lying neglected at his side. Upon the central platform of the print are six of the characters from Gay's opera, each with the head of an animal — Lockit a bull, Macheath an ass, Polly a pig, Lucy a cat, and so on. Under the print we again find a stanza of verses testifying to Hogarth's intimate relation with the author's trade:

> Brittons attend — view this harmonious stage,
> And listen to these notes which charm the age.
> Thus shall your tastes in Sounds & Sense be shewn,
> And Beggars Op'ras ever be your own.

The popularity of Hogarth's satire is shown by five different states of the plate now existing, a number indicating that there were at least four piracies of it.[14]

A more skilful satire of the opera appears in the levee scene

[18] This painting has contributed generously to all subsequent performances of the piece as well as to our knowledge of the eighteenth-century theater; few Macheaths have dared substitute anything else for the red coat Hogarth has endowed them with.

[14] *B. M.*, number 1807.

of *A Rake's Progress*. Hogarth engraved this after the arrival of Farinelli and after Fielding had already made a number of thrusts at the Italians. In the print, from over the back of the chair in which the harpsichordist sits, a long roll of paper extends to the floor. It is inscribed "A List of the rich Presents Signor Farinello the Italian Singer Condescended to Accept of ye English Nobility and Gentry for one Night's Performance in the Opera Artaxerses." The list is staggering in its splendor. At the end of the scroll is an engraving showing Farinelli seated on a pedestal like an ancient god. Many women are offering their burning hearts to him on the altar before his feet. They cry out, "One God, one Farinelli."

Other examples of Hogarth's ridicule of the opera are *The Oratorio*, a print of 1732 picturing a number of men, who give the impression of foghorns, rehearsing Huggins's oratorio *Judith*; and secondly, the levee scene from *Marriage à la Mode*, where a repulsive castrato is singing to an enraptured dowager. Ironically, this scene has contributed to the first act of Richard Strauss's celebrated modern opera, *Der Rosenkavalier*, a fact not generally known.[15]

The significance of these theatrical satires of Hogarth has never been made plain, but I believe a few simple facts will serve to establish it. First, Hogarth is always, in his own words, a dramatic writer. And he writes not just with pictures, but employs verse printed below the pictures as an adjunct to his meaning. He is certainly not the first to complain of the stagnation of the theater or to complain of the pantomime's irrationality, immorality, and dullness. Contemporary journals are crammed with letters or editorials setting forth arguments against pantomime on those very grounds, and blaming the manners, the morals, and the education of the age, as well as theater managers and the incompetence of con-

[15] All Hogarth's figures appear in the Marschallin's boudoir — the flautist, the Italian singer, the blackamoor with the chocolate, and even the symbol of the cuckold. In Hogarth the little blackamoor points to a deer's horns as the countess dallies with her future lover; in the opera the Marschallin is attended by Octavian, who has already received her favors.

temporary actors in legitimate drama.[16] But beyond whining complaints, none of the writers ever does anything about the matter, and often they are themselves contributing to the depravity of the stage even as they lament it. Colley Cibber admitted that he presented pantomimes against his conscience, but he would have starved else.[17] Since Buckingham's *Rehearsal* there had been satires on the nonsense of heroic tragedy and early in the century satires on Italian opera, but nothing effective against pantomime, which had far outdistanced both the others.[18]

It remained for Hogarth really to begin to reform by complaining dramatically. To dramatize, to make one's grievances concrete, is to plant one's foot firmly on the ladder of reformation. Hogarth, the last man on earth ever to be content with passive resistance, comes storming forth with a new weapon, dramatic satire. Its effectiveness is suggested by three circumstances. First, the prints were so greedily pirated on all sides that Hogarth had to turn to oil painting to make a living. Second, four years after *Masquerades and Operas* Gay presented the overwhelming sequel, *The Beggar's Opera*, which chased Handel's Italian opera troupe right out of the theater. And Hogarth immediately illustrated the satire with a glorious painting, besides making use of it in another picture to burlesque Italian opera still further. Third, by 1729 a veritable stream of satirical prints and cartoons on the theater began to flow from the press, and continued through the next decade. The *Catalogue of Satirical Prints in the British Museum* lists not a single theatrical satire, except from Hogarth, until 1729. After this they come in abundance. In fine, it was Hogarth

[16] E. L. Avery, "The Defense and Criticism of the Pantomimic Entertainments in the Early Eighteenth Century," *Journal of English Literary History*, V (1938), 127–45.
[17] Cibber, II, 181.
[18] Allardyce Nicoll, *A History of Early Eighteenth Century Drama, 1700–1750* (Cambridge, 1929), p. 256, mentions only one early satire, *The British Stage*, a Harlequin farce where pantomime is mocked in the stage directions describing the audience's ecstatic rapture over the tricks. The year is 1724, the same as *Masquerades and Operas*.

who led the fray, rushing well ahead of his contemporaries, just as he did in the next decade with *A Harlot's Progress* in the field of fiction. As early as 1724 he awakened a satirical trend, which is seen most powerfully of course in *The Beggar's Opera*, but which Hogarth again took up energetically and handed on with numerous suggestions to the man who was to reduce theatrical claptrap to smoldering embers, Henry Fielding. This purgation and the way it drew upon Hogarth for occasional stimulation is the theme of the rest of this story.

IV

In the same year of *The Beggar's Opera* Fielding came up to London to see his first play, a comedy of intrigue called *Love in Several Masques*, produced at Drury Lane. The author was a youth of twenty-one years and obviously not one who could write a good play. In it he attempts some mild satire on certain contemporary London types, but he makes no reference to the theater. After this inauspicious debut he retreated to Leyden for two years of study at the university, returning to London late in 1729 to resume playwriting. His next play, *The Temple Beau*, first acted in January 1730, is of the same type as the first and is no better. Yet the prologue of this play contains the first hint of what Fielding was soon to make his particular province, theatrical satire. It begins,

> Humor and wit, in each politer age,
> Triumphant, rear'd the trophies of the stage.
> But only farce, and show, will now go down,
> And Harlequin's the darling of the town.

Though written for Fielding by James Ralph, his Grub Street friend and later associate in journalistic activities, it is clearly Fielding's own opinion and contains a couplet which is a happy expression not only of his dramatic burlesques but of his entire literary career:

> The comic muse, in smiles severely gay,
> Shall scoff at vice, and laugh its crimes away.

The prologue, like the complaining newspaper articles already referred to, merely laments the Reign of Junk, and like them is ineffective because it does not fight with action, is mildly defensive rather than stringently offensive.

But two months later Fielding, like Hogarth five years before, stepped very actively into the fray. By this time he was probably well acquainted with *Masquerades and Operas*. He spoke of it years later in the sixth number of the *Covent Garden Journal*, where speaking of trunk makers as destroyers of learned works, he says: "The ingenious Hogarth hath very finely satirized this, by representing several of the most valuable productions of these times on the way to the trunk maker."

His first dramatic burlesque neatly combines the satire of Hogarth's print with Fielding's own firsthand knowledge of Grub Street. Taking the form of a two-part play entitled *The Author's Farce; and the Pleasures of the Town*, this theatrical thunderbolt appeared on 30 March 1730. The first part deals with the frantic efforts of several witless literary hacks to keep theatrical managers and booksellers supplied and satisfied. In an extremely funny scene, which at once brings to mind Hogarth's *Distressed Poet*, we find three bards in a garret, with Bysshe's dictionary of rhymes in front of them, racking their brains in the service of the muse. Witwood in *The Author's Farce* makes a remark to his poor playwright friend, Luckless, which, in addition to serving as link to the second part of the play, *The Pleasures of the Town*, presents a clear picture of the barren theater:

. . . when the theatres are puppet-shows, and the comedians ballad-singers; when fools lead the town, wou'd a man think to thrive by his wit? If you must write, write nonsense, write operas, write Hurlothrumbos, set up an oratory and preach nonsense, and you may meet with encouragement enough.[19]

[19] *Hurlothrumbo* was a mélange of nonsense slapped together by a mad music master named Samuel Johnson.
The last sentence refers in part to Orator Henley, the Nonconformist preacher and florid orator, who would prove from his velvet-covered pulpit

This is really a brief digest of all the things to be ridiculed in *The Pleasures of the Town,* which takes the form of the rehearsal of a dramatic entertainment written and managed by Luckless. To the Court of Nonsense in the lower world Charon takes a number of ghosts: Don Tragedio, Sir Farcical Comic, Dr. Orator, Signor Opera, Mrs. Novel, and Monsieur Pantomime. Before Nonsense's throne they all compete for the chaplet which the goddess has promised to whoever is the most foolish among them. Signor Opera at last convinces the queen that he is the most ridiculous of the company and is accordingly awarded the chaplet. The piece is replete with satire on Handel's new troupe of Italian warblers at the Opera House, Cibber's company who were ranting Thomson's *New Sophonisba* (a revamping of Lee's *Sophonisba, or Hannibal's Overthrow*) at Drury Lane, Rich and his pantomimes, and the nonsensical bombast of Orator Henley. Since there is no bitterness in Fielding's satire, and a great deal of good humor, it easily won the favor of the town. Thus it became the first really effective theatrical satire since *The Beggar's Opera.*

Fielding did not relent in his campaign of purgation. The very next month, on 24 April, he produced the most famous satire ever written upon the pomposity and claptrap of heroic drama, *Tom Thumb.* This high burlesque, aimed especially at the vapid *Sophonisba,* blows up the puny career of its tiny hero to all the sound and fury of a charging army. The important fact here is that when Fielding the next year expanded the play to three acts and the title to *The Tragedy of Tragedies, or, the Life and Death of Tom Thumb the Great,* Hogarth aided the piece by contributing a frontispiece. So far as is known this marks the beginning of the long and profitable friendship between the first painter and the first novelist of the age. It is of course significant that the first work in which Hogarth chose to support Fielding was this piece of

that all mankind were fishes of various sorts. He was satirized several times by Hogarth. Like Dr. Johnson, he enjoyed taking the wrong side of an argument just to exercise his ingenuity. Mr. Chadband in *Bleak House* is his closest counterpart.

powerful theatrical satire. The scene he selected to illustrate was that in which Huncamunca, betrothed of Tom Thumb, holds a candle before the face of the giantess Glumdalca, so that Tom, standing by, may see its ugliness in contrast to her own beauty. The scene is an exact parody of a scene between Cleopatra and Octavia in Dryden's *All for Love*. Fielding indirectly admits the source in the ironic notes attached to the play, where he says that he has not borrowed from Dryden, but that Dryden "is much beholden to our Author."

Hogarth also lent direct aid to Fielding the next year in another enterprise, partly theatrical. On 8 December 1732 were published eight volumes of Molière's works having the French and the English translation on opposite pages. Though the extent of Fielding's part in the whole undertaking remains uncertain, each play is dedicated to a well-known person, nearly all of whom were Fielding's friends, and some of the dedications show unmistakable traces of his hand.[20] Hogarth aided this undertaking with two illustrations, the frontispiece to the first play, a scene from *L'Avare*, and a scene from *Le Cocu Imaginaire* in the same volume.

The real importance of this venture to the theater is that Fielding, in an earnestly professed attempt to bolster theatrical fare with something of genuine worth, adapted two of these translations for Drury Lane. *The Mock Doctor* based upon *Le Médecin Malgré Lui* appeared on 23 June 1732, and *The Miser*, an adaptation of *L'Avare*, the following year on 17 February 1733. Fielding's good intentions succeeded, for both plays enjoyed great popularity. His hopes of theatrical reform are clearly indicated in the preface to the earlier play and the prologue, not written by Fielding but published by him, to *The Miser*:

[20] Cross, I, 144. One important piece of evidence (for it is the proof of the entire matter) Mr. Cross has overlooked. It is Fielding's preface to *The Mock Doctor*, in which he says: "One pleasure I enjoy from the success of this piece is a prospect of transplanting successfully some others of Molière of great value. How I have done this, any English reader may be satisfied by examining an exact literal translation of the *Medicin malgre Lui*, which is the second in the second volume of Select Comedies of Molière."

Too long the slighted Comic Muse has mourn'd,
Her face quite altered, and her heart o'erturn'd;
That force of nature now no more she sees,
With which so well her Jonson knew to please . . .

Here follows a caustic description of the vacuity of contemporary comedy; then the difference of Molière:

But to regale with other sort of fare,
Tonight our Author treats you with Molière.
Molière, who nature's inmost secrets knew;
Whose justest pen, like Kneller's pencil, drew.
In whose strong scenes all characters are shown,
Not by low jests, but actions of their own.

Cynics may say that these missionary professions are conventional, that every author liked to be thought both a man of taste and a public benefactor. But though Fielding sometimes pandered to public taste, he was never a hypocrite. Exactly the same, of course, is true of Hogarth. His contribution to the Molière translations is therefore another indication of his theatrical leanings.

Thus far we have seen how Hogarth was associated with Fielding commercially, but in the light of another connection this is of small importance beyond showing the intimacy existing between the two artists. The other connection is Fielding's lifting of character and incident directly from Hogarth's pictures, usually without acknowledging it. This, in turn, is less important in itself — for few of Fielding's plays can be called distinguished — than in its marking the beginning of a practice Fielding indulged heavily in while writing his greatest novels. Most important of all, in establishing Hogarth as a great reservoir which Fielding knew intimately and drew upon frequently, it will lead us to a more thorough understanding of Fielding's outlook upon human experience.

V

We have seen that when the six prints of *A Harlot's Progress* went on sale in late April 1732, they inaugurated an

exciting type of fiction that could not fail of success. It is not surprising, then, to find an author so young and so alive to news as Fielding drawing material from the prints to put into his plays, which were largely potboilers anyway. For example, *The Mock Doctor* itself, though a translation from Molière, probably bears a special relation to Hogarth and to a notorious contemporary figure. In this play, first performed on 23 June, Fielding directs a good deal of personal banter at the noted French quack, Dr. John Misaubin, whose reputation rested upon a little pill which he had compounded as a cure-all. There is an amusing scene where the hero, disguised as a Parisian doctor, tries to get his wife to take his "little peel" for her special distemper. The scene, which has no counterpart in Molière, is entirely gratuitous and seems to be included only because Fielding thought it might take with the audience. He had good reason for this belief, for only two months earlier Hogarth had ridiculed Misaubin with great success in *A Harlot's Progress*. It will be remembered that of the two quacks who are loudly proclaiming the infallibility of their respective medicines, the meager one, who stands holding a box of his pills, is a portrait of Misaubin, the other of Dr. Joshua Ward. One of the reasons why the prints caused so much excitement was that Hogarth introduced several portraits of actual people. Misaubin's pill is referred to in the verses printed underneath the first pirated copies published by Bowles. The doctors are called Meagre and Squab.

> Your pills, quoth Squab, with cool disdain,
> Not my elixir, prov'd her bane.

I suspect that the scene from Fielding, which plays no functional part in the comedy, was suggested by the success Hogarth was still enjoying at Misaubin's expense. Later, in the third picture of *Marriage à la Mode*, when Hogarth again introduces Misaubin and his pill, he may in turn have remembered this scene from Fielding.

In leaving *The Mock Doctor* for *The Lottery* and *The*

Covent Garden Tragedy, we pass from likely conjecture to undeniable fact. Both these plays draw unmistakably from *A Harlot's Progress.* In the first of them, a mildly amusing satire on the cheats and subterfuges of lotteries, the young suitor Lovemore comes to town seeking his sweetheart and discovers that she is set up in fine lodgings in Pall Mall. He exclaims: "Ha! by all that's infamous, she is in keeping already; some bawd has made prize of her as she alighted from the stage-coach. — While she has been flying from my arms, she has fallen into the colonel's." Not only does the reference to the bawd and the stagecoach link the speech to the first picture from the *Harlot,* but the mention of the colonel establishes the relationship as fact. Since there is no colonel anywhere in the play, can Fielding have been thinking of anything else but Colonel Charteris, who stands at the side of Hogarth's picture waiting to take the pliant Moll Hackabout into his arms? *The Lottery* was produced on New Year's Day 1732, over three months before Hogarth published his prints, but the painter's custom, as we have seen, was to invite friends and prospective puchasers to view the pictures at his house or studio long before they were even engraved. *A Harlot's Progress* was completed in the autumn of 1731, and though Fielding was hardly a potential buyer in those frugal years, he and Hogarth were already friends.

A Harlot's Progress had just been published when Fielding wrote *The Covent Garden Tragedy* in May 1732, and it was at the fore of Fielding's mind. Although it seems certain to me that the sensation caused by Hogarth's series gave Fielding the whole idea for his play, I can state as fact only a number of specific echoes from individual prints. This very funny play, which surprisingly was too coarse to be a success on the stage, has the same general purpose as *Tom Thumb.* In style it is a burlesque of the galloping bombast of *The Distrest Mother,* a tragedy by the same Ambrose Philips whose pastorals had suffered scathing ridicule from Pope twenty

years before. Philips had merely translated and lumpishly embellished the famous Racine play *Andromaque*. From the fair sunlight of ancient Greece, Fielding has transferred the action to the back parlor of a brothel in Covent Garden, a locale reminiscent of several plates in Hogarth's series. Pyrrhus and Andromache of Philip's play become Lovegirlo and Kissinda, while Orestes and Hermione are Captain Bilkum and Stormandra. The dialogue and soliloquies are parodies of the high-flown, yet halting and limping verse of Philips. Fielding's delight in sheer burlesque is emphasized by the absurd inventions of the denouement. Bilkum is supposed to have run Lovegirlo through, but Lovegirlo soon enters to discover that his coat, not his body, had received the thrust. Stormandra, reported to have hanged herself on her curtain rod, announces that it was merely her gown that had been seen hanging there, whereupon Lovegirlo closes the play with the couplet,

> From such examples as of this and that,
> We all are taught to know I know not what.

Just as Hogarth had done the month before in the *Harlot*, Fielding worked into his play a great deal of personal and contemporary scandal. The bawd, as in Hogarth, is Mother Needham. After speaking of being "exalted on the pillory" and "standing the sneer of ev'ry virtuous whore," she continues:

> Oh! couldst thou bear to see the rotten egg
> Mix with my tears, and trickle down my cheeks,
> Like dew distilling from the full-blown rose.

Mother Needham had met this notorious fate on the pillory. Stormandra's mock suicide is said to have been suggested by the hanging of a woman named Fanny Braddock, while Bilkum suggests Fanny's brother Edward.[21] Leathersides, who writes the dramatic criticisms for the *Grub Street Journal*, is clearly Leathercoat, the porter of no very high reputation

[21] Cross, I, 129.

at the Rose Tavern in Drury Lane. Hogarth later introduced him, with the candle and platter, into the third print of *A Rake's Progress*.

Fielding, like Hogarth, puts the profession of the harlot to contemptuous scorn, but in an altogether different way. Where Hogarth had with morbid realism pictured the trade in its true colors, Fielding mocks it by having the harlots themselves sing its praises in exalted and ridiculous language. For example Mother Punchbowl (who is Mother Needham) laments:

> Oh! Bilkum, when I backward cast my thoughts,
> When I revolve the glorious days I've seen,
> (Days I shall see no more) — it tears my brain.
> When culls sent frequent, and were sent away,
> When Col'nels, majors, captains, and lieutenants,
> Here spent the issue of their glorious toils . . .

At another point Kissinda scorns Stormandra's gross appetite:

> Sensual and base! To such as you we owe
> That harlot is a title of disgrace,
> The worst of scandals on the best of trades.

And the tone of some of Stormandra's soliloquies in which she struggles with her conscience between love and business is reflected in her line, "What shall I do? Shall I unpaid to bed?"

In Fielding's play there are definite suggestions, hitherto unnoticed, of five of the six prints of *A Harlot's Progress*. It must be remembered that the prints had just appeared, and with the effect of a bombshell. Inaugurating as they did a new field in English art and fiction, they were the talk of the town. One recalls Moll Hackabout's arrival in the York wagon when Stormandra cries:

> . . . dost think I came last week to town,
> The waggon straws yet hanging to my tail?

Hogarth's second scene, the harlot taken into keeping by the Jew, is reflected in Lovegirlo's speech:

I'll take thee into keeping, take the room
So large, so furnish'd, in so fine a street,
The mistress of a Jew shall envy thee;
By Jove, I'll force the sooty tribe to own
A Christian keeps a whore as well as they.

Later, when Stormandra upbraids Bilkum for refusing to pay
her, she reminds him of all she has done for him, ending:

Did I not pick a pocket of a watch,
A pocket pick for thee?

In Hogarth's third plate the harlot prominently displays a
watch she has just pilfered; and it is for this particular theft
that she is arrested. Beating hemp at Bridewell, the subject
of the fourth print of the *Harlot*, is mentioned several times.
Mother Punchbowl exclaims:

The hand to Bridewell which thy mother sends,
May one day send thee to more fatal gaol;
And oh! (avert the omen all ye stars!)
The very hemp I beat may hang my son.

At the news of Stormandra's supposed demise, Punchbowl
pictures the harlot's funeral:

Stormandra's gone!
Weep all ye sister-harlots of the town;
Pawn your best clothes, and clothe yourself in rags.

These passages would certainly have called to the minds of the
audience the Hogarth prints; but skeptics will say that this
does not prove that Fielding drew them from Hogarth. Beat-
ing hemp at Bridewell was the fate shared sooner or later
by most harlots. Yet consider how soon the play followed
upon the prints, and that Fielding was a master at turning
out a play in no time at all as opportunity or necessity dic-
tated,[22] and consider these details common to both. If that
were not enough to show that Fielding is in Hogarth's debt,
uncontestable proof appears in the Prolegomena to the play,

[22] See Cross, I, 130.

"A Criticism on the Covent-garden Tragedy, originally intended for The Grub-street Journal." Here Fielding, pretending to be a critic of his play, objects in hilarious fashion to all that is wrong with it, and by these absurd criticisms indirectly praises it. He concludes by quoting Stormandra's line, "Nor modesty, nor pride, nor fear, nor rep," and asks what the word "rep" can mean.

Perhaps it is a proper name; if so, it should have been in Italics. I am a little inclin'd to this opinion, as we find several very odd names in this piece, such as Hackabouta, &c.

There is no such name as Hackabouta in the play at all, but Hackabout was a name on every tongue, for she was Hogarth's heroine. Fielding has simply appropriated her.

A Harlot's Progress also contributes to a play Fielding wrote a few seasons later in 1735. On 25 January appeared *An Old Man Taught Wisdom, or The Virgin Unmasked*, in which both opera and dancing tricks are ridiculed in the persons of a singing master, Mr. Quaver, and a dancing master, Mr. Coupee. Because of its success, Fielding followed up with a sequel, *Miss Lucy in Town*, but for an unknown reason this play was not performed until 1742. In the latter play Lucy, still "fresh and raw out of the country," comes up to London with her bridegroom and by mistake takes lodgings at the infamous house of Mrs. Haycock (Mrs. Haywood, the Covent Garden bawd). Considerably overstepping herself, Mrs. Haycock promises Lucy to a debauched nobleman reminiscent of Colonel Charteris:

But pray, my Lord, how go the finances, for I have such a piece of goods, such a girl just arrived out of the country!

Hardly has she concluded the bargain with him, when she next offers Lucy, "pure country innocent flesh and blood," to a rich Jew, Zorobable. The Jew later offers to take Lucy into keeping and give her fine jewels and a house in any part of the town she likes. It will be remembered that Moll Hackabout's first lover was a debauched nobleman, her second a

rich Jew who sets her up in luxurious quarters. Another character in the play, a ridiculous tenor called Signor Cantileno, is a burlesque of the Italian opera.

In nearly all these plays of Fielding's one thoroughly natural characteristic predominates, his desire to amuse his audience. Because of this they all contain some sort of sensationalism. Obscenity, being the easiest sort to achieve, is the most frequent. At his best, as in *Tom Thumb* and *Pasquin*, sensation is part of the satire, inextricably blended with it. The gory ghost of Tom Thumb is a good instance. But at other times Fielding panders outrageously to his undiscriminating public. For example, some of the lewdness of *The Covent Garden Tragedy* is burlesque, but much of it is simply lewdness. In *The Virgin Unmasked* some of the conversation between Lucy, the pretended innocent, and her suitors (particularly the masters of singing and dancing) is well-pointed satire of their professions, but a great deal of it is peppered with the coarsest double-entendre. Other plays like *The Old Debauchees, The Coffee House Politician,* and *The Modern Husband,* bristle with disgusting trash. Obviously neither Fielding nor his audience ever took much interest in the moral justice that usually creeps into the artificially forced and laughably weak denouements. Their very weakness is the best proof.

There are always "morals," but these do not set the tone of the plays. To pounce upon two or three moral speeches in a Fielding play and regard them as the impression of the whole is to be as foolish as those modern critics who herald Chekhov's *Cherry Orchard* as the ecstatic dawn of a brave new world on the basis of a single speech of sweetness and light delivered by the student, Trofimov, who throughout the rest of the play is pictured as an utter fool.[23] Works of art must be judged not by an isolated part but by the total impression. In the light of these facts one is hard put to it to settle the extent of

[23] See, for example, Eva Le Gallienne's preface to the Modern Library edition of Chekhov.

Fielding's distaste for a debauched theater, for certainly in
his efforts to provide for the day that was passing over him
he himself contributes to the theater's prostitution.

By this time it is clear that Hogarth too is willing to pan-
der. I should guess that he would not have published satires
on the pantomime and Italian opera had he not known that
nearly anything connected with them would sell, and sell
rapidly. Still, the fact that his subject is always somewhat
sensational does not mean that Hogarth is any the less sincere
in his satire; for in his memoirs, written in old age, he is still
railing against all varieties of exotics and tricks. Though his
pen was earnest, he was reluctant to waste it on subjects un-
appealing to the popular taste. Whatever his intention, his
satire succeeds as satire, and this is all that really matters. He
discovered how to be what Fielding until his later career too
often was not, sensational and satirical at the same time. He
has blended several levels of appeal. Fielding borrowed details
from *A Harlot's Progress* for spice and scandal, perhaps the
very reasons Hogarth put them there in the first place. But
Hogarth's reasons do not matter, for these details also lend to
his pictures a realistic and journalistic air; and the effect of the
entire series is one of pungent comedy blended with a power-
ful social tragedy. In Fielding's plays these details more often
emerge as meretricious smut.

VI

In tracing the influence of one artist upon another, the
scholar is in danger of giving the impression that he has lost
all sense of perspective. Since he examines only one facet of
a whole, he makes it appear sometimes that one artist com-
pletely accounts for another, which of course can hardly be so.
Hogarth is certainly not responsible for Fielding any more
than Dryden is responsible for Pope or Marlowe for Shake-
speare. Fielding's theatrical satires are due mainly to the fact
that he went often to the theater and he had two good eyes
and a brain in his head. When he saw a mess of nonsense like

Hurlothrumbo become the rage of the town, all that was just and honest in him cried out to denounce it. Had Hogarth never begun mocking pantomimes back in 1724, and had Gay never startled London with *The Beggar's Opera* and shown new possibilities, Fielding would still have expressed himself in some sort of dramatic satire. But what is important is that Fielding had those two men already before him, that he had not only observed but had studied their work, and that then he produced his own, which turned out to be the most effective of all.

Pasquin, the best and most successful of them and probably the finest thing of its kind in English literature, marks Fielding's last theatrical relationship with Hogarth. The first performance of this work, a far advance over his earlier plays, was on 5 March 1736. Like *The Author's Farce* it takes the form of Buckingham's celebrated satire, *The Rehearsal*, and pictures two ridiculous plays in the throes of being doctored for the public. The first part, *The Election*, is a brilliant and daring political satire, a comic version of the last general election. The second half, Mr. Fustian's tragedy called *The Life and Death of Common Sense*, is fitted out with all the necessary machinery for thunder, lightning, and ghosts, as well as with numerous other accoutrements of pantomime entertainments. They had all been taken off earlier by Hogarth in *A Just View of the British Stage*, in *Southwark Fair* (published less than a year before *Pasquin*), or in both. In fact every bit of theatrical satire in Hogarth's early prints finds its way into Fielding. The double bill is characteristic of Fielding's shrewdness, for if one half did not go down with the audience, the other half would sustain it. Hogarth assisted the fortunes of the play by drawing a ticket for the benefit performance on 5 April of John Roberts, who played Trapwit. His sketch shows the murder of Queen Commonsense in the last act. A benefit ticket was no small contribution, as may be seen in the advertisement of the performance where the ticket is actually described, and in a piracy of Hogarth's

picture to which Alexander Pope and a number of other spectators have been added.[24]

The popularity of *Pasquin* was almost unparalleled. It ran for more than sixty nights, the only play to enjoy such a record since *The Beggar's Opera*. Although the audience had at first found more pleasure in *The Election*, by April the tide was beginning to turn in favor of the tragedy, which the newspapers agreed was "much the finer performance of the two." As a result the performances at all other theaters, even at the Italian opera, fell off. Farinelli's benefit came and went with no mention of his receiving any presents, a custom laughed to scorn by Hogarth the year before in *A Rake's Progress*.[25] Fielding was fulfilling his promise to himself of laughing the town out of its vices. Though the Licensing Act passed the next year put Fielding out of the theater, his battle against pantomimic frivolities had not been in vain. His biting yet buoyant satire had made the theatergoing public see clearly the emptiness of their tastes, so that they began to be irritated with the sort of nonsense Rich offered. When David Garrick made his meteoric debut as Richard III at Goodman's Fields in 1741, they welcomed with a joyful noise a new era in Shakespearean and theatrical history.

As I have said before, it is difficult to decide exactly the extent to which pantomime entertainments really outraged Fielding, for he was certainly in the theater to make a living, and his best burlesques took magically with the paying public. In fact *Tom Thumb* and *Pasquin* were far more successful than any of his legitimate plays ever were. But since most of his plays are not burlesques, since he got the burlesques up only upon special occasions, since in the novels he is still mak-

[24] Pope was rumored to have attended Roberts' benefit. In the picture he turns to his companions and says, "There is no whitewashing this stuff," which certainly refers to Hogarth's earlier satire, *The Man of Taste*, where Pope is pictured whitewashing the front of Burlington House, Stephens *(B. M.,* III, Part One, 358–59) mistakenly thought that this design instead of the simpler one was Hogarth's.

[25] Cross, I, 188.

ing contemptuous references to Rich and pantomimic tricks, and since he is always passionate in defense of forthrightness and honesty, it is obvious that here Fielding is writing from his heart as well as for his pocket.

In this period of theatrical writing, as later on, the pattern of Fielding's career follows very closely that of Hogarth's. During the first decade of his active career as an artist Hogarth produced several prints concerned entirely with theatrical satire. He probably did others which have not survived, for we have precious little from his pen during the most productive period of most artists' lives, the middle twenties to the middle thirties. But by the third decade of the century he was finding his métier as an artist, which Fielding had not yet done. In *A Harlot's Progress* he initiated his great narrative series, where he was naturally not concerned with full-fledged attacks on the theater. His work now had become creative rather than destructive. Satire for the sake of satire he left largely with his salad days, and now merely in passing and with his left hand slapped theatrical nonsense, as in the jibe at opera in Plate II of the *Rake* and at Rich in Plate VII.[26]

Fielding's pattern is the same. His great creative works do not begin until he has found his métier in the novel. Before that he had done a few brilliant satires, but they were destructive, not creative. When he turns to more extended fiction his satire, like Hogarth's, becomes less blatant and more artistic. He, too, though he has left the theater, laughs at pantomimic nonsense in passing. In *Joseph Andrews*:

Not the great Rich, who turns men into monkeys, wheelbarrows, and whatever else best humours his fancy, hath so strangely metamorphosed the human shape . . .[27]

or in *Tom Jones*:

[26] Exception must be made of the glowing *jeu d'esprit* and favorite of many Hogarthians, *Strolling Actresses Dressing in a Barn*. But by depicting them on the last night before their troupe is disbanded forever, that picture is as much narrative as it is satire on tricks and claptrap, and is miles ahead of anything Hogarth did in the 1720's.
[27] I, 7.

I wish, with all my heart, some of those actors who are hereafter to represent a man frighted out of his wits had seen him [the sentinel at Hambrook], that they might be taught to copy nature, instead of performing several antic tricks and gestures for the entertainment and applause of the galleries.[28]

The bludgeon can still appear, but the interest of both artists is far wider. As Hogarth aged, his work becomes grimmer and more didactic (*Industry and Idleness, Gin Lane, Four Stages of Cruelty*), and sometimes very bitter (*The Times* and *Wilkes*); also Fielding (*Amelia, An Enquiry into the Increase of Robbers*). It is an interesting coincidence, and no more, that Hogarth ended his career as sergeant painter to the king, and Fielding his as justice in his majesty's court.

In conclusion, this chapter, besides reviewing briefly the unusual theatrical fare of the second quarter of the eighteenth century, has served to establish the intimacy and the congeniality of spirit that existed between Hogarth and Fielding, and their concern with exactly the same things. By looking at the work of either we may learn of the other. The actual debt that Fielding's plays owe to Hogarth is not remarkably great; but, in seeing how from the very inception of his career Fielding was related to his older friend, we are prepared to examine the very great indebtedness of the novels to Hogarth. Without Hogarth Fielding would doubtless have written his novels, but they would have been quite different from what they are.

[28] VII, 14.

Hogarth's Role in Fielding's Novels

Among all the writers of any particular age there must be, irrespective of their own wills, a resemblance. They cannot escape subjection to a common influence which arises out of many circumstances belonging to the times in which they live. In this view of things it is hardly more intelligent to call Shakespeare the imitator of Marlowe than Marlowe the imitator of Shakespeare. The age makes the man even more than the man makes the age. Yet Marlowe did materially influence Shakespeare in particular ways that go far beyond their common Elizabethan milieu, and a study of these ways contributes immensely to our understanding of the experience that is Shakespeare. In like fashion the eighteenth century made both Hogarth and Fielding, and a study of either artist in relation exclusively to only one other man must omit the great broad currents which are most important of all. Yet Fielding owes even more to Hogarth than Shakespeare does to Marlowe, and to fail to interpret him in this light is to have an imperfect illumination of the experience that is Fielding. It is the aim of this chapter not only to speak of the broad currents of the age reflected in both artists, but also to explore the particular paths into which the painter led the writer.

I

Fielding's first novel, *Joseph Andrews*, was published in 1742. With its appearance, for the first time in English prose fiction every character is a living individual; every incident could have actually happened. Before this time no writer of

prose fiction had ever filled his canvas with such wealth of zestful comedy, or had created so many memorable characters, or had ever sustained so delightful a story. Defoe, walking on the border line between biography and fiction, had come closest to writing a novel in *Robinson Crusoe*; but he could almost never look at the world and laugh, and his books moreover were without plot. Samuel Richardson actually founded the novel, but I can imagine no one calling *Pamela* "zestful comedy." Yet there was one artist who, ten years before *Joseph Andrews*, had contrived a simple story consisting of exuberant activity, truly individual characters, and capital humor. What is more, he had made it demonstrate clearly a sound moral lesson. With all these attractions it naturally could not fail. Thus, in *A Harlot's Progress*, Hogarth discovered his métier, and the world discovered him.

This exciting innovation, the blending of comedy and characterization with a well-knit plot, could hardly help influencing Fielding. We have already seen that Hogarth's literary usefulness was well established in 1732 and that he had become a friend of Fielding's as early as 1731. It is therefore by no means surprising that in *Joseph Andrews* Fielding showed that he was heavily indebted to Hogarth. In the celebrated preface to that book he compares comic writing and burlesque to comic painting and caricature. To show how he himself is a comic writer, as opposed to a writer of burlesque, he cites Hogarth as a comic painter, in distinction from a caricaturist. In other words, he is defining his own art in terms of that of the painter. Such a declaration from Fielding himself certainly intimates an important bond between the art of the greatest novelist and the greatest painter of the age.

When he speaks of caricature and burlesque as against comic painting, Fielding emphasizes immediately one of the most important connections between himself and Hogarth. This, the difference between character and caricature, is a distinction absolutely compulsory to any understanding of Fielding's novels and Hogarth's prints, and consequently a

good place for us to begin. The affinity of the two artists in this respect has been felicitously expressed by Hazlitt in his well-known essay on the painter:

What distinguishes his compositions from all others of the same general kind, is, that they are equally remote from caricature, and from mere still life. . . . For his faces go to the very verge of caricature, and yet never (I believe in any single instance) go beyond it: they take the very widest latitude, and yet we always see the links which bind them to nature: they bear all the marks, and carry all the conviction of reality with them, as if we had seen the actual faces for the first time, from the precision, consistency, and good sense with which the whole and every part is made out. They exhibit the most uncommon features, with the most uncommon expressions: but which yet are as familiar and intelligible as possible, because with all the boldness, they have all the truth of nature. Hogarth has left behind him as many of these memorable faces, in their memorable moments, as, perhaps, most of us remember in the course of our lives, and has thus doubled the quantity of our experience.[1]

Anyone who knows Fielding's novels will realize that these words apply equally well to them as to the pictures. Though caricatures amuse us we can never accept them as being real, as people having an actual existence. Thus caricature will play as small a part in the novels of a master of realism like Fielding as in the pictures of England's most realistic painter. But this affinity between the two artists is much more than just a pleasant similarity, for it is almost certainly Hogarth who restrained Fielding's inclination toward burlesque, or caricature. The novelist himself intimates as much in the preface to *Joseph Andrews*:

Now, what Caricature is in painting, Burlesque is in writing; and in the same manner the comic writer and painter correlate to each other . . . He who should call the ingenious Hogarth a burlesque painter, would, in my opinion, do him very little honour; for sure it is much easier, much less the subject of admiration, to

[1] *Lectures on the English Comic Writers* (London, 1819), pp. 277–78.

paint a man with a nose, or any other feature, of a preposterous size, or to expose him in some absurd or monstrous attitude, than to express the affections of men on canvas. It hath been thought a vast commendation of a painter to say his figures seem to breathe: but surely it is a much greater and nobler applause, that they appear to think.

Fielding had just been insisting upon his own position as a comic writer and not a mere writer of burlesque. The quotation shows, of course, that he had been pondering the distinction between character and caricature in terms of the art of Hogarth. Although this is but intimation of their relation, other evidence will prove corroboratory.

Everybody knows that Fielding began *Joseph Andrews* as a broad burlesque of *Pamela*, just as Cervantes undertook to burlesque the romances of chivalry in *Don Quixote*. Fielding even acknowledges Cervantes as his master and guide. Yet the fact that both novels have achieved immortality indicates obviously that they are far more than mere burlesque. They are principally read and remembered not as skilful parodies (which of course they are), but as matchless comedies of real life, possessing eternally fresh humor and characters deeply rooted in human nature. Critics have usually said that Fielding largely abandoned sheer burlesque early in *Joseph Andrews* because he fell in love with his characters, and this must be partly true. The recognized authority on Fielding, Mr. Cross, suggests another reason. "Fielding's tendency to exaggeration," he says, "was checked by the example of his friend Hogarth, which showed him how in a sister art character and incident may be heightened for comic effect and yet escape caricature." [2]

Hogarth learned to stop his pencil before he crossed over that precarious boundary between character and caricature. His personages are usually flesh-and-blood human beings, characterized in some particular way which makes them stand out from the crowd. Contrast the intoxicated revellers of *A*

[2] W. L. Cross, *The History of Henry Fielding* (New Haven, 1918), I, 323.

Midnight Modern Conversation with the gross though amusing caricatures in some of Thomas Rowlandson's sketches of drunken routs, or Hogarth's witty *Laughing Audience* with Rowlandson's monstrous *Comedy in the Country*, and my meaning becomes clear at once. Hogarth's drunken crew are made absurd by accentuation, yet they remain human beings; Rowlandson's are gross cartoons, quite unrealistic, yet they give the *idea* of drunkenness.

The distinction was important to Hogarth himself. He always insisted that he was no caricaturist:

There are hardly any two things more essentially different than *character* and *caricature*, nevertheless they are usually confounded, and mistaken for each other, on which account this explanation is attempted . . . It has ever been allowed that when a character is strongly marked in the living face, it may be considered as an index of the mind to express which with any degree of justness in painting requires the utmost efforts of a great master.[3]

This, of course, is character where, to quote Fielding, the figures "appear to think." Hogarth goes on to say that caricaturing is making trick likenesses, drawing the features "with any sort of similitude in objects absolutely remote in their kind." This is exactly what Fielding speaks of when distinguishing between comic writing and burlesque:

But to illustrate all this by another science, in which, perhaps, we shall see the distinction more clearly and plainly, let us examine the works of a comic history painter, with those performances which the Italians call Caricatura, where we shall find the true excellence of the former to consist in the exactest copying of nature; insomuch that a judicious eye instantly rejects anything *outré*, any liberty which the painter hath taken with the features

[3] John Ireland, *Hogarth Illustrated* (London, 1806), II, 340. In the *Analysis of Beauty*, p. 125, Hogarth speaks similarly: ". . . we have daily many instances which confirm the common received opinion, that the face is the index of the mind. . . . It is reasonable to believe that aspect to be a true and legible representation of the mind, which gives every one the same idea at first sight."

of that *alma mater*; whereas in the Caricatura we allow all licence — its aim is to exhibit monsters, not men; and all distortions and exaggerations whatever are within its proper province.

The "comic history painter" is Hogarth — the rest of the preface calls him by name. The faces and figures of Hogarth's dramatis personae are often exaggerated for comic effect, but only a few of them can be called true caricature, even in our broader definition of the word today. Probably the best proof is a comparison with the plates of Rowlandson for Combe's poem *Dr. Syntax*: Tom Rakewell's character becomes more and more credible as we examine each of his eight pictures in which he visibly develops, but Dr. Syntax, who appears in eighty scenes, never once becomes a real person. Hogarth is the inventor of character in narrative painting, and he defines it in his memoirs as "that intermediate species of subjects, which may be placed between the sublime and grotesque."

I do not mean to imply that caricature is synonymous with amateurish grossness. Indeed there are critics who with some reason regard caricature as a profound art, for it discloses the secret of a man's individuality. To them caricature is more lifelike than portraiture, for the artist must discover the disproportions which in nature appear only as inclinations, and bring them to a sharp focus in his caricature. Because of generous accentuation of prominent features Hogarth can achieve this very sharp focus of individuality in his figures; yet they nearly always remain realistic, and his method is not that of the caricaturist at all. He excels in minute delineation of character and story. Each of his plates is like a whole act of a play; the most trifling object or situation introduced into the picture has an intimate relationship with the whole. In contrast, the method of the caricaturist is brevity.

Although Hogarth has heightened what has come within his own experience beyond the bounds of photographic realism, he still paints human beings. We see in *Joseph Andrews* that this is the lesson Fielding learned from him. My reasons for saying this will appear in the next three sections; here we

may be reminded of a few of the characters. If any man was ever so absent-minded as Parson Adams — and that is not likely — certainly, as a consequence, he was never led into so many misadventures in such a short time. Except for one other woman, herself a literary creation, no person ever embellished mere prose with such admired misuse of great words as Mrs. Slipslop. There was never a parson so hoggish as Trulliber, nor a miser so contradictory as Peter Pounce; and the list might be extended indefinitely in *Tom Jones*. Notwithstanding, these figures are all human beings, who are made the more real by their peculiarities. Fielding asserted in the preface, just as Hogarth insisted in his memoirs, that all his characters were taken from nature. The artistic effect, however, requires emphasis on certain traits of character, just as it requires some elaboration of incident.

Hogarth emphasized the relation with Fielding by painting in the subscription ticket to *Marriage à la Mode* a sketch of heads called *Characters and Caricaturas*, which shows the distinction and gradation between the two. Under the design is printed: "For a farthar [sic] Explanation of the Difference Betwixt Character & Caricatura See ye Preface to Joh. Andrews."

II

Mr. Cross has suggested, at least, this much of the relationship; but there are many other facets yet untouched, as well as all the proof of the relationship. If we are to begin at the beginning, we must go back nearly a hundred years before *A Harlot's Progress*, because during an entire century the delineation of character in the art of narration had been dead. Hogarth revived it in 1731.

One of the most important influences on English literature in the seventeenth and eighteenth centuries was the Character Book, a collection of brief sketches of familiar types of human characters. The best known of these books, which stem from Theophrastus, is Bishop Earle's *Microcosmography* (1628). It contains such sketches as "A Flatterer," "A Coward," "A

Young Raw Preacher," "A Downright Scholar," and "A Bold Forward Man." Character Books, popular with all classes of people, made writers more conscious of the various types of humanity than even Ben Jonson had in his "humor" plays. In Jonson everyone exhibited a certain ludicrous peculiarity, the mainspring of the creation; but in Character Books this vein of comic exaggeration is often lacking, and instead every person in the world is reduced to some type. Not content with the unusual "humor" character, everyone had to be neatly categorized. Their effect on literature was stultifying, for they produced either flat types or caricature. Their influence may be seen in all the type or stock characters who cluttered Restoration and eighteenth-century drama and in the essays of Addison and Steele.

Paradoxically, the one thing the Character Books failed to stimulate was the delineation of character. By character I mean what makes the individual distinctive, what the Oxford English Dictionary calls "the sum of the moral and mental qualities which distinguish an individual . . . viewed as a homogeneous whole; the individuality impressed by nature and habit on man or nation." Its keynote is individuality; it may be best summarized in the word *personality*.

Restoration drama contains many amusing types and caricatures but no real personalities. The dramatis personae are usually painted in the broad, every man in his particular humor, though the humor is more inclusive and conventional than in Jonson. The delicacies of this drama are not in revelation of character, but in epigrams; its excitement not in soul-searching soliloquies, but in a Lady Wishfort's boudoir billingsgate. One sees only plain dealers, country wives, cuckolds, Hoydens, Foppingtons, and Lady Bountifuls. Congreve's stunning Millamont in *The Way of the World* is the most fully drawn character, yet she is as cold as she is brilliant. The heroic plays of Dryden and Otway contain even less of human nature. Time, the truest of all judges, has labeled these as claptrap; the label suits. The very fact that Buckingham

was able to burlesque them so easily in *The Rehearsal* is sufficient proof that they are largely *outré*. Most of the Elizabethan dramatists had written from an inward sympathy, the method of the poet; Ben Jonson wrote from external realization, the method of the painter (even the most introspective), and thereby set the tone for the Restoration and thereafter.

Turning the century, one may find less caricature, but the *Spectator* is filled with the same old types. The members of the *Spectator*'s famous club in Little Britain are all two-dimensional; in that, of course, lies much of their charm. Certainly they are more individualized than those of the Restoration drama, and we can even imagine them becoming characters in a novel. But of course they never do, for Addison drops them before they become elaborated. The first full-length of Sir Roger de Coverly (number 106) might be entitled "The Benevolent Man." Will Honeycomb, who has a certain way of making his real ignorance appear a seeming one, and Sir Andrew Freeport, who calls the sea the British Common, are amusing because they are so typical. Steele, in many of his papers, has taken descriptions almost without embellishment from the Character Books.

Defoe's marvelous realism brings us much closer to the art of Hogarth and Fielding, but he is far less rich than his successors. *Robinson Crusoe* has been justly praised because in it Defoe has kept the point of view of his hero throughout, but one may ask whether his hero is really a character or is merely a spectator who journalistically records events. The book is not allowed to be our first novel, because it has no plot; I insist that it has no characters either. Crusoe has patience, courage, and common sense, but he has the personality of a vegetable. He is a man of character, but is himself not a character. Moll Flanders is a splendid old girl whom the twentieth century has taken to its heart; yet once she is placed beside her natural prototype, Chaucer's Alice of Bath, it is obvious that she has no depth whatever as a character. Her story, like Crusoe's, is an episodic chronicle with no center.

Plot and characters do not arrive in the novel until *Pamela* in 1740. But they had both arrived nine years earlier, in *A Harlot's Progress*.

Hogarth is one of the great revolutionaries in art, not just in painting. In his first narrative series he breaks away not only from the stuffy artifice of his papier-mâché colleagues in painting, but also from the conventional caricature of contemporary literature, notably in the plays of Cibber and Fielding and in Pope's *Dunciad*. The type figures of eighteenth-century drama can be accepted during the performance, but having no personality they do not stimulate the spectator to fill in the background, to ask what has gone before and what will come after. In other words, they do not live in the imagination; they are not characters. This is what makes Hogarth so different, for his best characters are suggestive. They stand out in the mind as real people; we know this because we find ourselves filling in the gaps between the scenes of the three great series. Even in the single prints we discover that we actually know the characters as individuals and are curious about the before and after. It is for this reason that Hogarth must be called an inventor of character; his figures come to life as real people, and not just as types but as individuals. To make it harder for ourselves, let us ignore the figures in the narrative series and examine some of the minor prints. Mark the striking individuals in only two of the prints, "Morning" and "Noon" from *Four Times of the Day*: the withered old maid making her way to morning service; the shivering slip-shod footboy, who clutches her prayer book and looks at the fire in front of the tavern with a miserable longing; the boy in "Noon" bawling outrageously because he has broken the dish of pudding he has been sent to buy (what will be his punishment?); the little girl whose ravenous devouring of the fragments speaks volumes about her past and future; the gay and lecherous blackamoor, who rubs his sable cheek against that of a blossoming baker's maid; the contemptible little snip in Parisian silks and satins, who mimics the mincing gait of

his elders; and finally a prim and pious-looking wench who appears to be considering just how she can pick the beau's pocket. These people amuse us and also stir our imaginations. We become interested not only in their activities but in what sort of people they are.

It will be objected immediately that Hogarth's characters are nearly all familiar types of the day. True, they are, but that does not suffice. So are Chaucer's and Fielding's. They are typical of .their time, yes, but are not mere types. One could no more explain Parson Adams by calling him a type than Chaucer's Pardoner or Wife of Bath. I think it significant that Hogarth's first narrative he named *A Harlot's Progress*, not *The Harlot's Progress*. She is *a* harlot, not *the* harlot. Her history is typical of what a harlot might expect in this world, but no one seeing her picture would say, "Ah, yes, here is the harlot." She is a person who happens to be a harlot. In the first picture she is a country girl, simple and ungainly; in the second she has become the complete mistress of her trade, coquettish and affected; in the Bridewell scene she is overwhelmed with despair and bewilderment. She develops before our eyes, and each stage of her development is in keeping with the course of her career. To see *the* harlot, the woman whose every feature stamps her profession, one must turn to the caricature of Rowlandson, or to the picture Pope draws in the fourth book of the *Dunciad*:

> When lo! a harlot form soft sliding by,
> With mincing step, small voice, and languid eye:
> Foreign her air, her robe's discordant pride
> In patchwork fluttering, and her head aside.

In like manner Tom Rakewell is the hero of *A Rake's Progress*, not *The Rake's Progress*. For indubitable proof we need only turn again to Rowlandson's *Dr. Syntax*.

One other comparison. Ben Jonson's most famous "humor" character perhaps is Volpone. The very name has become synonymous with greed. Molière with equal brilliance

has produced the French counterpart in *L'Avare*. Either one of them would be perfectly well as an illustration for Bishop Earle's Character of a Miser or Sordid Rich Man. In *Marriage à la Mode* Hogarth too has drawn a miser, the father of the countess, but one would never take him to illustrate *Microcosmography*. He is a type, but he has been individualized. There is a solemn seriousness about him, and none of the miser's eager greediness, as he sighingly draws the rich ring from his dead daughter's stiffening finger. Obviously there is also a great deal of hypocrisy about him, but he is not "The Hypocrite." Molière's Tartuffe has become a byword for hypocrisy, but one cannot appropriate Hogarth's old maid in "Morning" to illustrate "The Hypocrite."

The individualized type is seen in its most highly developed form, of course, among Chaucer's Canterbury Pilgrims and in Shakespeare. After that it appears hardly at all in English literature until Fielding creates Parson Adams. The parson is a type if ever there was one—he might be called "The Absent-minded Benevolent"—but even the dullest reader can perceive that he is far more. The same is true of Mrs. Slipslop, Squire Western, Mrs. Honour, and a host of others.

In fine, from the days of the Jacobean drama to Pamela and Parson Adams, English literature is almost wholly devoid of character. The haunting creations of the Jacobeans completely disappeared; their soul-searching intensity does not return until the nineteenth century romantic poets and the novels of Emily Brontë and George Eliot. But the eighteenth century brought back character, and Hogarth was its *primum mobile*. Before him all was flat type, enlivened at best with caricature. He took this flat type (which always remained the center of his invention, as of Fielding's) and, by distinctly individualizing it, transformed it into character. In his narrative series he put that character into a tightly woven plot. With *A Harlot's Progress* modern fiction had arrived. The two arts had become one.

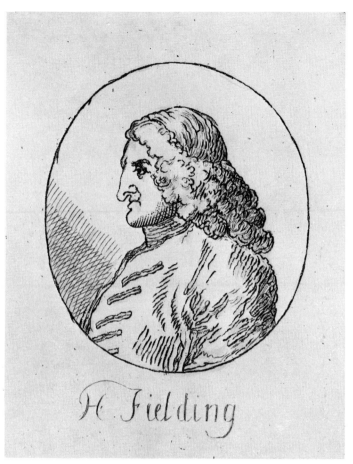

Henry Fielding

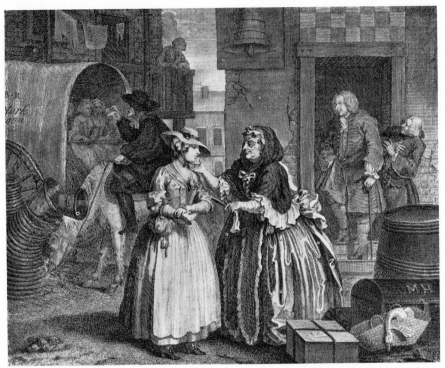

A Harlot's Progress, Plate 1

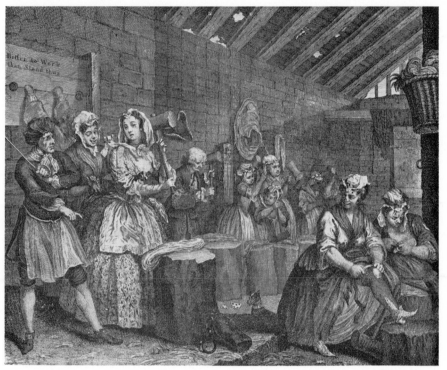

A Harlot's Progress, Plate IV

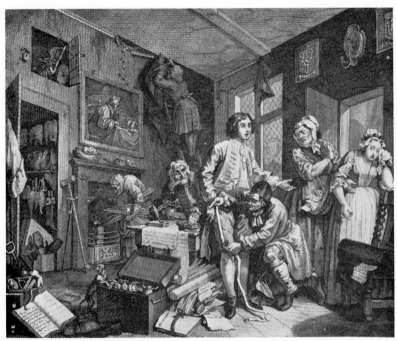

A Rake's Progress, Plate I, and Piracy

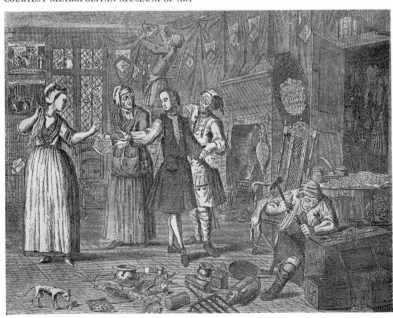

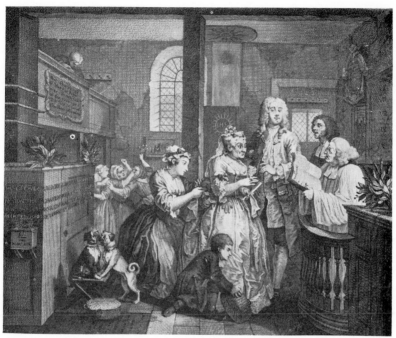

A Rake's Progress, Plate v, and Piracy

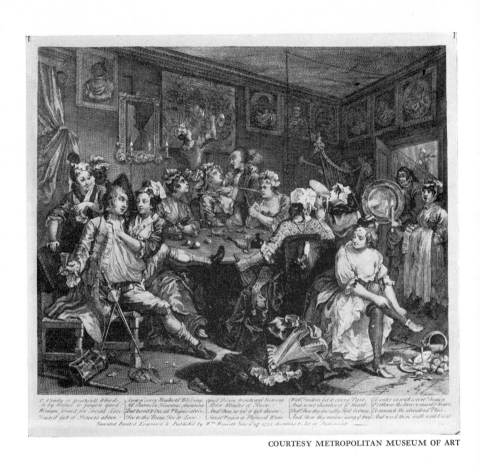

A Rake's Progress, Plate III

"The Wanton Revelling with her Companions," from *Diligence and Dissipation* by James Northcote

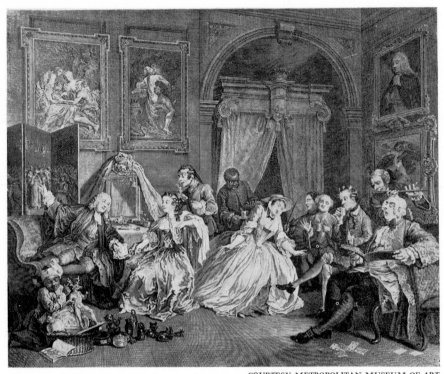

Marriage à la Mode, Plate IV

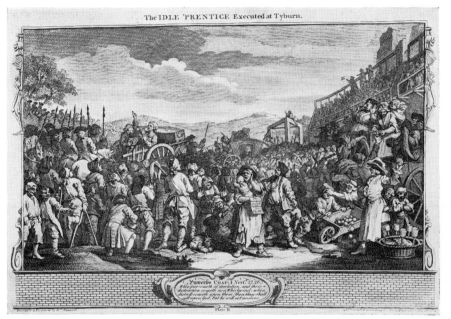

Industry and Idleness, Plate xi

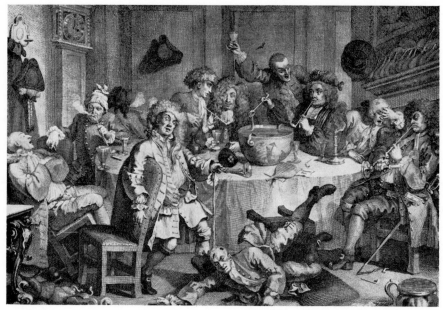

A Midnight Modern Conversation

The Hunt Supper by Thomas Rowlandson

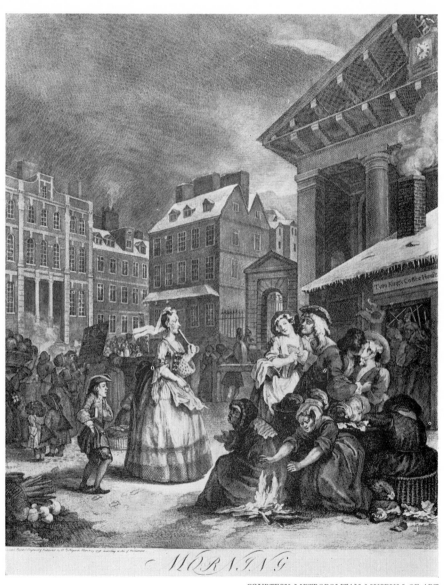

"Morning" from *Four Times of the Day*

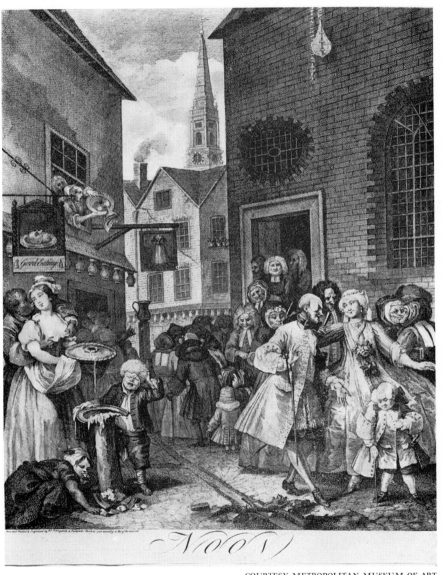

"Noon" from *Four Times of the Day*

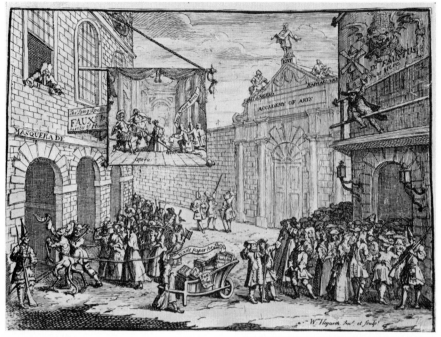

Masquerades and Operas

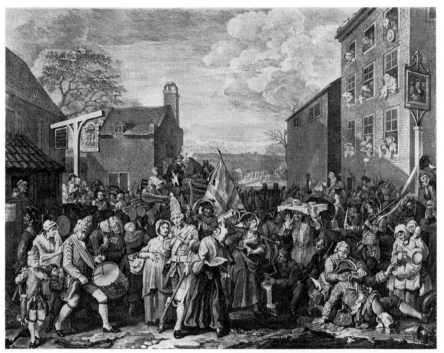

The March to Finchley

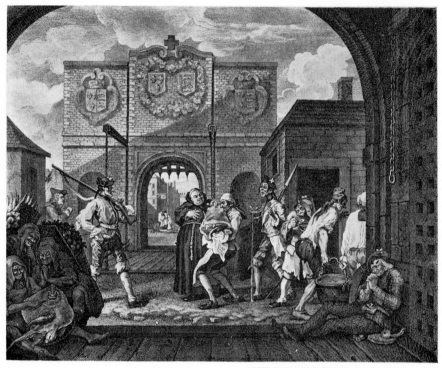

Calais Gate, or The Roast Beef of Old England

III

The relation of all this to Fielding becomes apparent once we turn to his early work for the theater. *Joseph Andrews* is a lively and realistic masterpiece, Hogarthian in spirit; but certainly Fielding had never ventured into this realm before. Prior to 1742 he had written some very funny burlesques and some indifferent drawing-room comedies; but from the first comedy, *Love in Several Masques* (1728), to his last dramatic burlesque, *The Historical Register* (1737), he created not a single real character. He never truly succeeded on the stage except with his dramatic burlesques, and the very nature of these pieces is caricature. In the personages of these plays Fielding mocks either specific individuals or contemporary types. *The Author's Farce*, for example, exhibits the Messrs. Marplay, father and son, whose name explains their profession. They are burlesques of Colley and Theophilus Cibber. *The Welsh Opera* is a comic version of the war between the prime minister, Walpole, and Pulteney. *Pasquin* and *The Historical Register* are in large measure political burlesques. Indeed it was universally conceded that Fielding had done much for the Opposition, and the Licensing Act of 1737 was passed to stop him. The most famous of all the burlesques, *Tom Thumb*, is a tragedy at which the audience is expected to laugh throughout. The extent of true characterization may be gauged by hearing those astonishing names of the two female leads, Dollalolla and Huncamunca. Almost as funny is another burlesque of the heroic drama, *The Covent Garden Tragedy*, written two years earlier. The amusing names of the chief characters – Stormandra, Kissinda, Lovegirlo – and the puerile contrivances of the denouement are sufficient indication of the nature of the piece.

One cannot in fairness cite these examples as proof that Fielding had not yet learned to draw characters, for, as he has said, the medium of burlesque is of course caricature. But one may certainly maintain that Fielding's prodigious success at this brilliant nonsense affected grievously his attempts at

character portrayal in straight comedy. The dramatic bur-
lesques are a sparkling potion indeed, but his comedies of
manners, where character would be a desideratum, for the
most part constitute a pretty flat dose. Patterned closely after
a far better playwright, Congreve, they contain some amusing
figures, but these are all well-worn comic types whose every
action may be predicted as soon as one sees the names: Sir
Avarice Pedant, Justice Squeezum, Lord Bauble, Captain
Spark, Mrs. Wisdom, Guzzle, Goodwill. Lady Charlotte
Gaywit in *The Modern Husband* is perhaps the most charm-
ing of the lot, but there is little originality or invention about
her simply because Fielding had not learned the difference
between character and caricature. His cousin, Lady Mary
Wortley Montagu, assured him that his Lady Charlotte was
"the picture of half the young people of her acquaintance," [4]
and that is exactly the fault. She is a parody of a common
contemporary type, the giddy yet innocent young scatter-
brain chasing after the pleasures of the town, but she has no
individuality whatsoever. The dramatis personae of these
plays, then, are all so conventional as to border on caricature,
and are certainly all wholly sterile.

That Fielding had learned the error of his ways before be-
coming a novelist is too obvious to require comment. The
situations and roles in *The Modern Husband* are exactly par-
alleled in his novel, *Amelia*; but although the characters do
the same things and in the main correspond to each other,
they are as different as the thorn from the rose. Fielding has
taken the flimsiest puppets and transformed them into mem-
orable men and women. What taught him to cast aside con-
ventional types of burlesque and caricature and to create
characters, individuals? Maturity had something to do with it,
and living under increased difficulties of various sorts. He
was thirty-five when his first novel was published, and had for
several years been doing the work of two or three men. His
marriage to Charlotte Cradock had been saddened by financial

⁴ *Tom Jones*, VIII, 1.

strain and continued ill health. Yet his creation of character was not entirely independent. One sure influence was the work of Hogarth, which any perusal of *Joseph Andrews* and *Tom Jones* will show that Fielding was studying closely. This is not at all surprising, for a study of the pamphlet literature reveals that Fielding was far from a pioneer in perceiving Hogarth's literary usefulness. And he had drawn occasionally from Hogarth during his playwriting career. When he came to compose a novel, to create a continuous story enacted by individual characters, he could find the recipe waiting for him in Hogarth. The story of Joseph Andrews and Parson Adams might even be called a progress. Before this Fielding had not had time to ponder the difference between character and caricature. His last regular comedy of manners during the decade, *The Universal Gallant*, opened in February of 1735, four months before *A Rake's Progress*. It is contrived in the same conventional and barren style of its predecessors, and obviously contains no real character. *Joseph Andrews* did not appear until 1742, ample time for Fielding to have formulated the new philosophy of composition set forth in the famous preface, a philosophy which he partially explains by direct reference to Hogarth's art.

In fine, all his comedies of manners were written without the influence of Hogarth, and are wholly barren; *Joseph Andrews*, however, burst upon the world in full flower of Hogarthian influence, and is one of the eternal marvels of English humor. I do not suggest that Hogarth alone is sufficient to account for the book; Fielding himself says on the title page that it is written in imitation of the manner of Cervantes, and modern scholars feel that it was influenced greatly by the Marivaux novel, *Le Paysan Parvenu*. Yet consider the Hogarthian element in the preface, consider that the two artists' outlook on life is much alike, that they portray the same people doing the same things, that they openly admire each other's work, and that they are close friends to boot; then it

seems certain that the younger and still unsettled learned from the older and eminently successful.

IV

We still want proof. Thus far, in speaking of Fielding's remarks in the preface to *Joseph Andrews* and of Hogarth's importance in the distinction between character and caricature, I have indicated in general the nature and scope of my argument. Before proceeding to develop it further, I shall endeavor to elucidate the matter by setting forth the actual debts of fact which Fielding, in his novels, owes to Hogarth. The simplest method will be to consider each novel in turn.

Hogarthian is the most suitable adjective to describe *Joseph Andrews*, even better than *Cervantean*. The spirit that pervades the book, from Fielding's first words on writing lives in general to the epic scene in Mrs. Slipslop's bed near the close, is thoroughly Hogarthian. At the very outset Fielding voices his irritation at the sham biographies currently in vogue, *Pamela* and Colley Cibber's *Apology*. Much more to his taste, plainly, were Hogarth's biographies of the harlot and the rake. Although there are few actual borrowings in incident from the prints, throughout *Joseph Andrews* specific references to Hogarth make it manifest that he runs often in Fielding's mind. After his words in the preface, it is not surprising that in his mind's eye he sees many of his scenes as pictures out of Hogarth. In the most prominent scene of the first book, the great moment when Joseph informs the lascivious Lady Booby that he cherishes his virtue, Fielding has occasion to remind his reader of Hogarth:

. . . no, not from the inimitable pencil of my friend Hogarth, could you receive such an idea of surprise, as would have entered in at your eyes, had they beheld the Lady Booby, when those last words issued out from the lips of Joseph.[5]

He pictures the scene as it would appear in a Hogarth print.

[5] I, 8.

At the end of the same book, he prefaces his description of the formidable Mrs. Tow-wouse with the following remarks:

And indeed, if Mrs. Tow-wouse had given no utterance to the sweetness of her temper, Nature had taken such pains in her countenance, that Hogarth himself never gave more expression to a picture.[6]

In all the novels, Hogarth is almost the only painter Fielding mentions, and certainly the only one he speaks of with any familiarity. His name appears even when Fielding is composing a humorous list of painters; Parson Adams is dozing as Joseph earnestly delivers numerous "Moral Reflections," among which is this observation:

. . . for when it hath been asked whose picture that was, it was never once answered the master's of the house; but Ammyconni, Paul Varnish, Hannibal Scratchi, or Hogarthi, which I suppose were the names of the painters.[7]

Although it is not until *Tom Jones* that Fielding admittedly borrows characters part and parcel from Hogarth's prints, for in that book he is bolder, yet he certainly finds in the prints as early as *Joseph Andrews* materials he can put to his own use. One of the particular incidents in the first book is that in which the stagecoach stops to examine Joseph, recently assaulted and now as naked as ever he was born. When this last bit of information is conveyed to the passengers within the stage, one of them, a lady of fashion, shrieks out, "O Jesus! a naked man! Dear coachman, drive on and leave him." Every reader will remember the lady's action as Joseph is at length allowed to approach:

Joseph was now advancing to the coach, where, seeing the lady, who held the sticks of her fan before her eyes, he absolutely refused, miserable as he was, to enter, unless he was furnished with sufficient covering to prevent giving the least offense to decency — so perfectly modest was this young man; such mighty effects

[6] I, 14.
[7] III, 6.

had the spotless example of the amiable Pamela, and the excellent sermons of Mr. Adams, wrought upon him.[8]

The lady, who is later discovered carrying a flask of Nantes (which she calls Hungary-water), may be found in the last print of *A Rake's Progress*. She is there with a companion, pretending not to see a naked Bedlamite, whom she is in reality avidly ogling from behind the sticks of her fan.

Another example, less striking only because he is a conventional type for whom Fielding need not necessarily resort to Hogarth, is Fanny's would-be suitor, Beau Didapper.

Mr. Didapper, or beau Didapper, was a young gentleman of about four foot five inches in height. He wore his own hair, though the scarcity of it might have given him sufficient excuse for a periwig. His face was thin and pale; the shape of his body and legs none of the best, for he had very narrow shoulders and no calf; and his gait might more properly be called hopping than walking.[9]

A figure remarkably similar to this is the beau in "Noon," the second plate of Hogarth's *Four Times of the Day*. This series Fielding knew very intimately, as may presently be seen. The hopping gait Hogarth underscores by the presence of a small boy at the right, who is slavishly imitating the mincing step of the beau.

It has not been pointed out, I believe, that both the history of Mr. Wilson in *Joseph Andrews* and the more famous story of the Man of the Hill in *Tom Jones* might well be called *A Rake's Progress*. Wilson's history follows Tom Rakewell's so closely that a debt to Hogarth is apparent. Like Tom Rakewell, Wilson deserts the university upon his father's death, and comes to town to acquire all the young rake's accomplishments: "namely dancing, fencing, riding the great horse, and music."[10] The masters in these very arts surround the rake in Hogarth's levee scene (Plate II). After a number of affairs with various women of the town (the milieu of Plate III), he

[8] I, 12.
[9] IV, 9.
[10] III, 3.

turns to gambling "where nothing remarkable happened, but the finish of my fortune" (Plate vi). Exactly like Hogarth's rake, he writes a play to repair his fortune, but eventually learns that his play "will not do" (to use Hogarth's own words in Plate vii), and so he is arrested for debt (Plate iv). It is while he is languishing in prison "in a condition too horrible to be described" (Plate vii) that Miss Harriet Hearty comes to his rescue, thus saving him from the final horror, Bedlam (Plate viii). It will be remembered that Hogarth's Sarah Young had also attempted, though vainly, to rescue her lover from the Fleet. Scholars have conjectured that something of Fielding's own career may be told in this history of Mr. Wilson,[11] but their evidence is singularly unconvincing. For example, he had begun writing plays before he entered the university, his father did not die, he did not take up the accomplishments of the rake, he was never in perilous poverty, and never in debtor's prison. Mr. Wilson's story probably owes more to Tom Rakewell.

In 1743, the year after *Joseph Andrews*, Fielding published *The Life of Mr. Jonathan Wild the Great*, which some critics believe to have been written first.[12] The entire history is enacted by thieves, rakes, harlots, bawds, and murderers – in short, by the same characters that people Hogarth's world. Their actions are the same. Moll Hackabout is committed to Bridewell, Tom Rakewell to the Fleet, Jonathan Wild to Newgate. Tom Rakewell ruins Sarah Young, Jonathan Wild strives energetically to ruin Mrs. Heartfree. Moll Hackabout entertains a young spark behind her keeper's back, Miss Laetitia Snap conceals her young lover at the same time that she accepts a handsome gift from Wild, her husband-to-be. All these parallels might possibly be mere chance, situations too common in mid-eighteenth century literature to be of any great significance; but it may be pointed out that they appear

[11] See Cross, I, 349.
[12] See an unsigned article in the literary supplement of the *London Times*, 14 August 1943, p. 396.

in Hogarth and Fielding before they appear elsewhere. Although there is a bitterness in the novel that is not often apparent in the work of the painter, the whole world of *Jonathan Wild* is the world of Hogarth; and the splendid comedy of the painter finds its match in the brilliantly sustained irony of the novelist.

Three incidents in the book are so remarkably like two Hogarthian scenes that they warrant especial notice. In the ninth chapter of the first book, Wild calls on the amiable Laetitia, for whom he has a violent attachment. She is in deshabille, and in this condition entertains him at tea. Soon he is inflamed to freedoms too offensive to the nice chastity of this gentle creature, who forthwith claws his face and cries out, "Damn your eyes, if this be your way of showing your love, I warrant I gives you enough on't." Wild has no sooner quitted the apartment than a young gallant named Tom Smirk steals from his hiding place in the closet and quite subdues the charmer. One is instantly reminded of the second plate of *A Harlot's Progress*, where the deshabille Moll has been entertaining the rich old Jew at the tea table, but has purposely got into a violent quarrel and is kicking over tea things, table and all. At the same moment her youthful spark is enabled to steal from his hiding place, behind her bed, toward the door, opened for him by the servant girl.

The second and third incidents and perhaps a hint from even a fourth in *Jonathan Wild* all relate to the same Hogarth print, the last but one of *A Rake's Progress*. In the second chapter of the third book, when the fair Laetitia, now Wild's wife, is committed to Newgate for picking pockets, she visits her husband's cell for the express purpose of harassing him. A fine illustration of this scene is the righthand side of the Hogarth print, where Rakewell's shrew has visited him for the same reason and is pouring billingsgate into his ears. There is a hint of this same scene when Laetitia visits Jonathan again on the eve of his apotheosis. Before she has railed for long, though, he catches her by the hair and applies his foot to the

sturdiest portion of her anatomy in such a way as to eject her, and quickly.[13] A few pages beyond the first of these incidents, Fielding describes a prison scene of a very different complexion, Mrs. Heartfree's visit to her imprisoned husband, She rushes into the cell, "all wild, staring, and frantic," and upon viewing her wretched husband faints dead away.[14] On the left side of the same Hogarth plate, the faithful Sarah Young has swooned at the sight of her former lover's condition, and is being attended by a number of the prison inmates. These scenes of course need not have come from Hogarth at all, but their close juxtaposition seems significant. Add to this the fact that the last of these scenes, as we shall soon see, is repeated in *Amelia*, and there is little room for doubt. And *Jonathan Wild* was written a very few years after the publication of *A Rake's Progress*.

In *Tom Jones*, Fielding lifts three of his characters bodily from the prints of Hogarth. Of Mrs. Bridget Allworthy, one of the finest characters he ever created, the author can only say that she was not remarkable for beauty. For the rest, the reader must turn to Hogarth:

I would attempt to draw her picture, but that is done already by a more able master, Mr. Hogarth himself, to whom she sat many years ago, and hath been lately exhibited by that gentleman in his print of a winter's morning, of which she was no improper emblem, and may be seen walking (for walk she doth in the print) to Covent Garden church, with a starved footboy behind carrying her prayer-book.[15]

This likeness of Mrs. Bridget appears in the first print of the series, *Four Times of the Day*, engraved in 1738.

Mrs. Partridge is also beyond Fielding's powers of description, or so he says:

This woman was not very amiable in her person. Whether she sat to my friend Hogarth or no I will not determine; but she exactly

[13] IV, 14.
[14] IV, 15.
[15] I, 11.

resembled the young woman who is pouring out her mistress' tea in the third picture of the Harlot's Progress.[16]

The third figure of importance in the novel who comes from a Hogarth canvas is Mr. Thwackum. The person of Square, says Fielding, was agreeable to Mrs. Blifil, but of the learned divine he says only this:

. . . the pedagogue did in countenance very nearly resemble that gentleman, who, in the Harlot's Progress, is seen correcting the ladies in Bridewell.[17]

When three important characters in the book always appear to the author's mind as from Hogarth's pictures, it is difficult not to assume that Hogarth exerted some influence on the composition of the whole. This assumption is heightened when we learn that Fielding often thought of his friend during the composition of the novel. He pays so many compliments to Hogarth that William Kenrick, writing in *The Scandalizade* the next year, calls him a jackanapes daring to recommend a lion. Certainly some of the casual references are unusual, and for that very reason the more significant. In discussing wisdom, for example, he brings in "Mr. Hogarth's poor poet . . . writing against riches," referring of course to the print of 1736.[18] Again, when Jenny Jones is called before Allworthy for examination in the matter of Tom's parentage, Fielding takes occasion to remark that some gossips "diverted themselves with the thoughts of her beating hemp in a silk gown." The unfortunate Jenny "they desired to have seen sacrificed to ruin and infamy by a shameful correction in Bridewell."[19] One can hardly doubt that, as he wrote this, Fielding was remembering the Bridewell scene in *A Harlot's Progress*, since Thwackum is admittedly copied from the guard in that very scene. The two warring whores in the bagnio episode from *A Rake's Progress* come to mind when

[16] II, 3.
[17] III, 6.
[18] VI, 3.
[19] I, 9.

Mrs. Partridge, pouncing jealously upon the innocuous Latin her husband speaks to Jenny ("Da mihi aliquid potum"), calls the girl "impudent whore," discharges a trencher of food at her head, and draws a knife with the intention of executing "very tragical vengeance."[20] The fifth scene from the *Harlot* discovers the two doctors engaged in hot dispute as their wretched patient expires. At the bedside of Captain Blifil this contumelious discourse is repeated. Making sport of physicians, few of whom he trusted, apparently amused Fielding as much as it did Hogarth. When Tom is wounded in the head at Hambrook, and later when Fitzpatrick is run through with Tom's sword, Fielding dismisses the attendant physicians with a smile perhaps indulgent but hardly kind.[21] In the two *Progresses*, the *Marriage à la Mode*, the final plate of *Four Stages of Cruelty*, and particularly in *The Company of Undertakers*, the medical profession fares very ill indeed at the hands of Hogarth.

One of the vigorous scenes in *Tom Jones* is that in which news of Sophia's disappearance is brought to Squire Western. Fielding sees it in terms of a picture:

Oh Shakespeare! had I thy pen! Oh Hogarth! had I thy pencil! then would I draw the picture of the poet serving-man, who, with pale countenance, staring eyes, chattering teeth, faltering tongue, and trembling lips . . . entered the room.[22]

Hogarth had drawn exactly such a servant in the last picture of the *Marriage*. Fielding's description here in every detail fits him like a glove. Since Fielding actually refers to Hogarth by name, it is probable that he had the picture of this quaking wretch in his head when he wrote the passage.

One is reminded again of Hogarth when Fielding describes the arrangements made by old Nightingale for his son's marriage:

In short, the old gentleman, and the father of the young lady

[20] II, 3.
[21] VII, 12; XVI and XVII.
[22] X, 8.

whom he intended for his son, had been hard at it for many hours; and the latter was just now gone, and had left the former delighted with the thoughts that he had succeeded in a long contention which had been between the two fathers of the future bride and bridegroom, in which both endeavoured to overreach the other, and, as it not rarely happens in such cases, both had retreated fully satisfied of having obtained the victory.[23]

This is certainly a perfect description of the two central figures in the contract scene from *Marriage à la Mode*; and this is the episode, of course, around which that whole tragedy was built.

Even when one makes allowances for situations common in the literature of the day, the evidence of Hogarth's influence is overwhelmingly strong. When he speaks of Jenny Jones beating hemp at Bridewell and dressed in a silk gown (not the usual Bridewell attire we should remember), Fielding is not necessarily thinking of Moll Hackabout dressed in a silk gown beating hemp at Bridewell; but since Thwackum is drawn from that very scene and Mrs. Partridge, Jenny's worst enemy, from the scene before, and since Fielding so frequently indicates an intimacy with Hogarth, the parallel is remarkable. Fielding has acknowledged his very considerable debt to Hogarth for three of his characters; it is natural to regard a number of striking parallels as further debt.

In Fielding's last novel, *Amelia*, there is no manifest indebtedness to Hogarth. The reason for this, one of the most revealing elements in any evaluation of Fielding's later work, will be considered in the last divisions of this chapter. Here I need only point out that in *Amelia*, according to his custom, Fielding compliments Hogarth from time to time. When he needs an artist's name, it is usually Hogarth's. For example, in the scene where Miss Matthews, in a transport of agitation, discovers to Booth that she has killed a man, Fielding comments:

Such indeed was her image that neither could Shakespeare de-

[23] XIV, 8.

scribe, nor Hogarth paint, nor Clive act a fury in higher per-
fection.[24]

Later on, when Booth describes to Miss Matthews the theft of
his Amelia's picture, he says:

. . . she knew that, next to Amelia herself, there was nothing
which I valued so much as this little picture; for such a resem-
blance did it bear of the original, that Hogarth himself did never,
I believe, draw a stronger likeness.[25]

The jackanapes is still at his recommending.

An amusing instance of Fielding's extravagant commenda-
tion of the painter is a passage which he omitted in revising
the novel after its initial failure. He had said that Dr. Harri-
son, the pious divine and friend of Amelia, lived very simply
in a house furnished with nothing unnecessary,

. . . except books, and the prints of Mr. Hogarth, whom he calls
a moral painter, and says no clergyman should be without all his
works, in the knowledge of which he would have him instruct
his parishioners, as he himself often doth.

This was carrying friendship too far; instruction in the works
of Mr. Hogarth could scarcely be considered one of the min-
ister's duties. The observation had to go.[26]

Beyond these there are no specific references to Hogarth,
but the prison scenes recall some of the pamphlets inspired by
A Harlot's Progress, pamphlets with which Fielding was un-
doubtedly familiar. Miss Matthews is mocked by the whores
at the jail, and later she entertains the whole company with
punch just like the harlot in *The Jew Decoyed.*[27] Both inci-
dents, however, were doubtless everyday occurrences at the
time. Amelia's fainting as she enters the prison cell and sees
her beloved Booth in confinement is singularly reminiscent of
that same seventh picture of *A Rake's Progress,* traces of
which we have seen in at least three scenes from *Jonathan*

[24] I, 6.
[25] III, 3.
[26] Cross, II, 354.
[27] See Chapter II.

Wild. This parallel hardly looks like mere accident. Finally, the chapter, "Containing a Brace or Doctors and much Physical Matter," left out of Murphy's edition of the collected works in 1762, describes another dispute between two physicians in the manner of that of Dr. Ward and Dr. Misaubin in the fifth picture of *A Harlot's Progress*. Notwithstanding, *Amelia* is definitely not Hogarthian in tone. The reason will shed considerable light on Fielding's debt to the painter.

V

Thus far we have observed Hogarth's part in the distinction between character and caricature, a distinction Fielding learns before he writes *Joseph Andrews*; and we have observed Fielding's actual borrowings from the pictures for his novels. We are now to examine the most important element in the works of the two artists, an element which links them more closely than any other—their conception of comedy. Since they are two of the very greatest comic artists, nothing is likely to reveal more about their genius. Fielding has conveniently set forth his ideas about comedy in the preface to *Joseph Andrews*; and though Hogarth never explained what he believed constituted comedy, it may be clearly inferred from a study of his pictures. Fielding, after intimating in his preface that he considers himself a comic writer in the same way that Hogarth is a comic painter, then proceeds to his well-known definition of the ridiculous:

The only source of the true Ridiculous (as it appears to me) is affectation . . . Now affectation proceeds from one of these two causes, vanity or hypocrisy: for as vanity puts us on affecting false characters, in order to purchase applause; so hypocrisy sets us on an endeavor to avoid censure, by concealing our vices under an appearance of their opposite virtue.

Affectation being the source of ridicule and the comic consisting in portraying these affectations was an old idea. Cervantes, Ben Jonson, and Steele had all noted it; or, to go back even farther, Fielding's revered master, Lucian, had built his

satires on the same foundation. But now Fielding proposed to go behind affectation and find its source. This, he decided, was always either vanity or hypocrisy. When this affectation is discovered, is unmasked, is stripped from its wearer, then we have the ridiculous.

From here he goes on to observe that the misfortunes and calamities of life, or the imperfections of nature, may become the objects of ridicule only when they are being covered with affectation. Ugliness, infirmity, or poverty are not ridiculous in themselves, but only when they ape grandeur. A dirty fellow riding through the streets in a cart is not funny, but if the same figure should alight from a coach and six, or spring from a sedan chair with his hat under his arm, we should laugh, and with justice. A quality in itself is not funny; it is only pretentiousness, affectation, that makes it so. A number of the characters in *Joseph Andrews* and *Tom Jones*, and to a lesser extent in *Amelia*, are constructed upon some affectation allied to vanity or hypocrisy, but few are exposed to ridicule at the end. Before discussing this phenomenon of Fielding's art, wherein his practice differs strongly from his avowal, we must examine briefly the practice of Hogarth.

Like Fielding, Hogarth was too level-headed ever to be hoodwinked by any form of affectation. He never lets slip the opportunity of exposing it as ridiculous. Yet the discovery of affectation through the exposure of vanity and hypocrisy does not seem, to my mind, to be Hogarth's primary definition of the comic at all. Indeed the only examples of hypocrisy exposed are the pictures of the harlot's funeral, the marriage scene in the *Rake*, the heavy-handed satire on Methodism called *Enthusiasm Delineated*, and some of the incidents of the *Election* series. Vanity is laughed at more often, as one should expect from a good-natured satirist, but even the list here is short: the levee scene in the *Rake*, the pompous earl and his son in the first scene and the musical group in the fourth scene of the *Marriage*, the feast at Guildhall and possibly the Lord Mayor's procession in *Industry and Idleness*,

the French beau in "Noon" (from *Four Times of the Day*), and the lean painter in *Beer Street*. A final example, *Taste in High Life*, was painted to order and cannot be judged like the others.

As for the *discovery* of affectation — that is, the unmasking of an affected person before the eyes of the other figures in the picture — this is not to be found in Hogarth even in a single instance. The reason for this may be put best as a simple question: how *could* a painter accomplish this discovery of affectation? Listen again to Fielding:

From the discovery of this affectation arises the Ridiculous, which always strikes the reader with surprise and pleasure; and that in a higher and stronger degree when the affectation arises from hypocrisy, than when from vanity; for to discover any one to be the exact reverse of what he affects is more surprising, and consequently more ridiculous, than to find him a little deficient in the quality he desires the reputation of.

To show this in painting is of course next to impossible, be-cause we do not know enough about the characters in a picture and cannot ever know enough about them, particu-larly about events or attitudes in their past, merely by looking at their facial expressions. Hogarth said, and showed in his painting, that the face is the index of the mind, but it cannot reveal an entire biography. In other words, one difference between Fielding's theory and Hogarth's pictures arises from a difference in medium. The painter can never achieve the same elaboration of character that the writer can. Hogarth speaks of this in the *Analysis of Beauty*, published the year before Fielding's death:

. . . but the bad man, if he be an hypocrite, may so manage his muscles, by teaching them to contradict his heart, that little of his mind can be gathered from his countenance, so that the char-acter of an hypocrite is entirely out of the power of the pencil, without some adjoining circumstance to discover him, as smiling and stabbing at the same time, or the like.

This principle Fielding recognizes in his distinction between burlesque and true comedy:

Now, what Caricatura is in painting, Burlesque is in writing; and in the same manner the comic writer and painter correlate to each other. And here I shall observe, that, as in the former the painter seems to have the advantage; so it is in the latter infinitely on the side of the writer; for the Monstrous is much easier to paint than describe, and the Ridiculous to describe than paint.

Coming as it does at the beginning of a eulogy on Hogarth's lifelike characters, and his eschewing of caricature, this must be taken as a subtle compliment to one genius from another.

It would appear, then, that Hogarth's work has little to do with Fielding's *theory* of the ridiculous, that his comedy does not arise from the exposure of affectation. But this by no means closes the issue; and certainly it does not mean that Fielding owes little to Hogarth. On the contrary, since the spirit of the two artists' work is so very similar, it forces us to put Fielding's theory to test, to revaluate the essence of his comedy; and this will lead to an infinitely clearer picture of it and a far less restricted one than Fielding himself has given in the preface to *Joseph Andrews*. In other words, we must ask ourselves if the exposure of affectation is really the quintessence of Fielding's humor. The answer I believe is no, but in order to see this it will be necessary to recall what the substance of Hogarth's comedy is.

Most definitions are to some extent compromises, the best possible settlements in a world where limitations and distinctions are infinite. Thus to say that Hogarth's comedy is built upon incongruity, or consists in incongruity, is perhaps not to include every element of the comic; on the other hand, it is in some ways such an all-inclusive definition as not to be sufficiently distinctive. Yet if we examine in some detail one of the better Hogarth pictures, the nature of the comedy becomes plain, and will serve as a clear commentary upon the definition and upon the similarity between Hogarth and Field-

ing. Incongruity arises when two things fundamentally unlike and incompatible are yoked together. The result is surprise, the keynote of the incongruous. The surprise may arise from a number of things — incongruous actions, for example, or exaggeration in expression.

Incongruity is the foundation of the comedy in the richest of all Hogarth prints in surprise, the *March to Finchley*. The print is full to overflowing with people and actions, an exaggeration of numbers, and all these are presented with unexpected twists. The scene is laid in the thoroughfare between the Adam and Eve and the King's Head, two notorious public houses on Tottenham Court Road. The foot guards are here represented on the way northward to their camp at Finchley. The year is 1745, the time of the Scotch Rebellion, which should arouse all the noblest patriotic instincts in the English soldier. Yet instead of a band of heroes devoting their lives to their country's service, we find a shouting, seething rabble that would awaken the seven sleepers. The comedy of the print is due not merely to the presence of a fat and prosperous madam who appears at one of the windows of the King's Head, her thriving brothel, for that is no great matter of surprise, but to the fact that she has lately turned Methodist and, with hands clasped toward heaven, is piously praying for the safe return of her best customers. We may smile at an officer who, taking advantage of the general hurly-burly, steals a kiss from the not unwilling milkmaid, but the surprise that brings a laugh is a jolly rogue who takes advantage of the girl's preoccupation to fill his hat with milk from her pail. We are not surprised that another soldier directs the attention of the grinning pieman to the incident, but we laugh to see him seize this opportunity to appropriate some of the pies. Comedy arises not from a tipsy soldier's being offered a drink of water, but from the fact that he scorns it and turns to a sturdy camp follower for more gin; not from the mere crying of the wizened babe at the woman's back, for that is a time-honored means of transportation and the babe might well be frightened

at all the uproar, but from the fact that it is crying for the same draught of spirits; not from the frightened chicks running wildly about in search of their vanished mother, but from the fact that she reposes incongruously in a soldier's pocket. We are amused at the central group in the foreground of the picture not because a soldier is distressed at parting from his mistress, but because he has two mistresses who are harassing him simultaneously. The ridiculous exaggerations, but not caricatures, of countenance and attitude seen even better in the levee scene from the *Marriage*, also contribute to the comedy of the print.

But although we may be surprised at the incongruous actions of the *March to Finchley*, and be amused at the exaggerations both of number and of countenance, we have failed to savor the best of the comedy until we are conscious of the satire of the entire conception — that is, of the incongruity between what a group of soldiers on their way to duty amid a grave national crisis *should* be doing, and what under Hogarth's pencil they *are* doing. Of the satire in other prints it is unnecessary to speak.

A study of theories of comedy and humor during the century reveals that nearly all writers regarded incongruity as the source of the comic.[28] Since many of these theorists, especially in the first half of the century, were themselves eminent contributors to comic literature — Pope, Congreve, Farquhar, Fielding — we find that actual practice was in accordance with theoretical pronouncement. Of course Fielding's theory of the ridiculous rests upon incongruity. But by limiting himself to the exposure of affectation he does not, as we shall see, make anything like a full application of the term. Hogarth, proving no theory of the ridiculous, worrying about neither vanity nor hypocrisy, is content merely to take the simple ingredients of life, to spice them by heightening certain features for

[28] See, for example, John W. Draper, "The Theory of the Comic in Eighteenth-Century England," *Journal of English and Germanic Philology*, XXXVII (1938).

purposes of comedy and satire, and to serve them up to his public for whatever delectation they may derive from them.

Now Hogarth's practice is clearly different from Fielding's carefully formulated theory set forth in his famous preface. Indeed, one would expect the novels, regulated by his omnipresent theory, to smack of the artificial, a charge which could never be brought against Hogarth. But if, after reading *Tom Jones* and *Joseph Andrews*, one asks whether the spirit of those books is actually different from the painter's work, the answer must certainly be no, it is just the same. Moreover, the elements of comedy that have been noted in the *March to Finchley* are the very essence of Fielding's comedy as well. At a first hasty glance the multiplicity of characters and action in *Tom Jones*, once the story has taken to the road, suggests a chaos just like the wild disorder of the *March to Finchley*. Coleridge has pointed out, however, what everyone now recognizes — that the structure of *Tom Jones* is well-nigh perfect, one of the marvels of English fiction. Likewise, in the field of painting, there has seldom been a more ordered chaos than that of the *March to Finchley*. All the bursting activity of the picture is carefully balanced around the central group and is regulated by a conscious artistry that few masters have surpassed. In fact, "bursting with activity" might be the happiest phrase for a general characterization of the entire work of both Hogarth and Fielding.

Typical scenes come instantly to mind. Forgetting for the moment all about the discovery of affectation, we may examine some of these scenes from Fielding merely to discover their Hogarthian qualities. After that, we may test them by Fielding's theory to see how well they conform to it. Parson Adams, interfering in a quarrel between an innkeeper and his wife over Joseph Andrews, gets a pan of hog's blood full in the face for his trouble, but is saved from worse by the arrival of Mrs. Slipslop, who enters the fray with the fury of a Thalestris.[29] All the elements of Hogarth's incongruity are

[29] II, 5.

found in profusion in this scene, a hilarious satire on the
folly of mortals. The incongruity of a parson's leaping pell-
mell into a bloody fist fight is matched by the surprise of the
hitherto genial landlady's sudden inspiration to hurl a pan full
of hog's blood at him. Fielding exaggerates the results: a
"large stream" flows down Adam's person, so that "a more
horrible spectacle was hardly to be seen, or even imagined."
When Slipslop rushes into the breach, she with one swoop
pulls out a whole patch of the hostess's hair and gives her at
the same moment several hearty cuffs in the face; which (and
here is Fielding's genial derision) "by frequent practice on
the inferior servants, she had learned an excellent knack of
delivering with a good grace." As the poor woman begins to
roar, surprise and exaggeration are mingled, for the ranks are
swelled not only by several ladies newly arrived by coach, but
also by two road acquaintances of Adams's, and by a traveller
just returned from Italy, who excitedly comments upon the
whole in an Italianate English. The final note of surprise is
achieved when the innkeeper turns furiously upon his wife,
who was defending him all along, damning her for wasting
the hog's puddings, "and telling her all would have been very
well if she had not intermeddled, like a b—— as she was;
adding, he was very glad the gentlewoman [Slipslop!] had
paid her, though not half what she deserved." Small wonder
that Hogarth admired this book. The same strands of surprise,
exaggeration, and genial derision may be traced in the parallel
scene from *Tom Jones*, the battle in the inn at Upton.[30]

Later Adams is subjected to the most vigorous indignities
by Parson Trulliber, who mistakes him for a dealer in hogs.[31]
Adams, who came to ask for a loan of money from Trulliber,
is forced to enter the sty to examine the stock. The entire
scene is a scathing satire on Trulliber, and a gentle one on the
naïvete of Adams. Trulliber's rudeness and Adams's misfor-
tunes are both somewhat exaggerated. And at every hand there

[30] IX, 3.
[31] II, 14.

are touches of incongruity and surprise, not the least of which is Adams, in the midst of the hog-sty, covered with mire from head to foot, desperately calling out: "Nihil habeo cum porcis"!

The humor of the parson's "roasting" by the fox-hunting squire is easily imagined merely by reading the extempore poem composed by one of the squire's cronies:

> Did ever mortal such a parson view?
> His cassock old, his wig not over-new,
> Well might the hounds have him for fox mistaken,
> In smell more like to that than rusty bacon;
> But would it not make any mortal stare
> To see this parson taken for a hare?
> Could Phoebus err thus grossly, even he
> For a good player might have taken thee.[32]

The squire and his rowdy, cruel companions are depicted as heartless rogues from their first appearance. There is no sudden unmasking or discovery of affectation.

The final example from *Joseph Andrews*, one of the funniest scenes in all literature, takes place in and about Mrs. Slipslop's bed. That lady, having made a small slip in her youth, had remained a good maid until middle life. Then she decided that by so long a self-denial she had not only made amends for the slip, but had likewise laid up a quantity of merit to excuse any future failings. Besides, she thought she was old enough to indulge in any liberties with a man, with no danger of bringing a third person into the world to betray them. Accordingly, when Beau Didapper invades her bed, thinking it Fanny's, she, thinking him Joseph, receives his embrace with an ardour far beyond his expectations. They soon discover their mistake, but Slipslop, refusing to let him go, roars out: "O thou villain! who hast attacked my chastity, and, I believe, ruined me in my sleep; I will swear a rape against thee, I will prosecute thee with the utmost vengeance." When the beau struggles to leave, she shrieks, "Murder! murder! rape! rob-

[32] III, 7.

bery! ruin!" Hearing this from his room next door, the naked Parson Adams dashes wildly into the chamber, pounces upon the bed, and seizes what he thinks is her seducer, only to discover that he has the charmer herself. He mistakes her sex because of the rough beard on her chin, and fights with her for several minutes until, just before the lights are brought, he discovers that she is a woman. It is needless to point out the elements of surprise in this scene, for everything is surprising, nor how Fielding has exaggerated nearly every circumstance for comic effect. Our feeling of amused superiority to the three principals is obvious, but the best satire of all is in Mrs. Slipslop's admirable recovery when she discovers that she is to be denied the pleasures she had anticipated, but may yet make the whole affair look like an attack upon her virtue.

Now that we have recalled four thoroughly typical comic scenes from *Joseph Andrews*, and have observed how closely they follow the pattern of comedy we saw in Hogarth's prints, we may ask how faithfully they fulfill Fielding's theory of the ridiculous set forth in his preface. In the first place Fielding is to build his characters around some affectation arising from vanity or hypocrisy. Immediately many characters from *Joseph Andrews* come to mind, the best of whom are tinged with hypocrisy: Lady Booby, Mrs. Slipslop, Peter Pounce, Parson Trulliber, and a number of minor personages. The three principal figures in the book, however, will not conform at all. Surely there is no affectation about either Joseph or his sweetheart Fanny, though Fielding, had he not been mocking *Pamela*, might easily have turned Joseph's declarations of virtue to Lady Booby into hypocrisy. Of course neither Joseph nor Fanny is particularly comic, and they might be dismissed from consideration. Parson Adams is different. He is the really great comic creation of the book, probably the greatest in Fielding, and his humor arises from the same source as that of Don Quixote — the incongruity between things as they appear to the ordinary man and as they appear to one who receives his knowledge of the world

chiefly from books. This is certainly not affectation, nor does it have anything at all to do with either vanity or hypocrisy. In *Tom Jones* the same is true. Some of the characters are hypocrites — Bridget Allworthy, Thwackum, Square, Mrs. Honour, Black George, Mrs. Waters (at Upton), Lady Bellaston, and Blifil — but of that group not all may be called comic. A great many of the characters, often the most important ones, are not affected at all, and this list includes at least one of the superb comic creations of literature: Tom, Sophia, Allworthy, Squire Western, Ensign Northerton, Mrs. Miller, and others.

Affectation is but the source of the ridiculous; the ridiculous actually appears only when this affectation is discovered or unmasked. It is here, the crux of the theory, that it seems to me the entire structure breaks down; for the scenes that are most comic in Fielding, the scenes we remember most vividly, depend very little upon the exposure of affectation. Mr. Cross has said, "The same theory of humour underlies both novels. The characters are mainly built upon some affectation flowing from hypocrisy or vanity, and they are all unmasked in the end." [33] He said earlier, "In the end they all betray themselves through some incident or remark when they are taken off their guard." [34]

It seems impertinent to confute Mr. Cross's vast authority, but very few characters are unmasked in the end. In *Joseph Andrews* the only figures of any note who are unmasked are Lady Booby, Peter Pounce, and Trulliber. In the scenes we just examined, the exposure of affectation contributes very little indeed to the comedy. Except in the Trulliber scene (the funniest part of which is Parson Adams), the unmasking of affectation does not even appear. Mrs. Slipslop, for example, though certainly a hypocrite, is not unmasked in the great bedroom scene at the end. Far from it, she makes the whole affair look like an attempted rape that at her age will

[33] II, 206.
[34] I, 336.

redound enormously to her credit. Fielding speaks of the surprise which strikes the reader when he discovers anyone to be the exact reverse of what he affects. But most of his characters Fielding exposes to his readers in the very first paragraph in which they appear. We are surprised when Trulliber turns out to be a skinflint, and Peter Pounce tries to be a braggart and a miser simultaneously; but most of the characters are unmasked for the reader at the start and there is no discovery of affectation at the end.

Tom Jones is plenteously supplied with episodes as spirited as the four we examined from *Joseph Andrews*. Squire Western, in his cups or on the hunt, is ever bursting with activity and incongruity. All the events at Upton, whether they involve the landlady, Mrs. Honour, Mrs. Waters, Fitzpatrick, or Tom, or all of them at once, are teeming with liveliness and with these same ingredients of Hogarthian humor. I can remember not a single instance here of affectation unmasked. When Tom is discovered in Mrs. Waters's room, she, like the good Slipslop, exhibits the same admirable presence of mind:

Jones was so confounded with his fears for his lady's reputation, that he knew neither what to say or do; but the invention of women is, as hath been observed, much readier than that of men. She recollected that there was a communication between her chamber and that of Mr. Jones; relying, therefore, on his honour and her own assurance, she answered, "I know not what you mean, villains! I am wife to none of you. Help! Rape! Murder! Rape!" And now, the landlady coming into the room, Mrs. Waters fell upon her with the utmost virulence, saying, "She thought herself in a sober inn, and not in a bawdy-house; but that a set of villains had broke into her room, with an intent upon her honour, if not upon her life; and both, she said, were equally dear to her." [35]

The most celebrated passage perhaps in the entire novel, the wild battle between Molly Seagrim and the other wenches in the country churchyard, is compiled of surprise and incon-

[35] X, 2.

gruity, exaggeration and overstatement, and a derisive superiority.[36] Molly's pretensions to grandeur are punished, but the comedy is due not to the fact of her exposure, but to the wild bumptiousness of the actions and to Fielding's burlesque style. Part of the exaggeration here is in the mock-heroic style, for which Hogarth obviously has no equivalent, but the incidents are thoroughly Hogarthian. The only hilarious episode in *Tom Jones* in which a hypocrite is unfrocked (and literally) is in Tom's discovery of Mr. Square in Molly Seagrim's chamber.[37] The exposure of Blifil is not funny, nor is the posthumous unmasking of Mrs. Bridget.

As a postscript to the painter's comedy, we glanced at its appeal to sex. Another postscript will serve to cover the same element in Fielding. A more talented writer might indeed compose a Homeric catalogue of the frailties of the flesh in Fielding's novels. Besides a bevy of unclothed women — Molly Seagrim, Mrs. Waters, Lady Booby, and Slipslop, to name the most conspicuous — many of the scenes have sexual significance: the Potiphar's wife episode between Joseph and Lady Booby, the stagecoach scene wherein Joseph arrives naked, every scene in which Slipslop is left alone with a man and some in which she is not, the various rencontres with Molly in *Tom Jones* climaxed by the great moment of Mr. Square's unfrocking, the adventures of the night at Upton, Tom's first meeting with Lady Bellaston at the masquerade, and countless others. These scenes are the sort that are found over and over again in Hogarth. Indeed, the celebrated episode of Partridge at the play should not be separated from its obvious complement, Hogarth's *Laughing Audience*. Most of these scenes and others like them, the scenes that delight us most in Fielding, the scenes that linger in the memory as the most typical expression of his genius, depend very little indeed on the exposure of affectation.

It should now be obvious that Fielding does not adhere to

[36] IV, 8.
[37] V, 5.

his theory of the ridiculous in his novels, that there is a disparity between theory and practice. Of course this is a not uncommon mortal failing and no cause for disparagement. For another example, in the same preface Fielding holds that tragedy "sets the highest before us"; its theme should be the great and admirable. Yet in the prologue he wrote for his friend Lillo's *Fatal Curiosity* he defends domestic tragedy and seems to repudiate the tragic hero:

> No fustian hero rages here tonight;
> No armies fall, to fix a tyrant's right:
> From lower life we draw our scene's distress; —
> Let not your equals move your pity less!
> Virtue distrest in humble state support;
> Nor think she never lives without the court.

Though we can respect Fielding's Aristotelian dictum about tragedy, we can also recognize tragic elements in "virtue distrest in humble state." His inconsistency is thoroughly understandable.

Fielding, then, transcends his theory. This is certainly no discovery of mine, though I know of no other analysis of the way in which his theory fails in *Joseph Andrews* and *Tom Jones*. Mr. Cross, having just observed that the characters are all unmasked in the end, confutes himself by saying, "Fielding's notions were sound enough so far as they went; and when they failed him, he disregarded them, as a wise man should, and followed the natural bent of his genius, which was certain to lead him aright." [38] And Miss Ethel Thornbury in her study of Fielding has said, "His own comedy is richer than his theory of comedy." [39] She goes on to say, however, that Fielding, like Meredith, excludes satire from the comic, a position which seems utterly untenable for both men.

Fielding recognizes in his novels, like Hogarth in his prints, that incongruity lies at the heart of laughter. Though Field-

[38] I, 341.
[39] *Henry Fielding's Theory of the Comic Prose Epic* (Madison, 1931), p. 160.

ing does not take it this far, his theory might even be held to imply this incongruity. There is incongruity between what an affected individual professes and what he actually is; most artists depicting affectation, particularly hypocrisy, rely on exaggeration; and finally derision or satire is always directed at the affected person. In other words, while incongruity is at the root of affectation, Fielding's theory, by limiting the comic to affectation alone, is far too narrow to embrace his practice. His practice is exactly like Hogarth's, but his theory does not say so. My purpose has been not to disparage his theory, but to make clear the relation of his comedy to Hogarth, a relation far more revealing than the relation to unmasking affectation. In the light of Hogarth, we have been forced to revaluate both Fielding's theory and his practice of the ridiculous, and, I believe, to get at a truer picture of the nature of *Joseph Andrews* and *Tom Jones*. In other words, the prints of Hogarth give us an infinitely clearer conception of the lifeblood of Fielding's two immortal novels than does his own preface.[40]

VI

Although the unmasking of affectation plays no great part in Fielding's procedure, we have seen that a great many of his characters are built around some affectation, whereas in Hogarth affectation seldom appears. Thus the question still remains: why is the effect the same when we have seen that the two artists proceed on different tacks? The answer is simple. Affectation is often the cornerstone of Fielding's structure of plot and character, but in the execution it never gets in the way. Though one expects Fielding's art to be more artificial than Hogarth's, this is not the case; for certainly Fielding works not from theory to observation, but from observation

[40] Fielding, being a writer, is able to indulge in one type of comedy that is denied the painter — understatement. Some of his finest touches are achieved through this matter of style: he slyly smiles and says too little. One of the most brilliant examples is the sentence in *Jonathan Wild*: "He in a few minutes ravished this fair creature, or at least would have ravished her, if she had not, by a timely compliance, prevented him."

to theory.[41] The preface to *Joseph Andrews* is clearly *ex post facto*; it explains certain things about comedy, but it explains only partially what makes *Joseph Andrews* comic. Nearly every sentence of the preface reveals that the book had already been completed. The effect of the two artists is the same not because of any theory but because they both copied only what they had seen and experienced in life. That is a simple answer but surely the right one. In his preface Fielding expresses a sentiment he many times reiterates:

Everything is copied from the book of nature, and scarce a character or action produced which I have not taken from my own observations and experience.

Dr. Johnson, in his Dictionary, defines nature as "Sentiments or images adapted to nature, or conformable to truth and reality," and quotes the celebrated line from Pope, "Nature and Homer were, he found, the same." This definition, which I have used throughout, includes not only real and objective existence, the external world of mind and matter, but human nature as well. Even though Fielding sometimes fails — as with Blifil, for example — the justice of his claim of fidelity to this nature cannot be gainsaid.

Hogarth, as he himself often boasted, was the first British artist to follow the same rule, to "copy from the book of nature," to paint not an idealized conception, but the reality itself. This explains why he had scant success as a portrait painter. To realize the impression this would have made on Fielding one has only to list the painters contemporary with and immediately preceding Hogarth. It is significant that Fielding consciously linked himself with Hogarth in this very respect in one of the essays on writing which interlard the panorama of *Tom Jones*, an essay asserting the futility of imitating fashionable or classic authorities, and the necessity of first-hand observation:

Vanbrugh and Congreve copied nature; but they who copy them

[41] See Cross, I, 341.

draw as unlike the present age as Hogarth would do if he was to
paint a rout or a drum in the dresses of Titian and of Vandyke
. . . The picture must be after Nature herself.[42]

What plainer indication that Fielding was distinctly conscious
of the bond between himself and his friend and fellow ar-
tist?

This bond they shared with few, if any, of their contem-
poraries. So closely did they follow the book of nature that
many of their characters were actual people. We have already
seen Hogarth's penchant for incorporating real people, usu-
ally scandalous ones, into his work. Some of these figures
were introduced for satire, others merely to lend an air of
reality to fiction.[43] Whatever his purpose, it made some of his
prints read like the morning newspaper; the fictional histories
of Moll Hackabout and Tom Rakewell had the atmosphere
of actual biography. The effect of all this on the sales of the
prints can be easily imagined. It was new, sensationally new,
and naturally opened a whole fresh expanse for the writer of
fiction. Later Smollett followed Hogarth's lead much more
avidly than Fielding, especially in the characters he intro-
duced to satirize, but throughout *Joseph Andrews* and *Tom
Jones* one meets many familiar contemporary names. Field-
ing is the first novelist to adopt this device of Hogarth's.

In contrast to Smollett, he introduces real people princi-
pally to create the impression of biography. One of the most
striking instances is found early in *Tom Jones*, where Tom
and Partridge stop at the Bell in Gloucester.

[42] XIV, 1. It is easy to see how Fielding has changed since the days of his
drawing-room comedies.

[43] In *A Harlot's Progress*, for example, Mother Needham in Plate 1 and
the reference to James Dalton in Plate III are there for realistic more than
satiric effect. Dalton had died in 1730 and Needham the following year.
Colonel Charteris, on the other hand, was still infamously alive when Hogarth
painted the series, and is doubtless introduced satirically. The last scene is
made much more real by the presence of the well-known quean Elizabeth
Adams. In the third scene of *A Rake's Progress*, Hogarth was probably not
bent upon satirizing Leathercoat, the porter of the Rose Tavern in Drury
Lane, but the biographical illusion is achieved.

The master of it is brother to the great preacher Whitefield; but is absolutely untainted with the pernicious principles of Methodism, or of any other heretical sect. He is indeed a very honest plain man, and in my opinion, not likely to create any disturbance either in church or state. His wife hath, I believe, had much pretension to beauty, and is still a very fine woman . . . She is at present as free from any Methodistical notions as her husband; I say at present; but she freely confesses that her brother's documents made at first some impression upon her, and that she had put herself to the expense of a long hood, in order to attend the extraordinary emotions of the Spirit; but having found, during an experiment of three weeks, no emotions, she says, worth a farthing, she very wisely laid by her hood and abandoned the sect.[44]

Later, after the frisky night at Upton, Fielding has occasion to mention the manner of Sophia's conveyance there:

The coach which had brought the young lady and her maid, and which, perhaps, the reader may have hitherto concluded was her own, was, indeed, a returned coach belonging to Mr. King of Bath, one of the worthiest and honestest men that ever dealt in horse-flesh, and whose coaches we heartily recommend to all our readers who travel that road. By which they may, perhaps, have the pleasure of riding in the very coach, and being driven by the very coachman, that is recorded in the history.[45]

There are many other examples in the book, all of which contribute wondrously to the illusion of reality.[46]

Closely allied to the use of actual people in fiction is the use of actual places. The former usually presupposes the latter. In Wheatley's book entitled *Hogarth's London*, there are few places in the city that do not sooner or later appear. A great number of the prints, especially exterior scenes, are carefully localized. The first plate of *A Harlot's Progress*, for example, is set outside the Bell Inn in Wood Street, and the fourth at Bridewell. The midnight shrine of *A Rake's Progress*, Plate III, is the Rose Tavern in Drury Lane; in the

[44] VIII, 8.
[45] X, 6.
[46] See Cross, II, chapter 19.

next scene, that of the arrest, St. James's Palace and White's Chocolate House appear; the rake marries at the church at Marylebone. When he loses his fortune in the gambling den of the next scene, he is oblivious of the fire which has broken out in the back of the room. Such a fire really occurred at White's Chocolate House on 2 May 1733, when Hogarth was engaged upon the series.[47] The seventh picture represents the Fleet, the eighth Bedlam. Each scene of *Four Times of the Day* is precisely located. So are several scenes from *Industry and Idleness*. The last, for instance, is laid at the east side of St. Paul's church, just turning into Cheapside. For this carefully realistic localization one looks to earlier painters in vain.

In *Tom Jones* Fielding also took the same care with his places. The hero's itinerary can be traced through Hambrook, Gloucester, Upton, Meriden, Coventry, to London. On the road he stops at a number of actual inns, for which Fielding sometimes has a word or so of praise:

Being arrived here [Gloucester], they chose for their house of entertainment the sign of the Bell, an excellent house indeed, and which I do most seriously recommend to every reader who shall visit this ancient city.[48]

When the novel reaches London, the scenes are again carefully specified. Tom's lodgings are in Old Bond Street, his first rendezvous with Lady Bellaston is in a house near Hanover Square, and he later spends nearly a week in Westminster jail. Many years ago, in his *Development of the English Novel*, Mr. Cross pointed out that before Fielding the localization of scene troubled neither storyteller nor reader; Arcadia would do.[49] The part this reality plays in producing the effect of a great comic epic is obvious.

This depicting of actual life, even to the point of keeping certain actual acquaintances in mind as he was drawing his

[47] John Ireland, I, 53n.
[48] VIII, 8.
[49] *Development of the English Novel* (New York, 1899), p. 46.

characters,[50] has far more to do with the success of Fielding's art than any theories he might have devised or learned from books. Recent scholars have attempted to show where Fielding got his ideas by a study of the books in his library. This can never reveal how the characters came to life, for it is an artificial method of creation, and though Fielding obviously drew hints from his book learning he is no more bound by it than he is by his theory of the exposure of affectation. In the introduction to the fourteenth book of *Tom Jones* he takes great pains to point out this very fact. The great difference to Fielding's mind between Hogarth and the books in his library was that Hogarth was no "source," he was nature herself. The highest compliment that can be paid to authors, he says, is that they "have been so capable of imitating life, as to have their pictures in a manner confounded with or mistaken for the originals." [51] That this is the way he regarded Hogarth is easily proved, for, after insisting repeatedly that "we should ever confine ourselves strictly to Nature," he lifts bodily three of the characters in *Tom Jones* from Hogarth's prints.

> But when t'examine every part he came,
> Nature and Hogarth were, he found, the same.

Whether Fielding consciously realized this or not is a matter of no importance; the result is seen in his work. And of course Hogarth was even easier to follow than nature, for he had already made that artistic selection, had given that form to the chaos of experience, which is essential to any true work of art.

Thus, with Hogarth and Fielding, characters, settings, events, and manner of presentation all are embedded in actual life; all have the spirit of biography rather than fiction. This cannot be said of any of their famous contemporaries, not of Colley Cibber, nor of Lillo, nor of Richardson. Richardson is writing the sentimental *Pamela* in the same decade that Ho-

[50] Cross, *The History of Henry Fielding*, I, 344.
[51] *Tom Jones*, VII, 1.

garth paints the two *Progresses*. Fielding refuses to idealize his characters in the manner of Richardson: Tom Jones's illegitimacy is a triumph of realism over romanticism. Until the advent of Smollett, Hogarth and Fielding alone present common life as it is, with enough of the better nature to chase away and disperse the contagion of the bad.[52] They both, in the words Lamb wrote to describe Hogarth, "prevent that disgust at common life . . . which an unrestricted passion for ideal forms and beauties is in danger of producing."[53] And no one will deny that they came when they were needed most.

Because this was all so new, it naturally caused some confusion at first. The comedy and scandal of Hogarth's prints made them popular from the very beginning, but *Joseph Andrews* mystified a public who did not know quite how to take a novel based upon English life and manners. Though it was admirable in its characters and observations, it seemed to a public nourished on French romances to lack invention and contrivance.[54] *Joseph Andrews* was widely read, but it could never keep up with the popularity of *Pamela*. As Mr. Cross has remarked:

A novel that deals seriously with a risky situation is sure to have many more readers than one that parodies that situation. For a sober narrative with a moral purpose, real or affected, is understood by everybody; whereas humour and irony perplex the average mind.

It is notable that one person who approved of *Joseph Andrews* wholeheartedly and without reservation was Hogarth. The most celebrated contemporary tribute to the novel is his little sketch known as *Characters and Caricaturas*, which

[52] Defoe of course presents very real settings and events, but since his work is without characters it must always fall short of being a full-rounded picture of actual life.

[53] *Reflector*, II (1811), 77.

[54] I draw here from Mr. Cross, who has given a full account of the contemporary reception of *Joseph Andrews* in *The History of Henry Fielding*, I, 354ff.

directed the reader's attention to the preface of *Joseph Andrews* where he would find more about the important distinction between character and caricature.

VII

Thus far I have indicated what I believe to be the very intimate relationship between the comedy of Hogarth and Fielding. There remains one other side of the painter's connection with the novels, however — a totally different one from what we have examined before. It is that perilous issue, morals, and chiefly involves Fielding's last novel, *Amelia*. The evidence is extremely interesting because it is for his moral lessons that Fielding praises Hogarth most ardently, and to include these in his own art that he modifies his theory and practice of the ridiculous before writing *Amelia*. Thus the final consideration is a just complement to our examination of the comedy of *Tom Jones* and *Joseph Andrews*.

As early as 1740 Fielding had lauded Hogarth for his splendid moral lessons:

I esteem the ingenious Mr. Hogarth as one of the most useful satirists any age hath produced. In his excellent works you see the delusive scene exposed with all the force of humour, and on casting your eyes on another picture, you behold the dreadful and fatal consequences. I almost dare affirm that those two works of his, which he calls the Rake's and the Harlot's Progress, are calculated more to serve the cause of virtue, and for the preservation of mankind, than all the folios of morality which have ever been written, and a sober family should no more be without them, than without the Whole Duty of Man in their house.[55]

These are commendable sentiments and doubtless sincere; but Fielding's implication that this is what he most admires in Hogarth's work — and he never elsewhere praises him in quite such glowing terms as these — must for a number of reasons be taken with a grain of salt. The evidence will not support it. What an author says is never so important as what he does;

[55] *Champion*, 10 June 1740.

often the intention is one thing and his work something different. Fielding wrote *Joseph Andrews* the next year after this grave pronouncement, and *Tom Jones* within the decade. Both novels are eminently Hogarthian; indeed, next to the prints themselves, they are the nearest things to Hogarth in the world; but they are hardly designed for teaching "the dreadful and fatal consequences" of "the delusive scene" to "sober families." This solemn lesson might in truth be derived from the two *Progresses*,[56] but enough has already been said to prove that Fielding derived much from other of the prints designed before 1740, and that among the things he learned from Hogarth stern moral truths are not to be found. Other proof will follow.

Naturally this is not saying that Fielding's two novels are immoral. They are brilliantly satirical, and satire, by its very nature, presupposes some moral belief. But they do not partake of that pious, narrow, Richardsonian view of morality which so many people see in Hogarth, which Fielding himself describes in the quotation above, and which this book, if it has done anything at all, has shown to be unfair to the painter's genius. In the preface to *Joseph Andrews* all that Fielding says of serving the cause of virtue are words spoken about burlesque entertainments:

I will appeal to common observation, whether the same companies are not found more full of good-humour and benevolence, after they have been sweetened for two or three hours with entertainments of this kind, than when soured by a tragedy or a grave lecture.

Joseph Andrews, like the earlier dramatic burlesques and the prints of "the ingenious Mr. Hogarth," may indeed be said to scoff at vice and laugh its crimes away, but that is a far cry from Fielding's prayer-meeting pronouncement about Ho-

[56] It might be argued, of course, that these two series effectively expose affectation to ridicule, but I think their subjects belong more properly to those darker vices which Fielding excludes from his theory of the ridiculous, and from his two most famous novels.

garth's "moral." As for *Tom Jones*, its morals are criticized to this very day because of its hero, who

> Consents to be kept
> By a demi-rep.

All Fielding bothers to say about the matter is contained in the unusually fine dedication to the novel:

> I have shown that no acquisition of guilt can compensate the loss of that solid inward comfort of mind, which is the sure companion of innocence and virtue; nor can in the least balance the evil of that horror and anxiety which, in their room, guilt introduces into our bosoms.

Virtue is its own reward, vice its own punishment — a subjective view of morality which must have been affected by the ridiculous moral expediency so apparent in the second part of *Pamela*. No, the chief interest in Fielding's two Hogarthian novels is in the joy one experiences in looking at and being a part of the *comédie humaine*.

But a year or two after *Tom Jones* was published, Fielding found this type of humor, which had so long satisfied him, inadequate. In the tenth number of the *Covent Garden Journal* (4 February 1752) he modifies the old theory and as his partner in this new belief cites, to our astonishment, none other than his long-standing rival, Samuel Richardson:

> Pleasantry (as the ingenious author of Clarissa says of a story) should be made only the vehicle of instruction; and thus romances themselves, as well as epic poems, may become worthy the perusal of the greatest of men; but when no moral, no lesson, no instruction, is conveyed to the reader, where the whole design of the composition is not more than to make us laugh, the writer comes very near to the character of a buffoon.

This sounds singularly like his sober praise of Hogarth twelve years earlier, the chief difference being that there he had merely found something to admire in Hogarth in addition to all the comedy, while here he is pronouncing not a stuffy

reflection but an active belief, which he is already putting into practice.

The fifty-fifth number of the *Covent Garden Journal* Fielding devotes to outlining a new theory of comedy that goes beyond that of the preface to *Joseph Andrews* ten years before. Here he makes "humours" the root of comedy, saying, "By humour then, I suppose, is generally intended a violent impulse of the mind, determining it to some one particular point, by which a man becomes ridiculously distinguished from all other men." Obviously comedy will arise from incongruity, as we saw in Parson Adams, Squire Western, and other earlier characters unrelated to vanity or hypocrisy. This is then a more inclusive and more intelligent view of comedy than the earlier one, but there is one more important circumstance yet to observe — simply that Fielding's whole conception of the "humour" and its relation to comedy is tied up with teaching morality. In the following issue of the *Covent Garden Journal* he points out that the greatest enemy of the "humour" is good breeding.

The ambitious, the covetous, the proud, the vain, the angry, the debauchee, the glutton, are all lost in the character of the well-bred man . . . Good breeding is, and must be, the very bane of the Ridiculous, that is to say, of all humorous characters.

The new theory of comedy turns into a plea for better education, a view not inconsistent with Fielding's new duties as magistrate.[57] Unhappily it augurs ill for *Amelia*, a book written in this exact frame of mind.

Turning to *Amelia* itself, we find the novel dedicated in this manner:

The following book is sincerely designed to promote the cause of virtue, and to expose some of the most glaring evils, as well public as private, which at present infest the country; though there

[57] In the tenth issue he had excluded Aristophanes and Rabelais from the rank of the greatest comic artists because they have made a wicked use of their talents: they do not inculcate virtue.

is scarce, as I remember, a single stroke of satire aimed at any one person throughout the whole.

Smollett always began his books in the same fashion, but that old salt never fooled anyone. In *Amelia*, however, Fielding actually sticks to his promise, and one is discomfortedly aware of it throughout the novel. Notwithstanding all the billingsgate heaped upon the book for its noseless heroine and other things, a great many critics were impressed by its morality. One of Fielding's friendlier critics, writing in the *Gentleman's Magazine* under the name of Criticulus, said:

Some of the characters are handled in so masterly a manner, virtue and vice meet with their due rewards, and it abounds with such noble reflections on the follies and vices, the perfections and imperfections of human nature, that he must be both a bad and ill-natur'd reader, who is not by it agreeably entertain'd, instructed, and improved.[58]

It is ironic that Richardson, whom Fielding might have expected to be pleased with *Amelia* (indeed the book could well carry the subtitle, *Virtue Rewarded*), saw nothing at all admirable in it. His remarks to Mrs. Donnellan are a fairly clear indication of why the novel was generally unpopular:

You guess that I have not read Amelia. Indeed I have read but the first volume. I had intended to go through with it; but I found the characters and situations so wretchedly low and dirty, that I imagined I could not be interested for any one of them.

Fielding, like Hogarth, refused to idealize his characters; thus to most contemporaries they were "low."

Amelia was plainly written in the light of Fielding's earlier theory of comedy, for it deals largely with the exposure of affectation. The more inclusive idea of the "humour" applies more closely to the two earlier books. In other words, Fielding's practice goes in exactly the opposite direction from his theories. It is easy to see how the tone of *Amelia* is different from that of *Joseph Andrews* and *Tom Jones*. Like much of

[58] XXII (1752), 102.

our contemporary music, its very commencement is on a sour note. As Booth attempts to save a wretched pedestrian from the hands of two assaulters, the watch comes up and arrests them all. The two assailants brighten the constable's palm and are released, while Booth and the man he defended are held on the outrageous charges of assaulting the watch and breaking his lantern. Fielding tells it all in a highly ironic vein which might be funny were it not so bitter. Though Mr. Thrasher, the justice, is scarce able either to read or write, he is very diligent in his post: "To speak the truth plainly, the justice was never indifferent in a cause, but when he could get nothing on either side." All poor people he immediately convicts, for

. . . in short, the magistrate had too great an honour for Truth to suspect that she ever appeared in sordid apparel; nor did he ever sully his sublime notions of that virtue, by uniting them with the mean ideas of poverty and distress.

Booth is conducted around the prison yard by a certain Robinson, a notorious gambler, who relates to him the story of each of the prisoners, commenting the while on the injustice of the courts and penal codes. His remarks constitute a sustained flight of the bitterest irony, reminiscent of *Jonathan Wild* but lacking the facetiousness of that earlier history. This sort of thing continues through the book. As always in Fielding, there are strokes of matchless comedy, but the total impression is one of gloom relieved only by the tender and long-suffering patience of Fielding's loveliest creation, Amelia herself.

A great deal of affectation is unmasked — Colonel James, Captain Trent, the young lord who keeps a room at Mrs. Ellison's, and so on. All these people, who on the outside cut the most charming and respectable figures imaginable, are utterly black. They are a far cry from the various shades of gray in Lady Booby, Mrs. Slipslop, Parson Trulliber, and Mrs. Bridget, all of whom appear comic even on the outside.

The masks of these earlier creations are stripped off amid the highest hilarity — who can forget Tom Jones's discovery of Square in Molly's chamber? — but in *Amelia* the characters are exposed with not even a chuckle. The fact that many more affected hypocrites are unmasked in *Amelia* than in the earlier novels shows its closer relation to the earlier theory of the ridiculous. It is much less Hogarthian than the other two, and it is much less funny.

One has not far to look for the reasons for this change in Fielding. Age, illness, and especially his position as Bow Street magistrate are responsible. In 1750, the year before *Amelia* appeared, Fielding was engaged upon the *Enquiry into the Late Increase of Robbers*, an examination into the causes of crime and misery in London. Obviously he was led into this inquiry by his experiences as magistrate. The *Enquiry* is certainly the background of *Amelia*.

This novel seems at first to bear a paradoxical relationship to Hogarth. Fielding had long before praised Hogarth's prints for their splendid service to "the cause of virtue," intimating of course that it was this that he most admired in them. When he comes, then, to write his own novel "sincerely designed to promote the cause of virtue," it is natural to expect that here, certainly, debts to the painter would appear in every chapter. They do not. True, the background of *Amelia* is often similar to scenes in Hogarth — the Bridewell episode from *A Harlot's Progress*, some of the pictures from the career of the hapless Tom Idle, the gilded vice of *Marriage à la Mode* — but the exuberant Hogarthian spirit which permeates *Tom Jones* and *Joseph Andrews* is unhappily absent. Moreover, the theory of comedy which we rejected as having less to do with these two novels than do the prints of Hogarth, is very closely followed in the un-Hogarthian *Amelia*. This, then, I take as the final proof that, despite Fielding's well-meaning praise of Hogarth as a missionary of virtue, he himself derives from the painter something altogether different, something that one may find on nearly every page of *Tom Jones*, but almost

never in the sterner stuff of *Amelia*. It is therefore to Hogarth that we must turn for a better understanding of Fielding's two supreme novels.

At the end of so long and involved a chapter, it may be helpful to summarize: Fielding in the preface to *Joseph Andrews* has distinguished both Hogarth and himself from caricaturists and has asserted that they are rather creators of character. Learning to avoid caricature — a lesson he had not acquired in his theatrical writings, done before Hogarth's ascendancy — is of prime importance to the success of Fielding's novels. It is impossible not to attribute much of this lesson to Hogarth, since there are so many evidences of his influence in both *Joseph Andrews* and *Tom Jones*. Further, Fielding has said that his own comedy consists of the exposure of affectation which arises from hypocrisy or vanity; but after examining a great many of his funniest scenes and discovering little related to that exposure, one is forced to reconsider Fielding's theory of comedy, to look for some better picture of the true Fielding spirit than the preface to *Joseph Andrews*. One has not far to look, for the real picture of Fielding's comedy can be seen in almost every Hogarth print. The Fielding and Hogarth spirit, copied directly from the book of nature, are one and the same. Finally, Fielding several times said that the greatest lesson to be derived from Hogarth's art, implying that it was a lesson he himself derived from it, was the sterling moral instruction. That his debt to Hogarth is in no way related to morality, despite all he might announce to the contrary, is proved by *Amelia*. This book, often gravely moral, adheres to the theory of the unmasking of affectation and is the one novel of Fielding's in which the Hogarthian spirit is totally excluded. The tone is somber, and the book was in part a failure.

Thus the importance of knowing Hogarth's works in order better to understand Fielding's becomes apparent. By looking at the work of either we may learn of the other. Fielding can elaborate where Hogarth cannot; yet Hogarth can appeal

directly to the visual sense to a degree Fielding cannot. They serve as the perfect complement one to the other, together preserving for us both the appearance and the experience of the age.

One might best conclude with a suggestion as to why Hogarth became popular for his treatment of Bridewell, the triple tree at Tyburn, the midnight modern conversation, and all the other sordid aspects of London life, while Fielding was dismissed as bitter and unpleasant. In Fielding's two greatest novels one feels that while there certainly is not a moral indifference, there is yet a serene acceptance of life as it is, even in its worst aspects. In *Amelia*, however, he is very plainly not indifferent, his purpose is deepened, and the book is often painful. But in Hogarth's most successful pictures there is immediately apparent a moral indignation which, far from paining the spectator, adds great pungency and impact and makes the edge of humor more keen. The reason for this more inclusive appeal of Hogarth is, I think, the same reason that he appealed so much to Fielding, the reason that he will probably always be England's most popular artist: the astonishing richness of nearly every print. *A Harlot's Progress* had something for everybody: it carried to those who were looking for it a relentless moral lesson, to some it had all the excitement of a scandal sheet, to others it was just downright funny, and to still others brilliantly satirical. In other words, Hogarth's art was like the pack of Autolycus: everyone could seize upon something there which suited his taste; but the art of Richardson and the art even of Fielding were not so rich or so flexible.

Hogarth and Smollett

Next to Fielding, the eighteenth-century novelist who paints the broadest canvas with the greatest vigor is the Scotch doctor, Tobias Smollett. These two artists are separated from the narrow shut-in world of Samuel Richardson on the one hand, and the whimsical stream-of-consciousness novel of Laurence Sterne on the other. An understanding of Hogarth can profit us little in reading Richardson or Sterne, but just as it helps us enormously in reading Fielding, so does it also in Smollett. The purpose of the present chapter is to discuss not merely the debt of Smollett to the painter, but in addition something much larger — the relationship of the art of the two men.

I

Thackeray was ever an enthusiast of the novels of Fielding and Smollett, and also of the prints of Hogarth. He seldom thought of the one without thinking of the other. In a graphic passage from his essay entitled "Hogarth, Smollett, and Fielding," one of the series *The English Humourists of the Eighteenth Century*, he speaks of the prints:

The Yorkshire waggon rolls into the innyard; the country parson, in his jackboots, and his bands and short cassock, comes trotting into town, and we fancy it is Parson Adams, with his sermons in his pocket. The Salisbury fly sets forth from the old Angel — you see the passengers entering the great heavy vehicle, up the wooden steps, their hats tied down with handkerchiefs over their faces, and under their arms, sword hanger, and casebottle; the land-lady — apoplectic with the liquors in her own bar — is begging a gratuity; the miser is grumbling at the bill; Jack of the Cen-

turion lies on the top of the clumsy vehicle, with a soldier by his side – it may be Smollett's Jack Hatchway – it has a likeness to Lismahago.

It is Thackeray's very valid contention that the prints of Hogarth are remarkable as illustrations to the novels of his two great contemporaries. A generation earlier Hazlitt had linked Hogarth even closer to the novelists by including him in the *Lectures on the English Comic Writers*. And Lamb had said that other pictures we see, but Hogarth's we read, just as we read *Tom Jones* or *Roderick Random*.

Nothing is so easy or so dangerous as to make sweeping assertions of the debts that one artist – whether he be painter, musician, or writer – owes to another. "Manifest obligations," "obvious relationship," "indebtedness impossible to mistake" – these phrases, all extremely inviting, are used often too freely, when there is really nothing but flimsy appearance to support them. A case in point is the supposed debt of Samuel Richardson to Marivaux; in spite of likenesses, scholarship has never settled that perplexed question. A more celebrated instance is the debt (as some would have it) of the mature Shakespeare to the fresh young novices, Beaumont and Fletcher. Similar broad assertions have often been made of Hogarth's influence on Fielding and Smollett, but they have hitherto never got beyond the stage of ill-defined generality. A good example of these comprehensive assertions is that of H. W. Hodges in an authoritative introduction to the Everyman edition of *Roderick Random*. Every word of the passage is as true of Smollett's other novels as of *Random*, but it becomes apparent that such generalities are not sufficient for discovering a true relationship. He says:

Roderick Random may be said to possess a general value and a special value. Its general value is best understood if we realize that Smollett is doing with his pen what Hogarth was doing with his brush. One cannot turn over the pages of his book without constant reminders of the works of Hogarth. In both artists there is a wide selection of types, the same narrow observation of low

life, the study of the fop, the imposter, the dupe and the criminal; often the same insistence in detail upon the brutal, the ugly, and the obscene . . . We are viewing in sharp outline those sides of society in the eighteenth century which can nowhere else be seen from the same angle or on the same scale, save always in the works of Henry Fielding.

Sometimes such generalizations are totally misleading, as I have attempted to show in the case of Fielding's *Amelia*. Blanket statements about Hogarth and Smollett can be equally fallacious. Specific instances of the relationships of the two artists have never, I believe, been pointed out before; nor has the one salient difference between them—the difference between character and caricature—which, as we have discovered in Fielding, is of paramount importance to the relationship between painter and author.

Smollett's literary career began a good deal later than Fielding's. He published his first novel, *The Adventures of Roderick Random,* in 1748, only a year before the appearance of *Tom Jones.* Its immediate success was due largely to two factors: first, it drew its finest characters and liveliest scenes from His Majesty's navy, and secondly, its humor was of the type that had already found an audience in the works of William Hogarth and to some extent in *Joseph Andrews.* Unlike Fielding, Smollett did not express any indebtedness to Hogarth, but a number of obvious borrowings make his debt very plain. He was violently jealous of Fielding but admired Hogarth, partly perhaps because the painter was not a rival novelist. He clearly recognized Hogarth as a kindred spirit and a powerful ally in a new type of art which he and, whether he liked it or not, Fielding were establishing.

Since the two artists deal with the same people doing the same things, one is not surprised to find that Hogarth runs through Smollett's mind as he writes his books just as much as through Fielding's. His own scenes seem clearer in his mind if he thinks of them as pictures by Hogarth. When one of his characters appears in a particularly arresting attitude, he often

refers to the painter. In *Roderick Random*, for example, he says:

It would require the pencil of Hogarth to express the astonishment and concern of Strap on hearing this piece of news. The basin in which he was preparing the lather for my chin, dropped out of his hands, and he remained some time immovable in that ludicrous attitude, with his mouth open, and his eyes thrust forward considerably beyond their station . . .[1]

Hogarth had painted such a character in the last scene of the celebrated *Marriage à la Mode*, the imbecile messenger who, having procured the poison for the countess, is being upbraided by the enraged physician. Smollett was thoroughly familiar with the *Marriage*, and probably even based an incident in his *Ferdinand Count Fathom* upon the bagnio scene from Hogarth's series. It is in the thirty-sixth chapter where an irate husband discovers Fathom in bed with his spouse at a Covent Garden bagnio. In Smollett's book the wife herself has betrayed the assignation.

Near the beginning of his second novel, *Peregrine Pickle*, Smollett remarks:

It would be a difficult task for the inimitable Hogarth himself to exhibit the ludicrous expression of the commodore's countenance, while he read this letter. It was not a stare of astonishment, a convulsion of rage, or a ghastly grin of revenge, but an association of all three, that took possession of his features.[2]

Smollett wants his readers to visualize the expression on Hawser Trunnion's face. The best way he knows of achieving his end is to remind them that this is the same sort of thing they are familiar with in the works of Hogarth. At times the painter seems to be a crutch upon which the novelist is leaning, for Smollett relies on him as the touchstone for realizing the countenances of his own creations. In *Humphry Clinker*, published seven years after Hogarth's death, he has Matthew Bramble say:

[1] Chap. 47.
[2] Chap. 14.

. . . the expression of the two faces, while they continued in this attitude, would be no bad subject for a pencil like that of the incomparable Hogarth, if any such should ever appear again in these times of dulness and degeneracy.[3]

Even when allowance is made for Bramble's character, the passage remains characteristic of Smollett. One must remember that 1771 was the heyday of the Ossian poems, of *The Castle of Otranto*, and of Beattie's *Minstrel*, three vastly popular works which had already assured the triumph of romanticism. Smollett was one of the last surviving monuments of a vanishing race; he knew that with Hogarth's death he had lost a strong confederate. This may have been his way of paying tribute.

His connection with Hogarth is the more striking when one considers that Smollett knew literally nothing about any other painter. Except when he speaks of Hogarth, his judgments on pictorial art are absurd. *The Travels through France and Italy* are noticed later, but a passage from *Humphry Clinker* is equally astonishing:

If I am not totally devoid of taste, however, this young gentleman of Bath is the best landscape painter now living: I was struck with his performances in such a manner, as I had never been by painting before. His trees not only have a richness of foliage and warmth of coloring which delights the view, but also a certain magnificence in the disposition, and spirit in the expression, which I cannot describe. His management of the *chiaro oscuro*, or light and shadow, especially gleams of sunshine, is altogether wonderful, both in contrivance and execution . . . If there is any taste for ingenuity left in a degenerate age, fast sinking into barbarism, this artist, I apprehend, will make a capital figure, as soon as his works are known.[4]

This proves certainly that Smollett was no very remarkable judge, for he ranks the painter, Mr. T——— (who is William Taverner), above Richard Wilson and other far more

[3] Letter of 12 June.
[4] Letter of 19 May.

gifted landscape painters of the day. Though Smollett knew little about art, he not only liked Hogarth but knew his works thoroughly. The most convincing proofs are the remarkable allusions to the print of *Paul Before Felix*, which Hogarth mockingly claimed was "Design'd and scratch'd in the true Dutch taste." In the midst of the bewildering volume, *The Adventures of an Atom*, Smollett says:

Fika-kaka sat about five seconds in silence, having in his countenance nearly the same expression which you have seen in the face and attitude of Felix on his tribunal, as represented by the facetious Hogarth in his print done after the Dutch taste.

The picture had been mentioned before in the twelfth chapter of *Sir Launcelot Greaves*:

. . . they seemed to produce the same unsavoury effects, that are humourously delineated by the inimitable Hogarth in the print of Felix on his tribunal, done in the Dutch style.

Anybody so familiar with *Paul Before Felix*, not only one of Hogarth's poorest prints but also one of the least known, is thoroughly soaked in Hogarth.

Throughout Smollett's works, just as in the novels of Fielding, one finds scenes or parts of scenes borrowed from Hogarth's prints. Fielding often mentions the debt; Smollett does not, indicating either that he was so immersed in the prints that he used them unawares, or that there is a fundamental difference between his character and Fielding's. In *Roderick Random*, Smollett has done a harlot's progress of his own, "The History of Miss Williams." It is not necessarily borrowed from Hogarth, but except for its termination it differs very little from the history of Moll Hackabout. I suspect that Smollett is following the example of *Joseph Andrews*, where Fielding has used all but the fifth and terminating scenes of *A Rake's Progress* in his "History of Mr. Wilson." Smollett has, with some justice, been criticized for introducing this unpleasant story into his book. Hogarth's series, on the other hand, even though it ends far more horribly than Smollett's,

has largely escaped censure, indicating a difference between him and Smollett as basic as that between Smollett and Fielding.

Smollett's early heroes are all rakes, and certain incidents in the careers of three of them exactly follow scenes from *A Rake's Progress*. At one of the frequent crises in the story of Random he is reduced to the ignominy of seeking a match with a rich old maid whom he has never seen.[5] This "ancient Urganda," as Roderick calls her, had been painted by Hogarth in the marriage scene from *A Rake's Progress* where Tom Rakewell is reduced to the same extremity. All her gestures are the same, even "the grin with her mouth shut, to conceal the ravages of time upon her teeth." To Roderick's credit it may be said that he abandoned all ideas of a connection after his first view of the "hoary dulcinea" with her "dim eyes, quenched in rheum." Other incidents resemble the *Rake*. For example, compare the seventeenth chapter, the revel in the night house and the arrest by the watch, with Plate III.

The adventures of Ferdinand Count Fathom resemble *A Rake's Progress* even more closely than Random's. He passes from the tavern scene "at the house of an obliging dame, who maintained a troop of fair nymphs for the accommodation of the other sex," to the marriage for money, the gambling misfortune, and finally imprisonment.

When Peregrine Pickle first goes up to London he falls in with a club of politicians whose favorite pastime is what Hogarth called the midnight modern conversation. "It was a constant practice with them, in their midnight consistories," says Smollett, "to swallow such plentiful draughts of inspiration, that their mysteries commonly ended like those of the Bacchanalian Orgia."[6] Upon one occasion they are elevated to such a pitch of intoxication that Peregrine induces them to set fire to their periwigs, an incident probably suggested to Smollett by the reveller in Hogarth's print who sets fire to his

[5] Chap. 50.
[6] Chap. 21.

shirtsleeve, and who appears again in another picture called *The Politician*. His joy in their disgrace is of course what Hogarth's or Fielding's would be: "Peregrine's satirical disposition was never more gratified than when he had an opportunity of exposing grave characters in ridiculous attitudes." Later in the book Peregrine has a nobleman, who is in his debt, arrested as he steps into his chair at the door of White's Chocolate House.[7] Not only is Hogarth's rake arrested in exactly the same manner in Plate IV, a striking parallel in itself, but he has taken especial pains to place his figures in front of a particular chocolate house — White's — which is exactly what Smollett has done.

One of Smollett's favorite prints was *The Gate of Calais*, better known as *The Roast Beef of Old England*. Although he never acknowledged it, he borrowed from the print at least four times in his works. In Hogarth's picture we see a half-starved cook, apparently employed at a hotel catering to foreign travelers, carrying a huge joint of English beef. A fat friar leers longingly at the meat, while two famished and tattered sentinels stare open-mouthed. At the left of the picture three fisherwomen are laughing over the resemblance of a huge skate to a human face, not realizing how closely its coarse leathern features resemble their own. A few lean vegetables are scattered about them. Two miserable exiles from the rebellion of 1745 are hovering in the foreground, and two ragged wretches carry away a pot of thin broth. Into the background Hogarth has introduced himself making a sketch of Calais Gate, an act for which he was arrested on his one visit to France.

In the first volume of *Peregrine Pickle*, the hero is forced to spend an entire day at an inn in Boulogne while he waits for his damaged chaise to be repaired.

Our young gentleman . . . demanded to know what they would have for dinner; the garcon or waiter, thus questioned, vanished in a moment, and immediately they were surprised with the ap-

[7] Chap. 84.

pearance of a strange figure, which, from the extravagance of its dress and gesticulation, Peregrine mistook for a madman of the growth of France. This phantom, which, by the by, happened to be no other than the cook, was a tall, long-legged, meagre, swarthy fellow, that stooped very much; his cheek-bones were remarkably raised, his nose bent into the shape and size of a powderhorn, and the sockets of his eyes as raw round the edges as if the skin had been paired off. On his head he wore a handkerchief, which had once been white, and now served to cover the upper part of a black periwig, to which was attached a bag, at least a foot square, with a solitaire and rose that stuck up on each side to his ear; so that he looked like a criminal on the pillory. His back was accomodated with a linen waistcoat, his hands adorned with long ruffles of the same piece, his middle was girded by an apron tucked up, that it might not conceal his white silk stockings rolled.[8]

One glance at the central figure in Hogarth's print (published only two years before the novel) reveals the source of Smollett's inspiration.

An even clearer reference occurs in Count Fathom, where not only are the meagre figures noted, but the soup maigre and the loin of beef as well. In the twenty-eighth chapter Fathom finds himself in a coach squeezed between "a corpulent Quaker and a fat Wapping landlady, in which attitude he stuck fast, like a thin quarto between two voluminous dictionaries on a bookseller's shelf." The entire scene is eminently Hogarthian, and one is immediately reminded of the fat lady being squeezed into the vehicle in The Stage Coach, which Thackeray has described in the quotation beginning this chapter. The Wapping lady has a tongue as ample as her bodily proportions, and rages at one of her fellow travellers who has the misfortune to bring down the full vengeance of her elocution upon his head:

"Flesh!" cried she, with all the ferocity of an enraged Thalestris; "none of your names, Mr. Yellow-chaps. What! yourself are nothing but skin and bone. I suppose you are some poor starved

[8] Chap. 36.

journeyman tailor come from France, where you have been learn-
ing to cabbage, and have not seen a good meal of victuals these
seven years. You have been living upon rye-bread and soup-
maigre, and now you come over like a walking atomy, with a
rat's tail at your wig, and a tinsey jacket; and so, forsooth, you
set up for a gentleman, and pretend to find fault with a sirloin of
roast beef."

The *Roast Beef* is recalled at least twice in Smollett's com-
edy, *The Reprisal*, produced with some success by David
Garrick in 1757. The piece is rendered acceptable only by the
presence of two of Smollett's capital naval characters, Oclab-
ber and Maclaymore, both exiled Britons in the service of the
French. The counterpart of Maclaymore, who has been exiled
from Scotland on account of the rebellion of 1745, lounges
dejectedly in the righthand corner of Hogarth's picture. In
the play's opening scene, we learn of a sirloin of roast beef
ravished from an Englishman by "two famished French
wolves, who beheld it with equal joy and astonishment." (No-
tice Hogarth's faces.) The third scene opens with the follow-
ing stage direction:

First the bagpipe — then a ragged dirty sheet for the French
colours — a file of soldiers in tatters — the English prisoners — the
plunder, in the midst of which is an English buttock of beef car-
ried on the shoulders of four meagre Frenchmen.

One of the best bits from Hogarth makes one of the best
bits from *Count Fathom*. The opening chapters of the book
have been widely admired, and remain vividly stamped upon
the memory, not because the rest of the book is so poor, but
because of the excellent pictures of the old camp follower
and her hapless babe, the future Count Fathom. Part of this
vividness derives from a splendid detail borrowed from Ho-
garth's *March to Finchley*, the infant carried in a knapsack
fastened to its mother's back, and living principally on the gin
from a cask which hangs before her. Here Smollett is to be
congratulated for his genius in borrowing.

172 HOGARTH'S LITERARY RELATIONSHIPS

As a final illustration of his gleanings from Hogarth, we may turn to two pictures from the painter's longest and most uneven series of prints, *Industry and Idleness*. In the eleventh scene, perhaps the finest of the lot, Thomas Idle finds that the wages of sin is death. He is seen in the cart on his way to Tyburn, holding *The Whole Duty of Man* in his hands and piously attending the admonitions of a Methodist zealot. In Smollett's much-censured novel, *The Adventures of Sir Launcelot Greaves*, a book which has been illustrated by the Hogarthian Cruikshank, a conjurer convinces the hero's squire, Timothy Crabshaw, that he will be convicted for horsestealing:

The conjurer . . . strenuously recommended it to him, to appear in the cart with a nosegay in one hand, and the Whole Duty of Man in the other. "But if in case it should be in winter," said the squire, "when a nosegay can't be had?" — "Why, then," replied the conjurer, "an orange will do as well." [9]

The more important debt to Hogarth comes at the end of Smollett's masterpiece, *Humphry Clinker*. It is the scene in which Humphry, now Mr. Matthew Lloyd, retires to the nuptial chamber with his bride, née Winifred Jenkins. The waggish Jack Wilson throws a cat shod with walnut shells into the bridal bower and thoroughly discomposes the lovers. The entire scene is hilarious, the climax coming when "Mr. Lloyd, believing that Satan was come to buffet him *in propria persona*, laid aside all carnal thoughts, and began to pray aloud with great fervency." [10] Humphry's consternation had already been delineated by Hogarth in what surely gave Smollett his idea, the seventh plate of *Industry and Idleness*, the scene in which Tom Idle, in bed with a prostitute, is violently shocked and frightened by a cat that comes hurtling down into the fireplace, bringing a clatter of bricks and stones with her.

[9] Chap. 22.
[10] Letter of 8 November.

II

It is clear from the examples just cited that Smollett not only knew Hogarth's prints well but also made considerable use of them as he composed his own broad canvases. The debt is rendered the more striking when we discover that Smollett had no use for any other painter, yet returns again and again to Hogarth. For pertinent evidence we need only look into the desultory compendium which Smollett compiled for the booksellers with conspicuous lack of interest, *The Present State of All Nations*. Even in the midst of that arid wasteland occurs this revealing passage:

England affords a great variety of geniuses in all the liberal arts, except in the sublime parts of painting . . . the spirit of invention, the grand composition, the enthusiasm of the art, seem wanting in this climate: not but that it affords some instances of surprising genius in other branches. In the comic scenes of painting, Hogarth is an inimitable original with respect to invention, humour, and expression.[11]

The only other artists mentioned are the architects Inigo Jones and Sir Christopher Wren. How significant to discover, in a work which treats the arts in so summary and inadequate a fashion, this enthusiasm for a sole painter! Reynolds, Gainsborough, and even his own countryman, Allan Ramsay, Smollett passes by; but he stops to bestow laurels upon Hogarth.

His emotional affinity for the painter is not surprising, for many traits of Hogarth's character find a closer parallel in Smollett than in any one else we know. Nor is it surprising that the most noticeable of these traits are the unpleasant ones. The two men possess that solidity, perseverance, and blunt honesty which we like to think of as British; but there is also in both of them much of British stubbornness, not unmixed with conceit. It is in this respect principally that they differ from Fielding, a man of greater and more refined spirit than either. To examine for a moment the personal affinities of Ho-

[11] *The Present State of All Nations* (London, 1768), II, 230.

garth and Smollett will bring us a clear conception of their work.

Hogarth unhappily affected to despise every kind of knowledge which he did not possess. Since he had not seen and certainly had never studied most of the great Italian masterworks, he persuaded himself that the praises bestowed upon them were the effects of prejudice. An anecdote exists testifying to his admiration for Titian, but in his memoirs he said that to study painting in Italy was to waste both time and money. This point of view was directly responsible for his two flagrant failures, the treatise on aesthetics, *The Analysis of Beauty*, where he attempted "fixing the fluctuating Ideas of Taste"; and a historical painting in which he tried to beat the Italian masters on their own ground, the *Sigismunda*. Smollett, who certainly had much less equipment than Hogarth for appraising great works of art, proceeded to pass judgment even more noisily. It has been shown that much of the learning displayed in *The Travels Through France and Italy* he lifted from an Italian guide book,[12] but the absurd pronouncements found there upon Italian art are his own. His critical capacity in these matters may be conclusively illustrated by a single statement: he preferred Guido Reni to Raphael. "The altar of St. Peter's," he says at another point, "notwithstanding all the ornaments which have been lavished upon it, is no more than a heap of puerile finery," and so on.[13] Further, just as Hogarth always reverenced his unhappy excursion into the sublime, *Sigismunda*, so Smollett never forgave the world for scorning his own execrable tragedy, *The Regicide*. The two men were blind to the same things. And the most merciless critic of both pieces was the same man, Charles Churchill, who blasted the tragedy in *The Apology* and the painting in his *Epistle to Hogarth*.

In addition to the marked affinity in temperament, the most

[12] Louis L. Martz, *The Later Career of Tobias Smollett* (New Haven, 1942), pp. 73ff.
[13] Letter 31.

practical of all connections exists between Hogarth and Smollett: they both employed the same method of insuring popular success. By the occasional use of real figures known to everyone, Hogarth was able to give his fictional series the atmosphere of biography. Knowing that the public expected to see well-known faces in his prints, he capitalized on current scandal. In the advertisement to *Marriage à la Mode* he took care to state that in this series, at least, the characters represented were not personal, proof sufficient that usually they *were*. Certainly this declaration did not keep an avid public from discovering all manner of personal resemblances there. We have seen that Fielding in his novels followed to some extent Hogarth's lead, but it was Smollett who leaned heaviest upon this device.

The real figures in Hogarth's prints are of two sorts, those introduced casually to lend an air of true biography to his fiction, and those who are clearly being satirized. Occasionally Smollett, like Fielding and Hogarth, would introduce nonchalantly into his tale a contemporary figure to lend the air of reality — Mr. T[averner], the painter from *Humphry Clinker* is an example — but usually his object is satire. He loves to give a fictitious name to someone whose real identity every reader will at once perceive. This was a favorite device in the satires of Dryden, Pope, and Swift, but it is Hogarth who developed its possibilities for fiction. Whereas Swift would sometimes build an extensive satire around various individuals whose identities he very thinly disguised — a method employed by Smollett in *Adventures of an Atom* — Hogarth would introduce the satire as a minor incident in an exciting narrative. The "speaking likenesses," as they were called, of the wrangling Misaubin and Ward in the fifth plate of the *Harlot* are telling strokes of satire; yet the central figure of the print is the dying heroine. In the levee scene from *Marriage à la Mode*, Hogarth took occasion to mock a renowned singer of the day, the castrato Carestini, whom he had earlier bludgeoned in satires on Italian opera. But Carestini, also, is a

minor figure in the severe tragedy. In the same series Hogarth had made trenchant fun of a quack generally taken to be the same Dr. Misaubin of the earlier series. The identity of the bawd standing nearby has not been positively determined, but the initials on her bosom indicate that Hogarth meant her to be known.

Smollett at once embraced this exciting apparatus of satire as a subsidiary of fiction, and in his first novel sneers at nearly a dozen well-known figures, little concealed by fictitious names. He prudently never admits this, and in the apologue to the novel even makes the familiar declaration that any resemblance to actual persons either living or dead is purely coincidental:

Christian reader, I beseech thee, in the bowels of the Lord . . . seek not to appropriate to thyself that which equally belongs to five hundred different people. If thou shouldst meet with a character that reflects thee in some ungracious particular, keep thy own council; consider that one feature makes not a face, and that, though thou art, perhaps, distinguished by a bottle nose, twenty of thy neighbours may be in the same predicament.

Naturally this has never fooled anyone. Smollett's biographer, David Hannay, has pointed out that the young novelist was a great deal more anxious that the illusion should be clearly perceived than passed unrecognized.[14] A more recent biographer has remarked that "he drew on his friends and enemies for his characters — and then he caricatured them. In all his books there is at least an inch of fact to every ell of fiction. He could not invent: he could only exaggerate."[15] *Roderick Random* was largely a *succes de scandale*. Gawkey, Crab, and Potion were at once identified; Roderick and Narcissa were Dr. and Mrs. Smollett; various persons contended for the distinction of originating Strap; Oakum and Whiffle were officers Smollett had served under in the navy; and in the Melopoyn inci-

[14] *Life of Smollett* (London, 1887), p. 69.
[15] Lewis Melville, *The Life and Letters of Tobias Smollett* (London, 1926), p. 39.

dent Marmozet was Garrick, Sheerwit was Lord Chesterfield, Vandal was John Rich, and so on.[16] Thus *Random*, like *A Harlot's Progress*, gave the appearance of a contemporary and true history.

The success of *Peregrine Pickle* (1751), which far exceeded that of its predecessor, was due largely to its scandalous attraction, *The Memoirs of a Lady of Quality*. This excrescence was the tale, supposedly true, of Frances Viscount Vane, née Hawes, whom Horace Walpole called a living academy of love lore. Smollett was handsomely paid by the lady to print the story, actually written by herself and revised in the second edition by Smollett,[17] but he almost killed his novel in the process. The excellencies of *Peregrine Pickle* were overlooked by a public interested temporarily in Lady Vane; later the novel, because of its association with a burnt-out comet, was neglected.

Characteristically, some of the scandal of *Peregrine* was due to Smollett's own bitter and unforgiving nature. The first edition was branded "a scurrilous libel" because of its excessive abuse of immediately recognizable victims—Fielding, Garrick, Quin, Chesterfield, Lyttleton, Akenside, and others. It was so abusive that in the second edition in 1758 Smollett felt it wise to eliminate much that was objectionable. All these men had offended the young Smollett in his lean years, and he was not of the complexion to overlook it. It is this peculiarity of Smollett's, his virulence of spleen, which brings us now to a consideration of the only conspicuous difference between his work and Hogarth's.

In the introduction to *Count Fathom*, Smollett has set forth with convenient clarity the intention of his art:

If I have not succeeded in my endeavours to unfold the mysteries of fraud, to instruct the ignorant, and entertain the vacant; if I

[16] See Sir Walter Scott's Prefatory Memoir to Ballantyne's edition of Smollett's novels (Edinburgh, 1821), vii–viii.

[17] The long-confused story of the authorship of the piece has been clarified by H. S. Buck, *A Study in Smollett* (New Haven, 1925), pp. 31–48.

have failed in my attempts to subject folly to ridicule, and vice to indignation; to rouse the spirit of mirth, wake the soul of compassion, and touch the secret springs that move the heart; I have at least adorned virtue with honour and applause; branded iniquity with reproach and shame.[18]

This might with equal justice have been written by Fielding; and except for the claim of adorning virtue with honor and applause — hardly an important aim in Smollett — the passage is in every way applicable to Hogarth. In adorning virtue with honor Smollett, like Hogarth, is successful only when he does it by implication; that is, virtue is the implied opposite of the vice which he is depicting. His strictly virtuous characters, like Monimia in *Count Fathom*, have no subtlety at all and are abysmal failures. The most important phrases in the declaration, "to subject folly to ridicule, and vice to indignation" and "to rouse the spirit of mirth," embrace Hogarth's entire art. The intention is the same in painter and novelist; and the intention is in this instance worth considering, for it is fulfilled in their art. To accomplish this intention they both concern themselves with the seamier side of life, so that there is a tone of vulgarity about all their works. They take contemporary society as they find it; if they discover there much that is unlovely, they must either reproduce it or give an inaccurate picture of their age; and the charge of inaccuracy has never been brought against either Hogarth or Smollett.

Why, then, should there be any notable difference between their works? The answer is that the enjoyment of human weakness and folly was no characteristic of Smollett's. In the preface to *Roderick Random* he speaks of "that generous indignation which ought to animate the reader against the sordid and vicious disposition of the world." Despite this admirable aim Smollett, in his heartfelt indignation, too often loses control of himself and can produce such abhorrent stuff as *The*

[18] I have omitted as manifestly untenable the last statement in the passage, Smollett's assertion that he has "carefully avoided every hint or expression which could give umbrage to the most delicate reader."

Adventures of an Atom. This Hogarth does not do. His in-
dignation, as heartfelt as Smollett's, seldom becomes unmiti-
gated spleen.[19] Although both men inevitably selected the
hardest and darkest sides of human nature, Hogarth like Field-
ing was more interested in the comic, Smollett (at his worst)
in the didactic. When Fielding becomes didactic, as in *Amelia*,
he deserts the Hogarthian spirit and becomes either senti-
mental or heavy. He does not reveal the same enjoyment of
human frailty that he did in *Joseph Andrews* and *Tom Jones*.

In *Count Fathom* we are asked again and again to observe
what a wretch Fathom is and how evil it is to steal, to lie,
and to be ungrateful. Here Smollett is a heavy-handed, dour
preacher. As irrevocable proof, the reader need only turn to
the last chapter of the novel, one of the most painful pas-
sages ever penned by a respectable author. It is the scene of
Fathom's reformation and is spun out to unconscionable
lengths. As a curiosity a very short passage is worth repro-
ducing:

He started up, and throwing himself upon his knees, exclaimed, –
"All-gracious Power! This was the work of thy own bounteous
hand: the voice of my sorrow and repentance hath been heard.
Thou hast inspired my benefactors with more than mortal good-
ness in my behalf; how shall I praise thy name! how shall I re-
quite their generosity! O, I am bankrupt of both! Yet let me not
perish until I shall have convinced them of my reformation, and
seen them enjoying that felicity which ought to be reserved for
such consummate virtue."

The moral of *Industry and Idleness* is quite as plain – we
even see Tom Idle sniveling over *The Whole Duty of Man* as
he is rolled up to the Triple Tree at Tyburn – but it never gets
in the way. In that very scene, the Tyburn throng, our inter-
est is in neither retribution nor reformation, but in the com-

[19] The nearest Hogarth ever came to this sort of work was in the two
prints of *The Times* and the satire on Churchill, *The Bruiser*, all inferior
products of his last two years. Hogarth himself has testified that the famous
picture of Wilkes he considered more portrait than caricature. (John Ireland,
Hogarth Illustrated [London, 1806], III, 217.)

edy of an old bawd piously gesturing and swallowing a bumper of spirits at the same time, of a sly young pickpocket taking advantage of an unnoticing pastry vender, of a jolly rogue on the point of throwing a live dog at the Methodist preacher, and of a dozen other touches. In the final plate, where we learn that only the brave (and the proper) deserve the fair, the hero is all but invisible. Instead a score of outrageous comic details assail our eyes. If anyone should want edification from *Industry and Idleness*, he could hardly miss it; but neither could he miss the rich comedy which quite overshadows all else.

This milder, more generous nature of Hogarth is responsible for the most significant difference between his work and Smollett's. For virulence of spleen usually manifests itself not in generously rounded portraits of characters in common life, but in highly exaggerated sketches, or caricature. This is what happened with Smollett and what separates him from Fielding and Hogarth. The essence of this distinction is set forth in the painter's compliment to Fielding, the little etching called *Characters and Caricaturas*, and has been discussed in the preceding chapter. It will be remembered that in the preface to *Joseph Andrews* Fielding allied himself with Hogarth as a creator of character, not caricature — as a comic writer, not a writer of burlesque. He sometimes has permitted the burlesque in his diction, he says, an example being Molly Seagrim's churchyard battle in *Tom Jones*, but has carefully excluded it from his sentiments and characters. His personages, like Hogarth's, "take the widest latitude" (to borrow Hazlitt's words) "and yet we always see the links which bind them to nature; they bear all the marks, and carry all the conviction of reality with them." [20] Smollett, as everyone knows, often leagued himself with the other camp, the out-and-out caricaturists. As Hazlitt says in another lecture, "Smollett excels most as the lively caricaturist: Fielding as the exact painter

[20] *Lectures on the English Comic Writers* (London, 1819), p. 278.

and profound metaphysician." [21] Fielding observes the char-
acters of human life; Smollett describes its various eccen-
tricities. Indeed, with the exception of his famous disciple,
Dickens, Smollett is the most eminent master of caricature in
the English novel. One proof — if it be needed — is that two
renowned caricaturists, Rowlandson and Cruikshank, delighted
in illustrating the works of Smollett, for which their talents
were singularly suited.

The distinction, then, is that Hogarth and Fielding are con-
tent to enjoy the weaknesses and exaggerations of human na-
ture, and they take care that their characters do not deviate
too greatly from reality; on the other side, Smollett, like
Swift, seems in cold blood and with malice aforethought to
sneer at the human race. Like Smollett, Hogarth was often
stubborn and arrogant, but he was not gloomy or malicious.
Of course Smollett may be a perfectionist who holds such
high ideals for humanity that he cannot help being angered
and disgusted at what he actually sees. Whatever his intention
in this respect, the effect of his work is somewhat different.
His caricatures seem to the reader unkind; they are often ex-
tremely funny, but are scarcely credible as real people no
matter how brilliantly they may depict a true social type. He
is thus different from Fielding and Hogarth.

As a pertinent illustration of this essential difference, one
recalls the two wrangling doctors at the side of the expiring
Moll Hackabout, a scene repeated at the deathbed of Captain
Blifil in *Tom Jones*. Both Hogarth and Fielding are indulging
in not ill-humored satire on the pretentiousness often found
in the medical profession. How different a treatment Smollett
gives! In the seventieth chapter of *Peregrine Pickle* an old
colonel is, at Peregrine's instigation, besieged first by three
physicians (who, in their eager entrance, get stuck in the
doorway), then by the whole faculty. The old man, seeing
himself completely surrounded by these gaunt ministers of
death, seizes one of his crutches and, says Smollett, "applied

[21] *Ibid.*, p. 230.

it so effectually to one of the three, just as he stooped to ex-
amine the patient's water, that his tie periwig dropped into
the pot, while he himself fell motionless to the floor." This
alarms the fraternity into a retreat, conducted in such admired
disorder that a tumultuous uproar ensues. The highly exagger-
ated scene is much funnier than Hogarth's or Fielding's, but
is hardly the work of a generous-minded author.

Turning to Smollett's personages, look at Narcissa's aunt,
who appears in the thirty-ninth chapter of *Roderick Random*:

She sat in her study, with one foot on the ground, and the other
upon a high stool at some distance from her seat; her sandy locks
hung down in a disorder I cannot call beautiful, from her head,
which was deprived of its coif, for the benefit of scratching with
one hand, while she held a stump of a pen in the other. Her fore-
head was high and wrinkled; her eyes were large, grey, and
prominent; her nose was long, sharp, and aquiline; her mouth of
vast capacity; her visage meagre and freckled, and her chin peaked
like a shoemaker's paring knife; her upper lip contained a large
quantity of plain Spanish, which, by continual falling, had em-
broidered her neck, that was not naturally very white; and the
breast of her gown, that flowed loose about her with a negligence
truly poetic, discovering linen that was very fine, and to all ap-
pearance never washed but in Castalian streams. Around her lay
heaps of books, globes, quadrants, telescopes, and other learned
apparatus. Her snuff-box stood at her right hand; at her left
hand lay her handkerchief, sufficiently used; and a convenience to
spit in appeared on one side of her chair. She being in a reverie
when we entered, the maid did not think it proper to disturb her;
so that we waited some minutes unobserved, during which time
she bit the quill several times, altered her position, made many
wry faces, and at length, with an air of triumph, repeated aloud:
Nor dare th' immortal gods my rage oppose.

Hogarth could easily have done full justice to this impossible
figure, but I venture to suggest that he would not have thor-
oughly approved. He had already drawn the admirable frost-
piece of religion and morality whom Fielding named Mrs.
Bridget Allworthy, and she is believable because she never

descends into mere caricature. On the other hand, it is hard really to believe in Narcissa's aunt, or, for that matter, in one of Smollett's funniest creations, Mrs. Tabitha Bramble, a maiden of forty-five winters, declining into the most desperate state of celibacy.

In her person, she is tall, raw-boned, awkward, flat-chested, and stooping; her complexion is sallow and freckled; her eyes are not gray, but greenish, like those of a cat, and generally inflamed; her hair is of a sandy, or rather dusty hue; her forehead low; her nose long, sharp, and, towards the extremity, always red in cold weather; her lips skinny, her mouth extensive, her teeth straggling and loose, of various colors and conformation; and her long neck shrivelled into a thousand wrinkles. In her temper she is proud, stiff, vain, imperious, prying, malicious, greedy, and unchari- table.[22]

Never was there another such female in fact or fancy. Be- yond that, caricature can hardly be expected to go.

The most admired original in Smollett's most admired novel is the unforgettable Caledonian lieutenant, Lismahago. Yet Smollett never before or after travelled further into the realm of caricature than in this amazing creation, who is almost the twin of his chosen bride, Mrs. Tabitha.

He would have measured above six feet in height, had he stood upright; but he stooped very much, was very narrow in the shoulders, and very thick in the calves of the legs, which were cased in black spatterdashes. As for his thighs, they were long and slender, like those of a grasshopper; his face was at least half a yard in length, brown and shrivelled, with projecting cheek- bones, little gray eyes on the greenish hue, a large hook-nose, a pointed chin, a mouth from ear to ear very ill-furnished with teeth, and a high narrow forehead well furrowed with wrinkles. His horse was exactly in the style of its rider; a resurrection of dry bones.[23]

It has been cleverly conjectured that Lismahago was con-

[22] *Humphry Clinker*, Melford's letter of 6 May
[23] Letter of 10 July.

ceived principally as a mouthpiece for Smollett's satire against the English.[24] Does this not bear out the suggestion that caricature is the natural method of the artist afflicted with overmuch spleen? The list of caricatures could be extended almost indefinitely: *Peregrine Pickle* and *Launcelot Greaves* are full of them; Sir Stentor Style and Sir Mungo Barebones in *Fathom* are amusing examples, and so on.

Thus, when the effect of Smollett is different from that of Fielding and Hogarth, his inclination toward caricature is usually at the root of it, and this I suggest is a result of the dour and violent nature of his personality. Fielding had too much good breeding to enjoy attacking private characters, and is consequently elevated far above the moral level of most eighteenth-century satirists, who stooped to gross personal abuse and contumely not because of a love of truth or a desire for reform, but because of a thirst for malice or revenge. To hurl Smollett unhesitatingly into this class would be unfair, but upon frequent occasion he is not averse to consorting with it.

Although Smollett carried exaggeration to limits that Hogarth could, but seldom would, approach, the exuberant spirit of the best parts of his novels is paralleled in the work of the painter. The free and easy world of blows and buttocks, a world at once combining the sordid with the outrageously funny, is the province of both artists. Scene upon scene in Smollett, even though not indebted to Hogarth for any suggestion at all, breathes the Hogarthian atmosphere. Most remarkable of all perhaps is the boisterous dinner after the manner of the ancients in *Peregrine Pickle*. The host has dismissed no fewer than five cooks because they cannot prevail on their consciences to obey his directions. After he finally, by means of an extraordinary premium, has secured a cook and brought forth his lavish feast, his guests revolt, causing a sequel of riot, havoc, and confusion which even exceeds

[24] Martz, pp. 167ff.

that of Hogarth's parallel scene, the *Election Entertainment*. Peregrine's next adventure, in which he persuades the gaunt painter Pallet to attend a masquerade dressed as a woman, is similarly vulgar, spirited, and Hogarthian. The discomfiture of old Hawser Trunnion during his ill-fated ride to church on the morning he is to marry Mrs. Grizzle Pickle is reminiscent of Hogarth's "Chairing the Member" from the *Election* series. In *Humphry Clinker* pandemonium bursts forth when Mrs. Tabitha's favorite dog, Chowder, engages with five other dogs in a fight which eventually involves Mrs. Tabitha, Winifred Jenkins, the footman, the cook-maid, and a band of musicians outside.[25] The scene, conceived in the spirit of Hogarth's *Enraged Musician*, puts Matthew Bramble in much the same attitude as the title figure of Hogarth's print. Clinker's "rescue" of the naked Bramble from what had been a peaceful surf bath,[26] and Lismahago's stratagem of luring Sir Thomas Bulford waist-deep into his own fishpond[27] are crammed with the same high energy and short shrift for dignity which fill the prints of Hogarth and which are not seen in English fiction until Hogarth's advent. In this respect the Hogarthian atmosphere is often closer to Smollett than it is to Fielding. There are vulgarities in some of the prints that appear nowhere in Fielding's novels, but frequently occupy a prominent position in the racier pages of Smollett. They are earthier than Fielding and less sophisticated.

It may be said finally of Hogarth and Smollett that, notwithstanding their unvarnished tirades against pretense, hypocrisy, filth, and corruption in general, their greatest success is in the remarkable vividness of individual personages and scenes, enlivened with very considerable license of expression in loose detail. The glory of Smollett, said Saintsbury, is "the rapid profusion of incident and adventure, of scene and personage"; and that was the glory of Hogarth before him.

[25] Letter of 24 April.
[26] Bramble's letter of 4 July.
[27] Letter of 3 October.

More than this, Smollett often thinks in terms of painting; he visualizes his scenes on canvas. One may venture this assertion upon the authority of Smollett himself. I submit two scenes from *Humphry Clinker*, in which, to mention no others, the novelist instinctively adopts the terms of pictorial art:

Accordingly he [Lismahago] took his leave of us at a place half way betwixt Morpeth and Alnwick, and pranced away in great state, mounted on a tall, meagre, raw-boned, shambling gray gelding, without e'er a tooth in his head, the very counterpart of the rider; and, indeed, the appearance of the two was so picturesque, that I would give twenty guineas to have them tolerably represented on canvass.[28]

Later, when Lismahago is rescued from his burning apartment, the offer increases fivefold:

Zooks, I'll give a hundred guineas to have it painted — what a fine descent from the cross, or ascent to the gallows! what lights and shadows! what a group below! what expression above! what an aspect! did you mind the aspect? [29]

III

Smollett and Fielding are not alone among writers in their debt to Hogarth. The wide scope of the painter's creative imagination forced its way into many currents of the literature of the age. The scope is so broad that many authors writing of life in the mid-eighteenth century frequently and perhaps almost unconsciously make use of his work. Hogarth was never a very successful illustrator of other men's work (though he illustrated such various authors as Cervantes, Milton, Butler, and Sterne), but the writers of the age very clearly succeeded in illustrating him — not so much in describing his pictures, for that is never very inspiring, but in absorbing them and making his genius a part of theirs. One may safely say that no other painter of the first rank is so clearly connected with liter-

[28] Letter of 15 July.
[29] Letter of 3 October.

ature as Hogarth; the very fact that he is nearly always judged by literary rather than plastic standards is a fair indication of it. He called himself a comic writer and, as Mr. Sitwell remarks, would rather be remembered in the company of Shakespeare and Dickens than of Gainsborough, Constable, or Turner.[30] Like most of the great comic geniuses of England, he is strictly native, with few foreign influences.

Fielding and Smollett are so thoroughly and obviously beholden to Hogarth that even more of this wide influence is revealed by going elsewhere, to those authors who seem to have absorbed him unawares, authors who suddenly drop into describing a Hogarth character or scene because his works are a part of their general usable knowledge and everyday mode of thought. To writers Hogarth speaks more clearly than life itself, for he has already selected and highlighted, has given form to chaos. Looking at *Gin Lane* is more impressive than looking into an actual street; when the artist heightens for artistic effect he becomes truer than life itself. Thus it is not surprising that a writer may remember a picture better than an actual face. One such author is Lord Chesterfield, who, in warning his son against "genteel and fashionable vices," falls into a description of the nauseated youth in *A Midnight Modern Conversation*, and of Tom Rakewell in the gambling den "tearing his hair and blaspheming," for having "lost more than he had in the world." [31] Of course he does not give his source, and, being asked for it point-blank, might even have been unaware of having any. Chesterfield is in no sense Hogarthian, but the debt is nevertheless there.

Another example is the finicky Samuel Richardson, who doubtless would have termed Hogarth "exceeding low," just as Hogarth would have agreed with much of Fielding's derision of *Pamela*. (Recall his endorsement of *Joseph Andrews* in *Characters and Caricaturas*.) Yet in Richardson's *Familiar Letters* Hogarth several times breaks in. It is very plain that

[30] Sacheverell Sitwell, *Narrative Pictures* (London, 1930), p. 28.
[31] Letter of 12 October 1748.

the first picture of *A Harlot's Progress* suggested the title of
Letter LXII, "A young Woman in Town to her Sister in the
Country, recounting her narrow Escape from a Snare laid for
her, on her first Arrival, by a wicked Procuress." A number
of reminders of *A Rake's Progress* occur in the book. The
most unmistakable is in Letter CLIII describing Bedlam, the
scene of the last picture of the *Rake*. One of the inmates has
been crossed in hopeless love, and the writer of the letter (a
"most dutiful Niece") is accused of being his sweetheart and
the cause of his misfortune. In Hogarth this love-frenzied
individual is the one who has chalked on a board the name of
"Charming Betty Careless." The young letterwriter is shocked
at the air of casual amusement with which some of the spec-
tators, particularly of her own sex, regard the Bedlamites. One
remembers the two smirking ladies of fashion who pass through
Hogarth's canvas. In Letter CXIII there is more than a hint of
the rake's despondency and his former mistress's collapse in
the debtor's prison, Hogarth's seventh picture, though Rich-
ardson, characteristically, has made the mistress into the pris-
oner's "dear good Wife." The shameful marriage scene of the
Rake is suggested by both the title of Letter CXLVIII, "From a
Gentleman, strenuously expostulating with an old rich Widow,
about to marry a very young gay Gentleman"; and by the
writer's remark, "It seems to me, to be next to a degree of
incest for a woman all hoary and grey-goosed over by time,
or who will be soon, so to expose herself to the embraces of a
young fellow, who is not so old as her first son would have
been, had he lived." A young lady in Letter CXLV is impor-
tuned not to keep company with a rake with whom she has
been seen late at night "at the R——— Tavern, a house of no
good repute." In Hogarth the rake fondles a wench at the Rose
Tavern, certainly a house of no good repute.

From Richardson we may turn to an even less likely quar-
ter. One must look very far and very wide before finding an
author more unlike Hogarth than Henry Mackenzie, who
wrote the tearful and tasteless and popular book, *The Man of*

Feeling, in 1771. Sentimentalism was triumphing, and the ro-
mantic movement was well under way. Yet even Mackenzie
felt the long arm of Hogarth's literary influence; and I
should guess that, like Lord Chesterfield, he may have been
quite unaware of it. The man of feeling at one stage in his
happily fragmentary career visits Bedlam with a party that
includes several ladies. He describes only four of the inmates,
and two of them are straight from Hogarth's Bedlam scene:
the mock monarch, who beckons to the ladies, and a mad
astronomer and mathematician, who has drawn a circle on the
wall and is trying to compute the longitude. Later the man of
feeling meets the inevitable fallen woman, a Miss Atkins, at
heart the essence of innocence, but unwittingly duped by an
artful seducer. In her first big scene she falls back prostrate
into a chair exactly as Sarah Young does in the Fleet scene
from the *Rake*; later on her lodgings are described very much
like Moll Hackabout's in Drury Lane.

These few examples from authors the least possible like
Hogarth are enough to suggest the extent of his penetration
into the very marrow of eighteenth-century literature. He was
a painter known for his literary parts, and has announced his
own split aim when, in a passage that should be constantly
remembered, he says he will treat his subjects "like a dramatic
writer." He was the intimate friend of both Garrick and
Fielding, the best representatives of the splendor of the actors
and writers in an age where painting outside of Hogarth him-
self did not exist. Small wonder that he directed his brush as
he did, and that the relationship with actor and novelist was
strong.

IV

In conclusion to all that has been said about the relationship
of Hogarth to the literature of the age and especially to the
novels of Fielding and Smollett, it must be insisted that had no
specific influences between them ever existed, had the painter's
works by some circumstance been lost until a later age, had

they been entirely unknown to the novelists, they would still be imperative to a complete understanding of eighteenth-century fiction. Hogarth can give us vital information obtainable from no other source. The novelists, in chronicling eighteenth-century life, describe places and customs only insofar as these affect their plot and characters. Fielding, with characteristic irony, even speaks of this in *Tom Jones* in a passage where he is making short work of what could be made into a rich incident:

But as we are apprehensive that, after all the labour which we should employ in painting this scene, the said reader would be very apt to skip it entirely over, we have saved ourselves that trouble. To say the truth, we have, from this reason alone, often done great violence to the luxuriance of our genius, and have left many excellent descriptions out of our work which would otherwise have been in it.[32]

Obviously he is indulging in one of his favorite poses, that of the smarty, but he expresses a profound truth. When he speaks of Joseph Andrews or Parson Adams encountering certain experiences in a stagecoach, or of Sophia and Mrs. Fitzpatrick flying to London in the coach kindly supplied by an Irish peer, he would never dream of stopping to visualize the coach for the reader of two hundred years later. Nor in these instances is the lack much felt, for the dullest fool can imagine some sort of coach that will serve the turn.

But there are other aspects of eighteenth-century life equally common, yet discomfortingly vague to the average modern reader, who flounders on through, keeping an eye cocked as best he can for the story, and running through all manner of underbrush in the attempt. A few illustrations from Hogarth will clear the prospect enormously. For example, the most common structure in Fielding's novels is the roadside inn, the most common and consistently amusing character the voluble landlady. What was common to Fielding, however, is

[32] XII, 3.

now a curiosity. Just how vaguely the modern reader envisions a Fielding inn may be quickly determined by asking a class of moderately intelligent undergraduates to attempt some description of one. The result often more closely resembles the ghoul-haunted woodland of Weir. Yet how greatly one's understanding of the entire roadside experience in Fielding is enhanced by an examination of Hogarth's picture called *The Stage Coach; or, Country Inn Yard*. It is the moment the passengers are getting into the coach, and the fat landlady, the image of half a dozen such characters in *Tom Jones*, is standing behind an open bar ringing a bell and roaring out for the chambermaid. The even fatter host is defending the enormity of the bill he has presented to a reluctant guest. Behind them the fattest character of all, an old woman, is being forcibly shoved up the wooden steps into the narrow door of the coach by a postilion, while on the other side another postilion sues in vain for his fee. We learn that the luggage is piled in back of the coach, that often a low passenger may ride atop it — in this case an aged female smoking away on a pipe — and that two soldiers are allowed to travel on top of the coach proper. The landlady's cries are in vain, for the maid is just inside the doorway locked fast in the embrace of a departing traveller. In the background an election procession has just entered the inn yard, creating as much clamor as the arrival of Squire Western at Upton. Another splendid picture of the entire milieu of the roadside inn is the second from the *Election* series. The real heart of the inn, the kitchen fire, where a traveller sits smoking his pipe as the landlady rushes out a bumper of ale, is perfectly delineated in the sketch Hogarth did for Garrick's interlude, *The Farmer's Return*. The rustic has just come down from London full of news, and, an absolute likeness of Partridge, can hardly wait for his refreshment to pour forth with it to the gullible kitchen help.

Discerning readers will say that the aim of reading a novel by Fielding or Smollett should certainly be more than merely visualizing pictures; and we should all concur. But no one

would deny that a clarification to the visual sense enhances the understanding and consequently the enjoyment of a scene, especially when the author has not described an object or a custom that has since disappeared. Often pictures will admit us into a past era as no words ever can. A rapid glance at a dozen or so Hogarth prints will reveal at once their really vital relationship to the great novels, and will even cause us to wonder that we had ever claimed to an understanding of the novels without knowing them.

A Harlot's Progress is the graphic commentary on the entire array of fallen women in the novels of Smollett. The squalor and misery into which they sink can be fully realized only by examining the actual accoutrements of their condition set forth in so horrifying a manner in the third and fifth plates of the *Harlot* and in the seventh of *Industry and Idleness.* Roderick Random's friend, Miss Williams, and the last starved companion of Count Fathom never really come to life until we have actually seen Moll Hackabout. This may be the fault of Smollett, but it is nevertheless true. In the fourth plate we are taken to the hemp block at Bridewell, a place referred to countless times in nearly every novel of Fielding and Smollett, yet a place never described. In Hogarth alone do we encounter the entire experience of Bridewell: the rows of blocks, the wretched women beating hemp — some of them decked out in fine silk gowns — the stocks for idlers, the brimstone jailor, the rampant bribery, and the filth and clutter of the place.

A Rake's Progress, because of its wider range and greater length and because it might serve as the title for all three of Smollett's early novels, is even more important to grasping the experience of the age. The debauched tavern revels in Smollett, particularly in *Count Fathom,* are not completely clear until we examine the third print of the *Rake.* In the fourth, as the rake's chair is stopped and he is arrested for debt in the middle of St. James's Street, we see what keeps Pickle, Fathom, and Amelia's Captain Booth within doors except on Sunday. The sixth print reveals a gambling den, its atmosphere

and arrangements, thus clarifying a great deal of *Amelia* and Smollett. The scene in the Fleet prison, Plate vii, helps to explain one of the notable curiosities of eighteenth-century novels. In *Tom Jones*, in *Amelia*, in *Peregrine Pickle*, in *Count Fathom*, in *Sir Launcelot Greaves*, and in *Humphry Clinker*, the heroes all serve time in jail, but their stay is like nothing known to the twentieth century. They bespeak private apartments, they receive all manner of visitors, they have meals brought from nearby taverns, they have drinking parties, they import wives and children and mistresses. One asks how such a cell was fitted out, and, with all these liberties, why prison life was so appalling. Some idea may be gained from this print of Hogarth's. Though Tom Rakewell is utterly penniless, the turnkey with his account book and the tavern boy with ale testify to former comforts, the huge four-poster with curtains testifies to a certain privacy, the several odd inventions scattered about the room testify to the prisoners' absolute freedom, and the number of people in the room, five of them female, testify to the unlimited stream and nature of visitors. On the other hand the rake's poverty shows that existence in prison was intolerable without ready cash, and the enormous clutter reveals the filth of the place. Like Bridewell, Bedlam is being forever mentioned in the novels, but without the closing scene of the *Rake* it may remain only a name.

Of the first importance to novels of social satire is that the reader have a clear idea of the beau monde, the milieu of Lady Bellaston, Lord Fellamar, Lady Booby, and Colonel James, and at times of Peregrine Pickle and Count Fathom. In *Tom Jones* Fielding once stops to define for posterity the fashionable institution known as a drum,[33] but usually we are left to gather what we can from the action. The levee scenes of the *Rake* and the *Marriage à la Mode*, to mention but two of a large number, open a flood of light upon this entire segment of life that pages and pages of narrative or description could not. In the second scene of the *Marriage* the condition,

[33] XVII, 6.

at an hour past noon, of the dining room in the background
is sufficient commentary upon Lady Bellaston's whole exist-
ence.

Lesser prints are full to profusion with *explications de
textes*. *A Midnight Modern Conversation* vivifies Squire West-
ern in his cups, and all the drunken scenes from Smollett,
Peregrine Pickle in particular. The contempt for the French,
politics aside, which heavily punctuates the remarks of Field-
ing, Smollett, and Dr. Johnson, is at once explained by Ho-
garth in such prints as *Noon, Calais Gate*, and the pictorial
contrast, *England* and *France*. The misfortunes of Peregrine
Pickle's arrival at Calais seem fantastic until projected against
the background of *Calais Gate*, where most of Smollett's fig-
ures appear. The hurly-burly of the soldiers thronging the inn
at Hambrook, which ends with the roasting of Tom Jones by
Ensign Northerton, as well as the over-all disorder of the 1745
rebellion, are explained in the *March to Finchley* as they are
not explained anywhere else. When Fielding and Smollett
speak of wretches being turned out to sleep in the streets,
there is considerable vagueness regarding the exact situation
until we turn to Hogarth's *Night*, where several waifs are
huddled under a kind of outside counter in front of a barber's
shop. A setting from *Jonathan Wild*, the night cellar, is de-
fined for us by the ninth print of *Industry and Idleness*,
where, in a place of sinister gloom (a dead body is being
pushed into a hole in the floor), Tom Idle is being betrayed
to the watch by the prostitute with whom he had consorted
earlier. The wild disarray and crowded canvas of Wild's
execution at Tyburn is utterly impossible to conceive in its
fullness without studying Hogarth's eleventh plate from this
same series. In fact this is perhaps the most exact illustration
for any scene in Fielding to be found in Hogarth. Finally the
popular masquerade, which plays a vital part in both *Tom
Jones* and *Amelia*, yet is never described, may be seen — if we
discount several allegorical decorations on the wall — with ut-
ter fidelity in Hogarth's large *Masquerade Ticket*.

In fine, a novelist does not stop to describe common contemporary objects and institutions, for that would be a superfluous addendum to his art. A later age must therefore turn to a pictorial artist for edification. A few illustrations are sufficient to indicate how much richer is our perception of the experience that is Fielding and Smollett if we supplement it with Hogarth's pictures. As far as the novels of those two eminent authors are concerned, the proper study of mankind is Hogarth.

It may be added in conclusion that although he is a prime force in the great realistic movement in eighteenth-century fiction, Hogarth's final effect is that of the satirist. Yet he is a satirist more human and more humane than Swift or Pope, than Smollett or indeed Fielding. He realizes that even the satirist must partake of some of the tragedian's wide acceptance of experience, insofar as his sinners are after all but human beings and are in part redeemed by their humanity. He refuses to let blackness swamp his canvas. Mr. Kronenberger remarks that if sordidness bulks overlarge in Hogarth's choice of material, the balance is restored by the health and freedom of his approach to it. He cleanses his degraded scene by discharging from it all cant, all artifice, all wishful thinking; he releases the dammed-up current of an age into the river of endless life.[34] But he does more than this — in his enjoyment of human beings, from the very best, like Captain Coram and Henry Fielding, to the very worst, like John Wilkes and old Simon Fraser Lord Lovat, he becomes reconciled to the inevitably incomplete nature of finite existence, and thus approaches what may be called divine comedy.

[34] Louis Kronenberger, *Kings and Desperate Men* (New York, 1942), p. 121.

Index

Index

NOTE. It has seemed unprofitable to include in the index every name and
title that appears in the book. Nearly every eighteenth-century reference
is noted, however, in addition to every other important reference.